IMAGES
of America

THE
SAVANNAH
RACES

PHOTOGRAPHS FROM THE COLLECTION OF
THE GEORGIA HISTORICAL SOCIETY

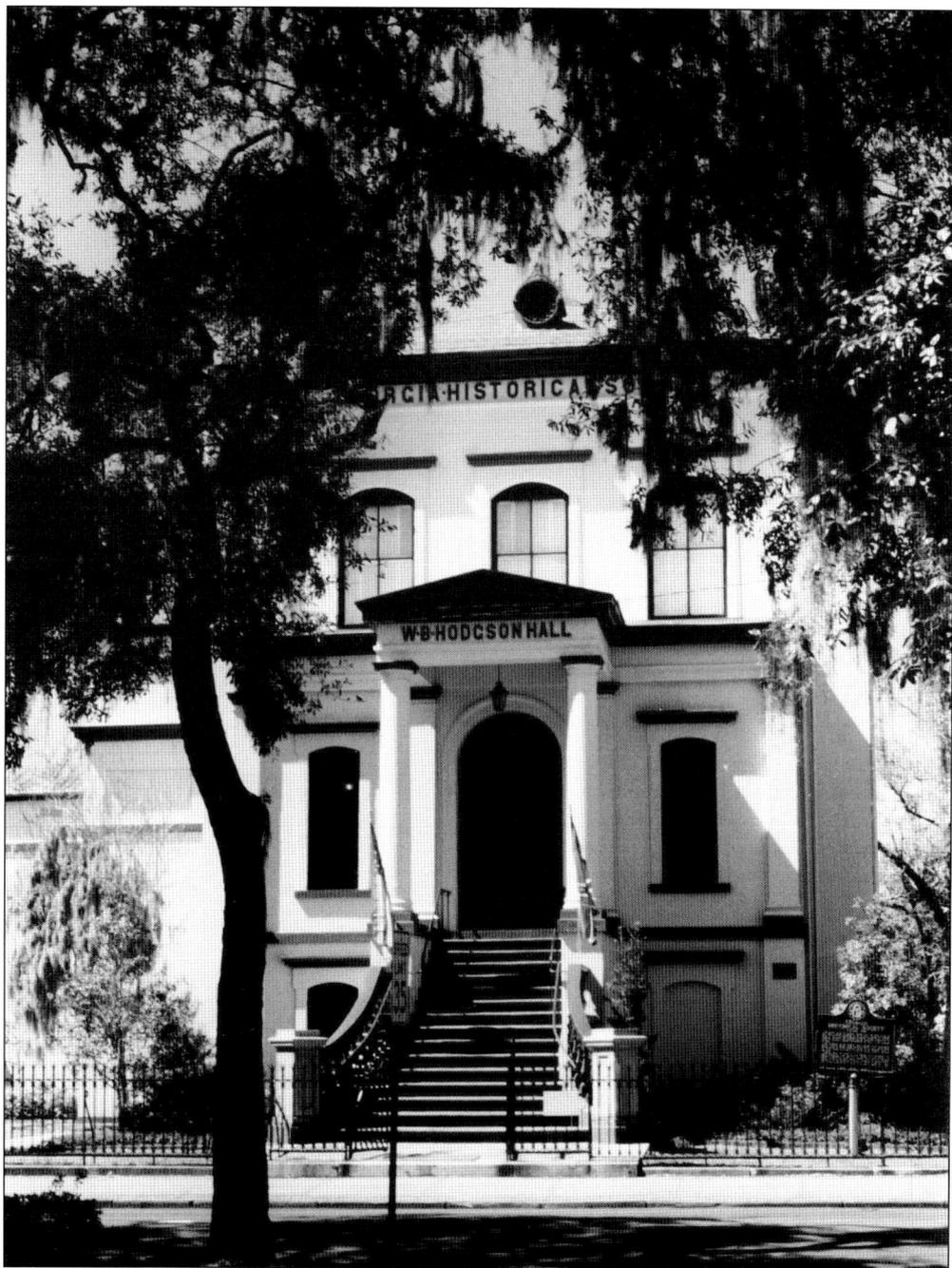

The Georgia Historical Society is headquartered in Hodgson Hall in Savannah. Hodgson Hall, named for William B. Hodgson, became the third home of the Society in September of 1875. The building was officially dedicated on February 14, 1876, and has been the Society's state-wide headquarters ever since. Housed within Hodgson Hall is one of the finest library collections of archives, manuscripts, photographs, books, and maps relating to the state of Georgia. The library is free and open to the public. Hodgson Hall is located at 501 Whitaker Street, Savannah, Georgia 31499.

IMAGES
of America

THE
SAVANNAH
RACES

PHOTOGRAPHS FROM THE COLLECTION OF
THE GEORGIA HISTORICAL SOCIETY

Frank T. Wheeler
for the Georgia Historical Society

ARCADIA
PUBLISHING

Published by Arcadia Publishing
Charleston SC, Chicago IL, Portsmouth NH, San Francisco CA

Printed in the United States of America

Library of Congress Catalog Card Number: Applied for

For all general information contact Arcadia Publishing at:
Telephone 843-853-2070
Fax 843-853-0044
E-mail sales@arcadiapublishing.com
For customer service and orders:
Toll-Free 1-888-313-2665

Visit us on the Internet at www.arcadiapublishing.com

Contents

The Georgia Historical Society

Chartered by the Georgia Legislature in 1839, the Georgia Historical Society is a private, non-profit organization that serves as the historical society for the entire state of Georgia. For nearly 160 years, the Society has fulfilled its mission to collect, preserve, and share Georgia's history through the operation of its library and archives in Savannah. The Society exists to tell the story of our state's journey through time and to give our citizens a sense of who we are as Georgians.

The Georgia Historical Society is headquartered in Savannah in historic Hodgson Hall and is a major research center serving approximately 16,000 researchers of Georgia history per year. Within the Society's library and archives is preserved one of the most outstanding collections of manuscripts, books, maps, photographs, newspapers, architectural drawings, portraits, and artifacts related to Georgia history anywhere in the country. The Society is continually adding to its collection through both donations and purchases.

In addition to its fabulous library, the Georgia Historical Society has an aggressive statewide outreach program. The Society accomplishes this mission in a variety of ways and to a wide audience. The Society conducts lectures and historical programs, administers a Historical Marker Program, and most significantly, has a statewide Affiliate Chapter Program. This program is the foundation upon which all statewide outreach is built.

The Affiliate Chapter program encourages historical agencies and interested groups throughout the state to join the Georgia Historical Society in our mission to save Georgia history. Through this professional education program the Society provides assistance, teaches workshops, and serves as an information clearinghouse for those historical agencies in need of help or advice. Staff members visit these organizations and conduct a consultation visit offering assistance in everything from archival management and administration to securing grant funds. The Affiliate Chapter Program, more specifically the workshops conducted as part of the program, were awarded the 1997 Professional Development Program of the Year by the Georgia Association of Museums and Galleries.

The Georgia Historical Society also has an active publication program. The Society publishes the *Georgia Historical Quarterly*, which is "The" magazine on Georgia history. The *Quarterly* is published in conjunction with the University of Georgia and has developed into one of the country's leading scholarly journals dedicated to a particular state. In 1840 the Society began publishing books with items from the collection. This is an ongoing activity at the Georgia Historical Society and this book is a continuation of that program.

INTRODUCTION

When thinking of the development of the automobile most people don't think of Savannah, Georgia. However, Savannah played a major role in increasing the popularity of the automobile in the South between 1908 and 1911. During this period, Savannah hosted several automobile races which attracted both drivers and spectators from around the world. Some were here for the party, some for the novelty. But most of all, they came to Savannah to see the daring drivers and the speeding automobiles.

Charles and Frank Duryea are credited with the first successful gas-powered automobile, which was unveiled in September 1892. The Duryeas were bicycle designers and tool makers living in Chicopee, Massachusetts. They tested their invention indoors, as they were worried about public ridicule. In 1893 a more powerful model had a successful trial run, and on June 11, 1895, Charles Duryea was issued the first U.S. patent for a gasoline-driven automobile by a U.S. inventor. On June 26, 1894, Karl Benz of Germany had been issued a patent for a motor car. From this point the development of the automobile followed an incredibly fast track.

A group of forward-thinking Savannah men were relentless in their pursuit of bringing an automobile race to the city. These men were rewarded in March of 1908 when Fred Wagner officially started the initial race by sending the first car down the course to the wild cheers of everyone on hand. The races would continue through the Grand Prize Race of 1911, held in November. It was realized that Savannah was growing and could no longer host a race without relocating the track a great distance from the city. People's attitudes had also changed and they were not as willing to put their lives on hold for the races. The novelty was wearing off, and in May 1911, the first running of the Indianapolis 500 indicated that the racing business was changing and Savannah would have to make drastic changes to maintain the frantic pace.

Many Northern newspapers did not feel that Savannah would be successful in her conduct of the race. The Northern cities felt themselves superior and thought that Savannah would lack the sophistication to have successful races. Savannahians proved the nay-sayers wrong by staging what many called the best races of their time. The drivers and visitors, arriving from all around the world, were won over by the charm of the city and the hospitality of its citizens. The drivers were impressed with the conditions of the roads and the safety measures taken by racing officials.

Overall the races were a tremendous success—so much so that they eventually led to their own demise. The popularity of the automobile soared in Coastal Georgia and more particularly Savannah. As more people owned cars, there was increased migration to the outskirts of the city. People could now live farther away from the city, and the roads constructed for the races were of such a high quality that migration to the "suburbs" tended to follow these routes.

This book is intended to provide a photographic history of the Savannah races. The images are from the Julian Quattlebaum Collection, owned by the Georgia Historical Society. Modern-day photographs were taken by the author. There are still numerous photographs in the collection at the Georgia Historical Society that were not used in this book or in Dr. Quattlebaum's *The Great Savannah Races*, published in 1957.

Hopefully, after looking at the images and reading the captions in this book, the reader will come away with a feel for life in Savannah during the race years and the impact that the events had on the city. It should also be evident to the reader that Savannah had a huge part in increasing the popularity of the automobile.

ACKNOWLEDGMENTS

This photographic history could not have been possible without the foundation being laid by Julian K. Quattlebaum, M.D. In 1957 Dr. Quattlebaum published a book entitled *The Great Savannah Races*. Between Dr. Quattlebaum's book and the Savannah newspapers, it is easy to paint a rather clear picture of the races. Dr. Quattlebaum's research notes and photographs of the races were donated to the Georgia Historical Society, and there are several hundred photographs within his collection. A major effort was made in this publication to include photographs that Dr. Quattlebaum did not use in his book.

In appreciation for what Dr. Julian Quattlebaum accomplished in his book, and in documenting the Savannah races, this volume is dedicated to his memory.

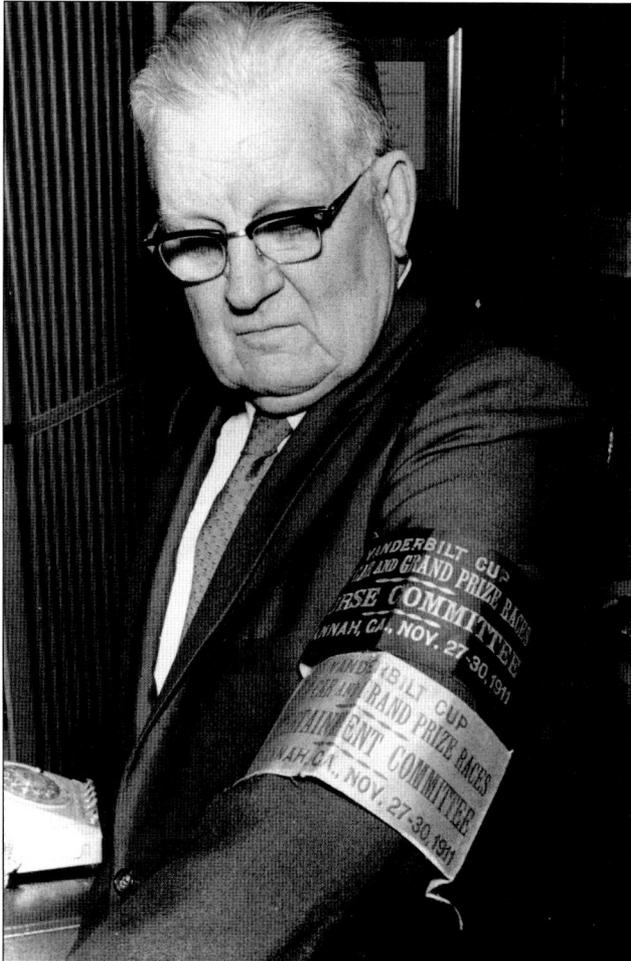

One

MARCH 1908

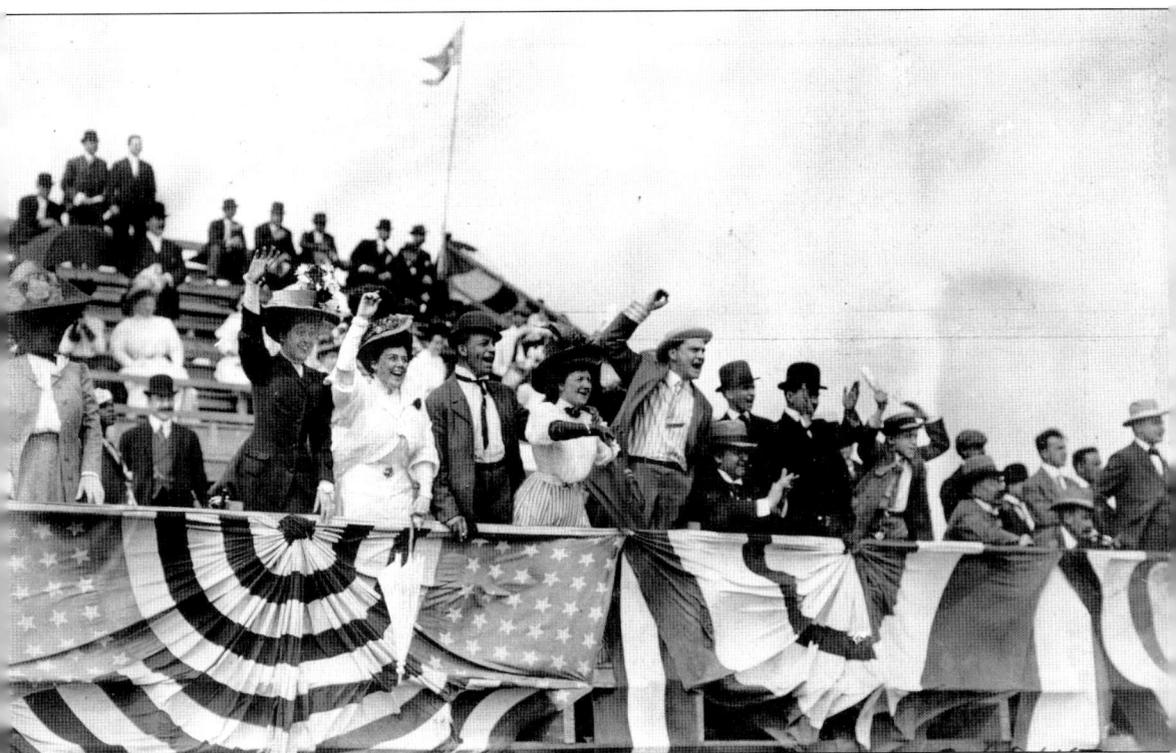

Savannah had never been so excited over a sporting event. The city was going to host three auto races in March of 1908. Two races took place on March 18, and the last race took place on March 19. The citizens decorated their houses with flags and bunting. The city had a very festive atmosphere and "eclipsed any celebration of the 4th of July." Businesses closed, schools closed, and the proud citizens of Savannah eagerly anticipated the arrival of the daring drivers who would compete in the upcoming races. This was to be the beginning of Savannah's auto racing heritage, one that would last until 1911. They were, as referred to in the title of Julian Quattlebaum's book, *The Great Savannah Races*.

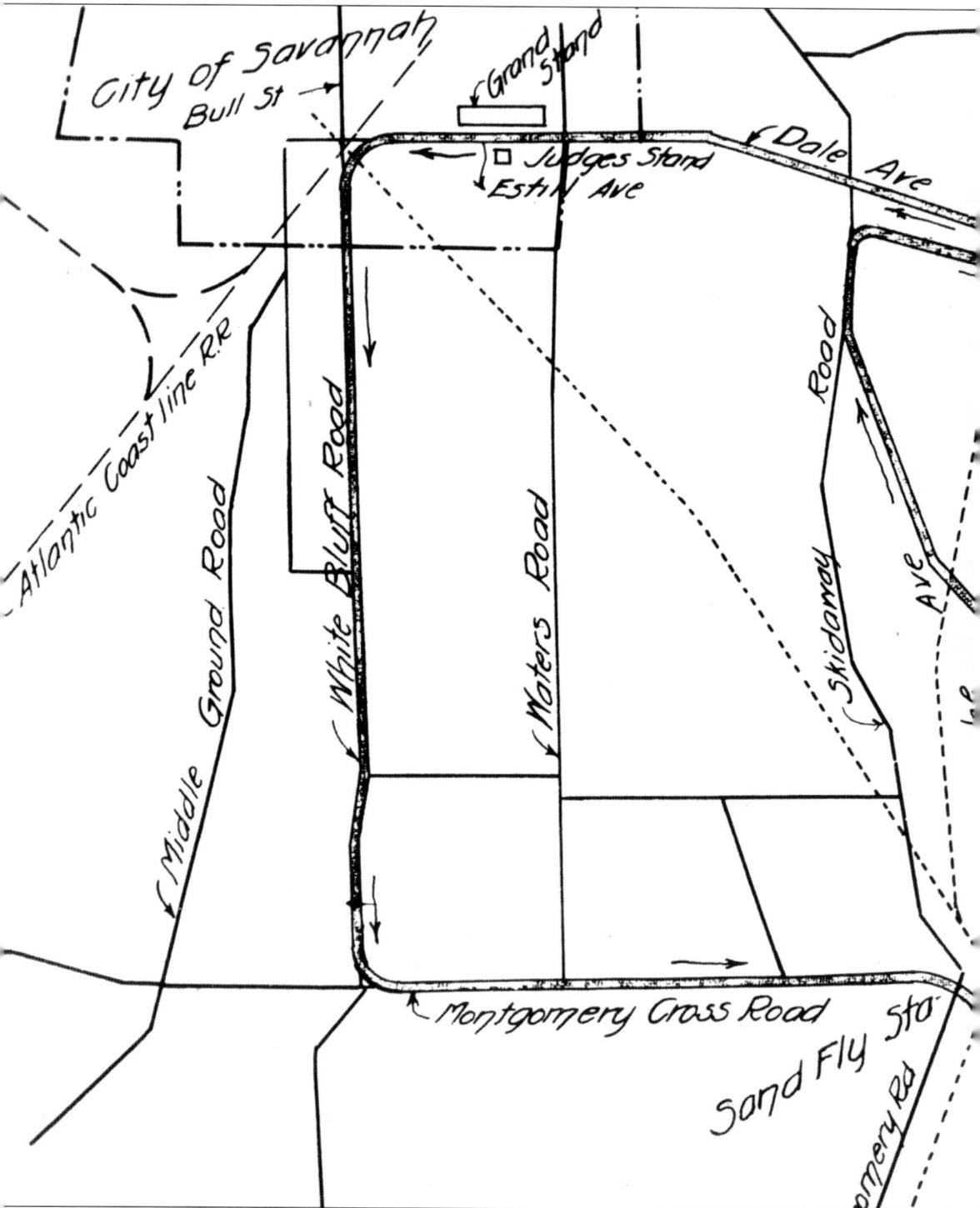

City of Savannah
Bull St
Grand Stand
Judges Stand
Estill Ave
Dale Ave
Atlantic Coast line R.R
Middle Ground Road
White Bluff Road
Waters Road
Skidaway Road
Ave
Montgomery Cross Road
Sand Fly Sta.
omery Rd

When the auto racing world arrived in Savannah, the sport was eight years old. Although races were taking place in Europe prior to 1900, the first "official" race held in the United States was on April 14, 1900. The highest speed reached in the first race was 25 miles per hour, which was

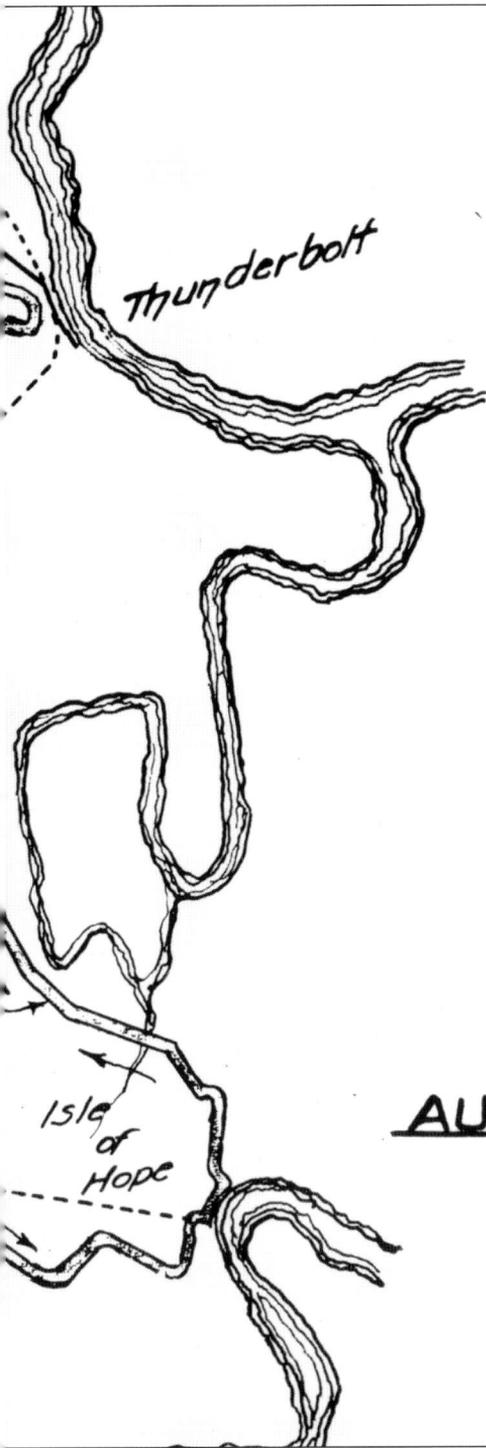

Thunderbolt

N

Isle
of
Hope

MAP OF

AUTOMOBILE RACE COURS

SAVANNAH

GEORGIA

MARCH 18TH & 19TH

1908

thought to be extremely fast. By the 1908 races most drivers were exceeding 65 miles per hour
and the cars were more durable.

Frank C. Battey was president of the Savannah Automobile Club, which was formed in 1904. Battey was a driving force behind getting the races to Savannah. He lobbied race promoters and national organizations and assured them that Savannah could provide safer and better racing conditions than northeastern cities. Problems had arisen at the races on Long Island, as racers were not allowed to practice at a reasonable hour or for an appropriate length of time. The people of New York resented their roads being closed and frequently entered the roads, obstructing the drivers. Occasionally this lead to injury or death for drivers or citizens of New York.

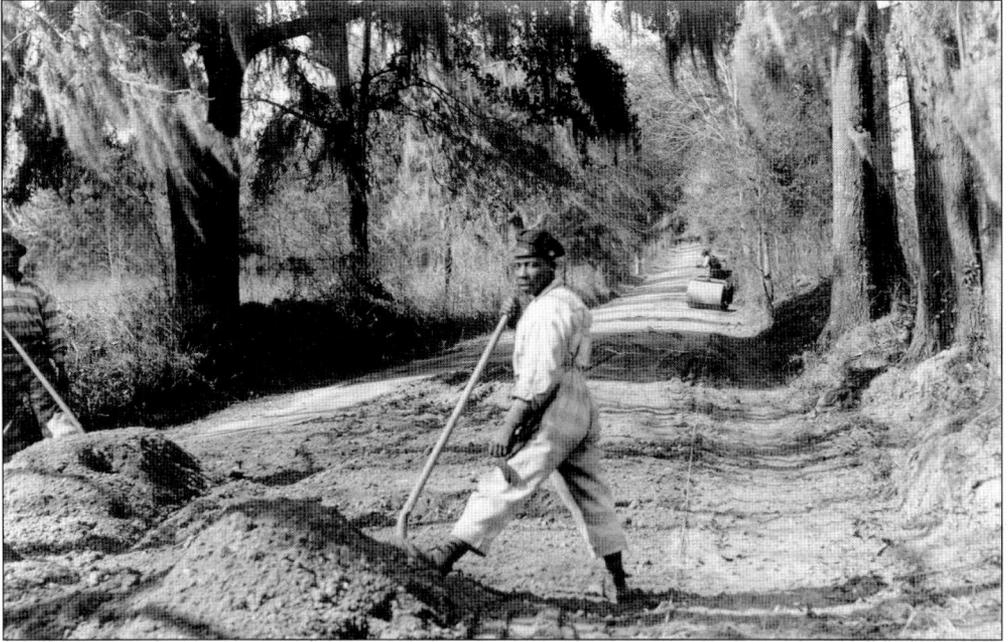

The *Savannah Morning News* of March 15, 1908, stated, "In Savannah they secured large flocks of striped birds, known as chain gangs. These men were given healthy outdoor exercise while building roads and improving existing roads. The novelty appealed to the Northerners as nothing else could have done and many a driver stopped to wonder at the sight and to marvel that such labor had not been utilized long ago in the North to build good roads." None of the prisoners attempted to escape, and the construction of the roads was a major success and completed at reduced cost due to the prison labor. The prisoners were also eager to see the flashy racers. Most likely these men are working on White Bluff Road near Montgomery Crossroads.

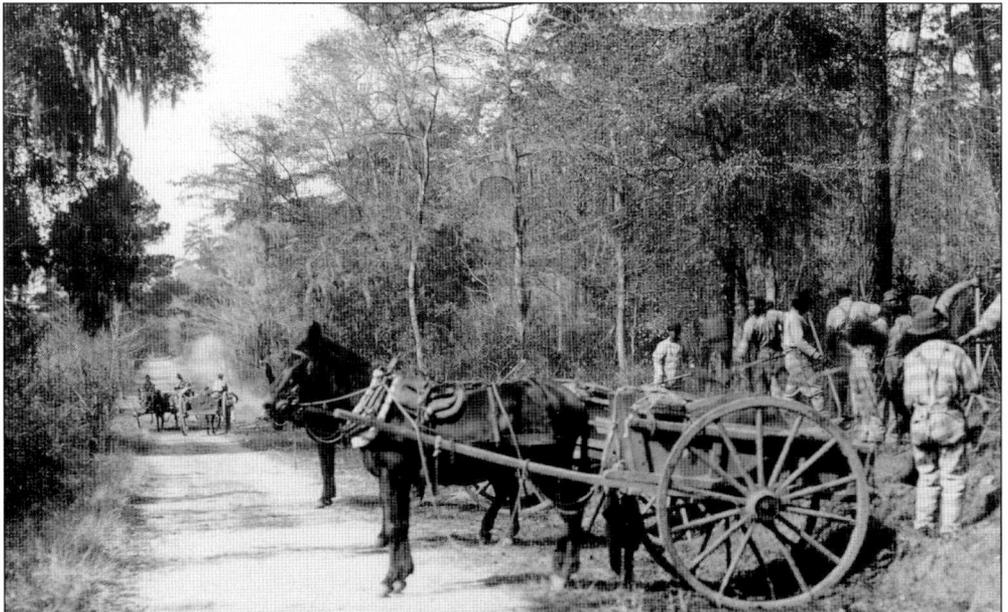

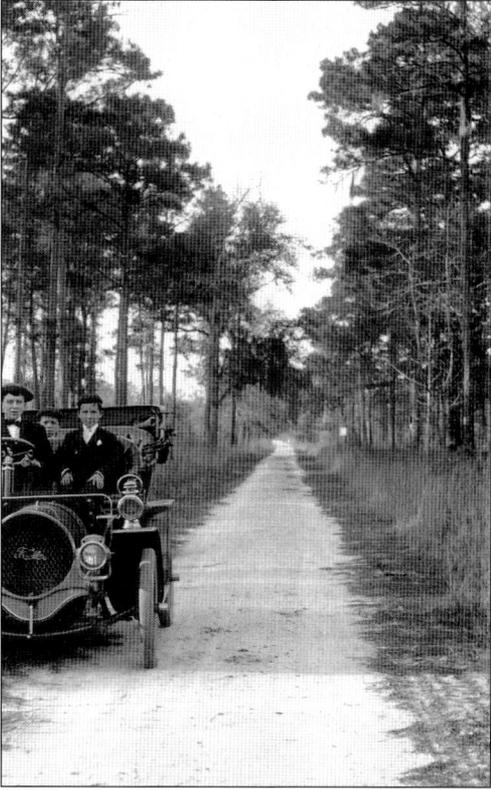

On March 12, 1908, it was stated in the *Savannah Morning News* that "In practice the Savannah course showed faster than did the famous Vanderbilt cup course, and that every indication points to a new record breaking speed in the three events." Pictured here is Montgomery Crossroads as seen in 1908 and 1998. Montgomery Crossroads was one of the straightaways that provided the racers room to increase to a high rate of speed for a sustained period of time.

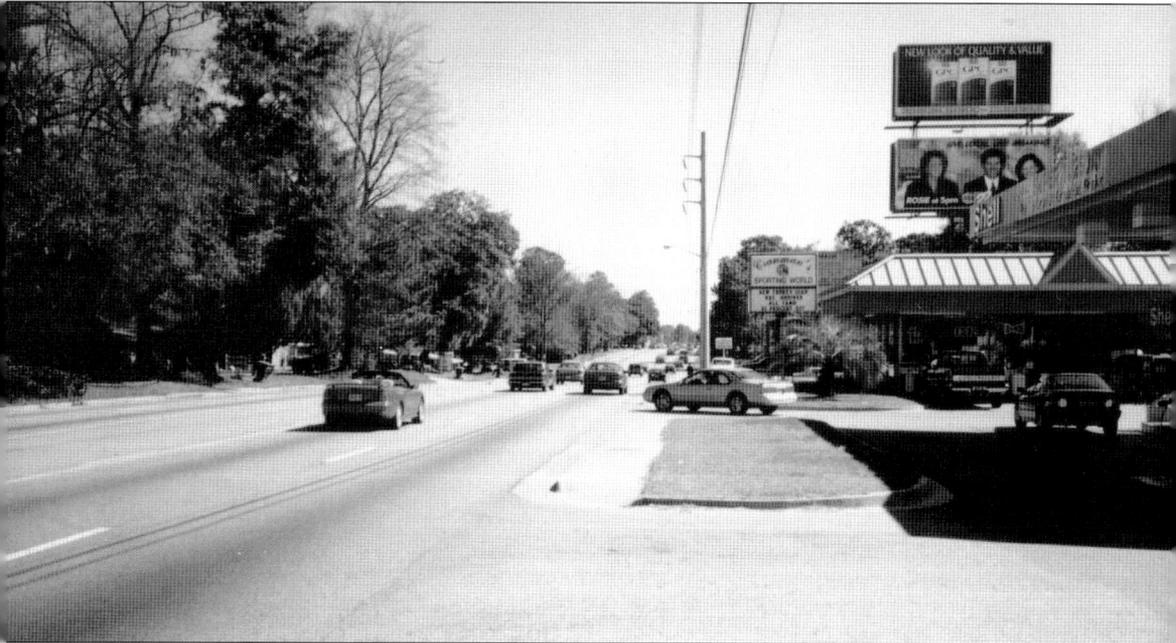

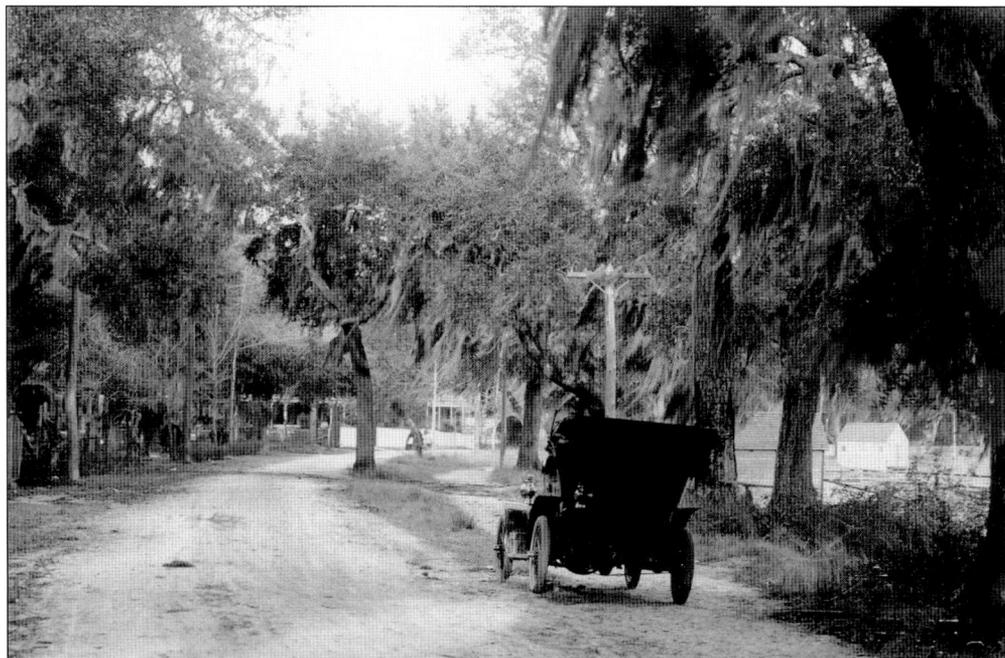

The Retail Grocers Association decided on March 12 to recognize the auto race days as holidays. The association decided that the afternoon of the second day, Thursday, they would close for a holiday. The holiday began at 1:00 and the grocers appealed to citizens to shop early. These photographs are of Isle of Hope in 1908 and 1998. Drivers covered the distance of Montgomery Crossroads between White Bluff Road and Sand Fly. Here they took Isle of Hope Road to LaRoche. The road through Isle of Hope has many curves and the drivers were forced to cut speeds almost in half as they approached this part of the course.

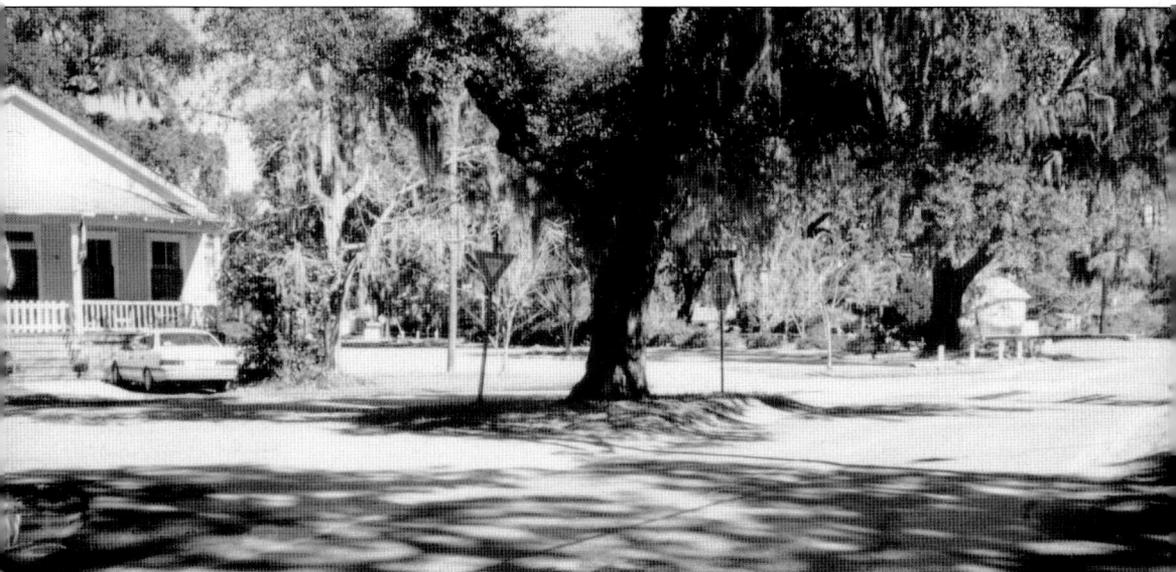

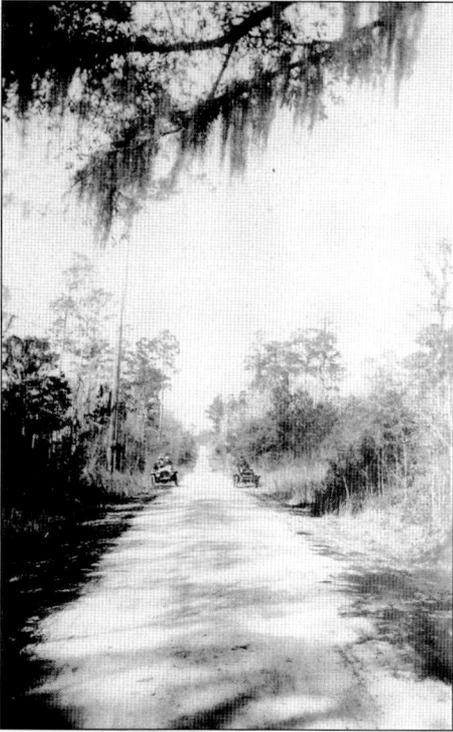

As specified by the race officials, each car was assigned a number and identified by having this number painted on its body. The numbers were painted on the cars by members of the Savannah Automobile Club and were 1 foot high and 1 inch wide in a color contrasting with the color of the car. The number appeared on the front, both sides, and rear of all cars. The large numbers allowed spectators and judges to see the identity of the cars at great distances as the cars entered the straightaways. The cars were equipped with padded seats and hoods and each car carried a driver and a mechanic. The cars did not have any type of safety equipment and a high-speed wreck often proved fatal. Pictured here is the 5-mile point on LaRoche Avenue in 1908 and 1998.

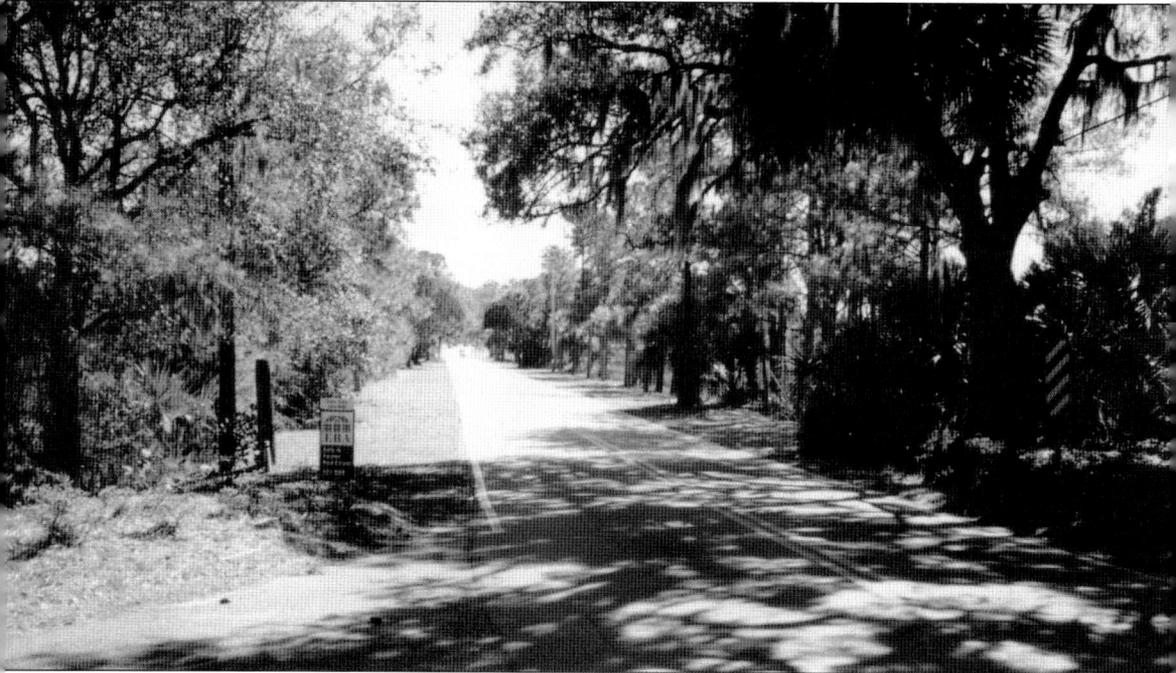

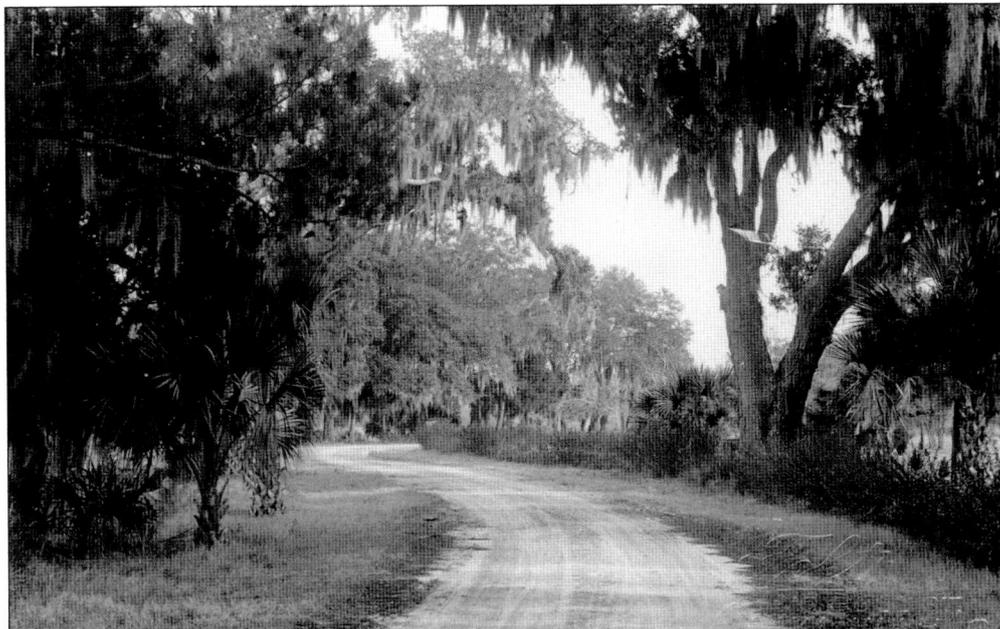

Under the leadership of Dr. T.P. Waring, 12 Savannah doctors were on hand to go to the aid of anyone injured during the races. Waring was known during the races as the "Chief of the Medical Corps." The other doctors were Jabez Jones, J.K. Train, E.R. Corson, J.G. Crowther, Ralston Lattimore, G.R. White, William Dancy, A.B. Cleborne, Marion Thomas, Lawrence Lee, R.V. Harris, and G.H. Johnson. The doctors were provided with a car containing medicinal supplies, bandages, and any other things felt necessary. Due to the excellent conditions of the course, it was not believed that the doctors would be needed. However, the Automobile Club wanted to "prevent any needless suffering." Pictured here is a curve on Isle of Hope in 1908 and 1998.

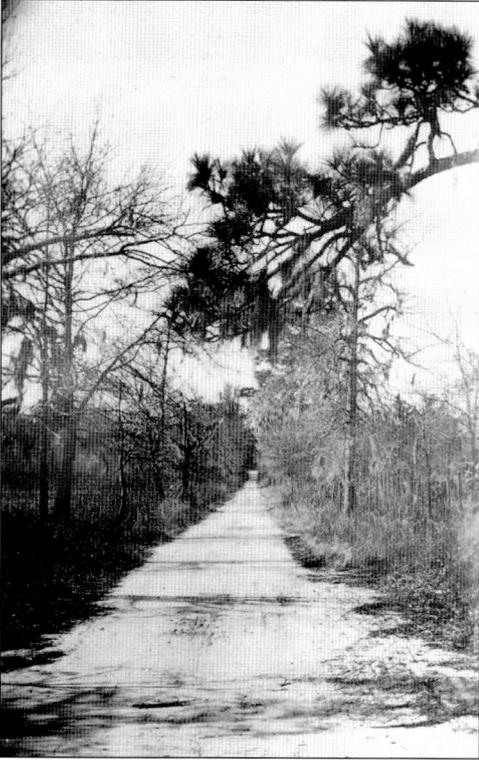

The drivers were given plenty of time to practice on the course prior to the race, and many of them stated that with one or two exceptions, the course in Savannah was almost entirely free of danger areas. Some of the curves were considered dangerous, but the smart driver would enter these without sacrificing safety for speed. Several cars found it difficult to stay on the course during the races. Drivers also welcomed expanded practice hours, as the citizens of New York had argued over any loss of the road for any length of time. Therefore, the New York races required that the drivers practice from sun-up to 7:00 a.m. Pictured is LaRoche Avenue in 1908 and 1998.

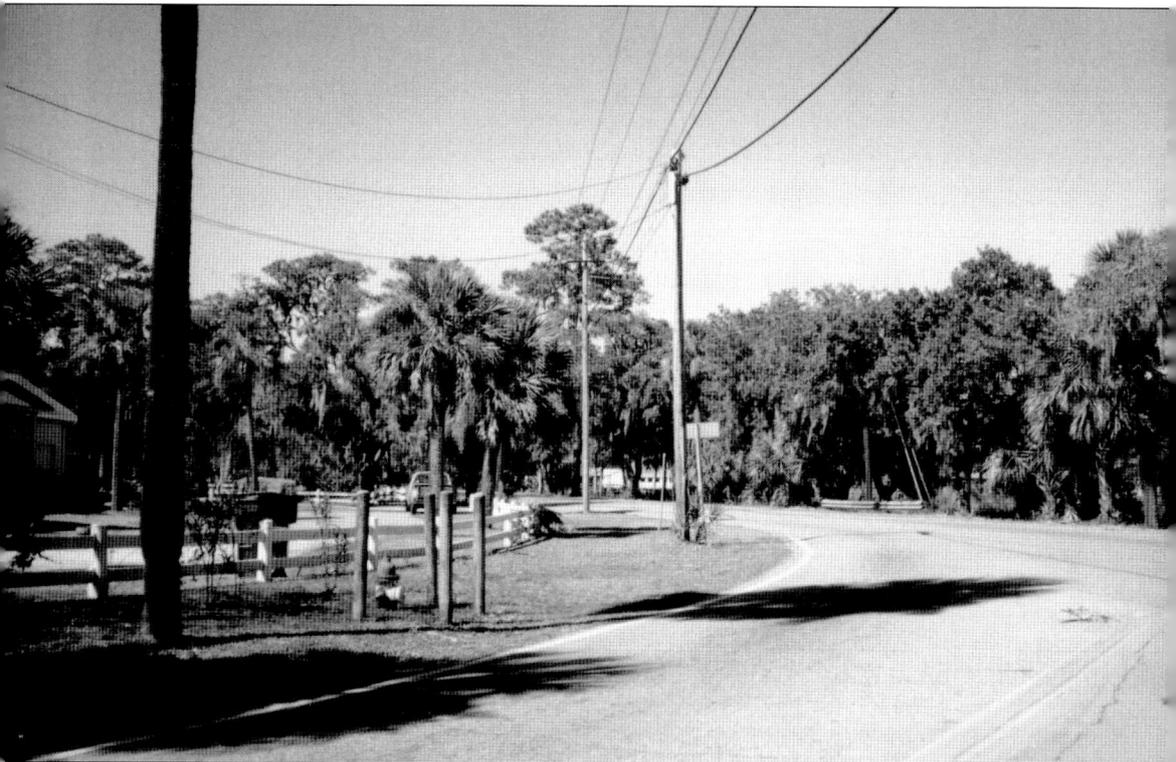

High school students in Savannah petitioned the board of education to make the race days a holiday. At first the board opposed this, even though an appeal was also made to them by Mayor Tiedeman. It was learned that the majority of the students planned to skip school and the board of education finally relented. Pictured is another stretch along LaRoche Avenue (1908) and the course prior to turning onto LaRoche (1998).

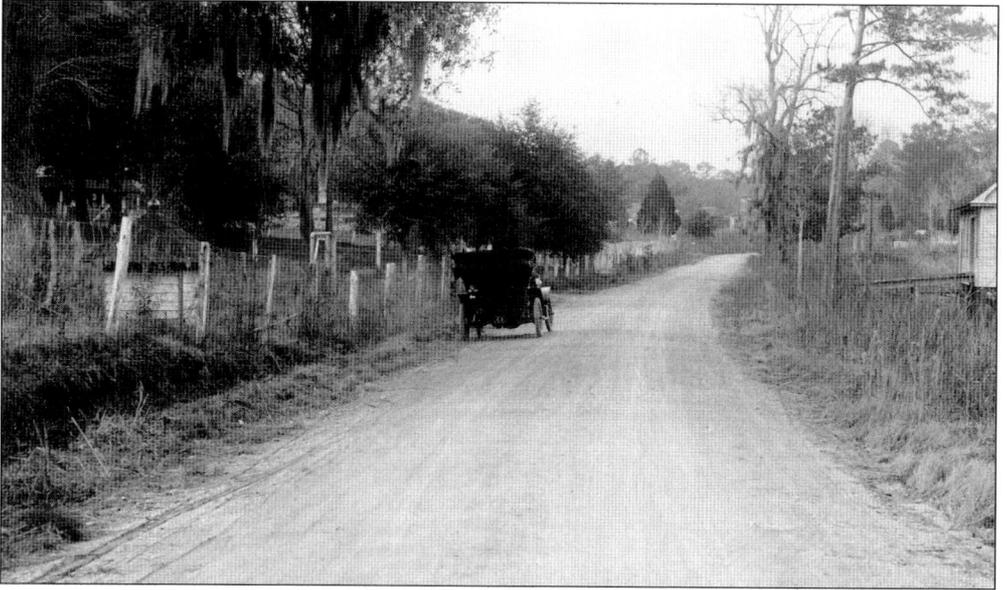

The governor and mayor authorized the use of soldiers and police to guard the course during the practice days and the races. This was a selling point for Savannah in the minds of the international and American racing communities, as the northeast was unwilling to make this type of commitment in 1908. The military men guarding the course were given specific orders and were under strict military rules, were to enforce the laws, and govern themselves with the strictest military discipline. No one was allowed on the course without a special order signed by Major William B. Stephens, commander of Savannah Volunteer Guards and senior officer of the military patrol assigned to the races. The soldiers were empowered to use any means to prevent a violation of the law. This was not necessary during the March 1908 races. These pictures show another stretch of LaRoche, which in 1908 (above) included chicken houses.

According to the drivers, the rest of the United States and Europe had nothing on the excellent quality of the Chatham County roads. Of particular note was the stretch of Dale Avenue and Estill Avenue. Some of the drivers felt that on the straightaways they could possibly reach 85 miles per hour. This was considered extremely dangerous, as a car hitting a rough spot in the road at 85 miles per hour would certainly be disastrous. These pictures show the straightaway on Dale Avenue and were taken in 1908 and 1998. The turn onto Dale Avenue was considered by the drivers to be the most dangerous spot of the course. The Dale Avenue stretch led to Estill Avenue (now Victory Drive) and the spectators in the grandstands.

OFFICIAL PROGRAM

SAVANNAH

CITY OF SAVANNAH.

INCOR -1789-

AUTOMOBILE RACES.

MARCH 18-19-1908.

PRICE 25 CENTS

This program, part of the Julian Quattelbaum Collection at the Georgia Historical Society, contains information on the race, the course, and some of the racers. Also included are advertisements from local businesses.

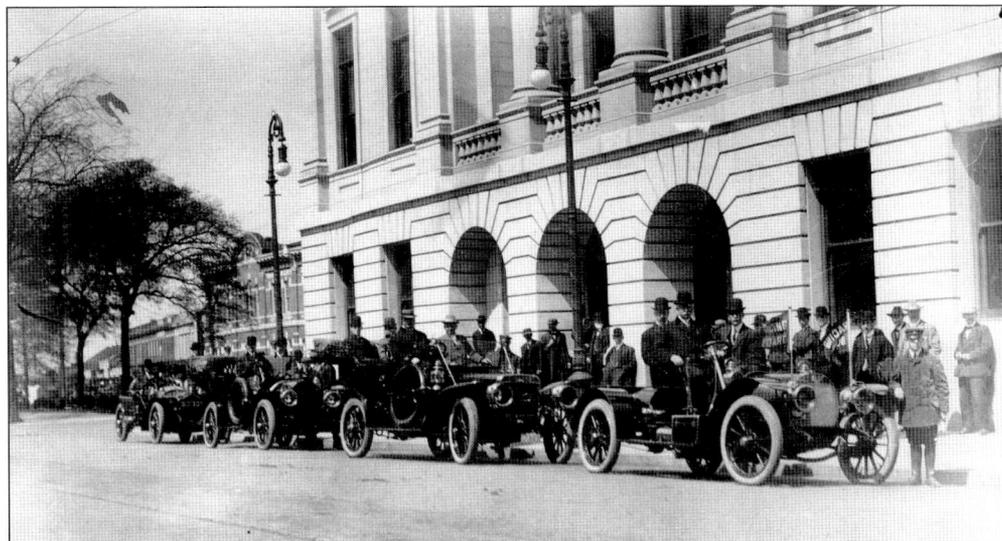

One of the more interesting sights on the streets of Savannah during the races was automobile processions. This procession, sitting in front of City Hall, consisted of the Racing Board, judges, the Savannah Automobile Club, and other dignitaries. They would form in the morning and drive to their positions. Most of the men from the Racing Board rode with citizens of Savannah, since they came to Savannah by train. Some drove to Savannah from far distances and, given that the roads weren't suited for cars, it is amazing they arrived.

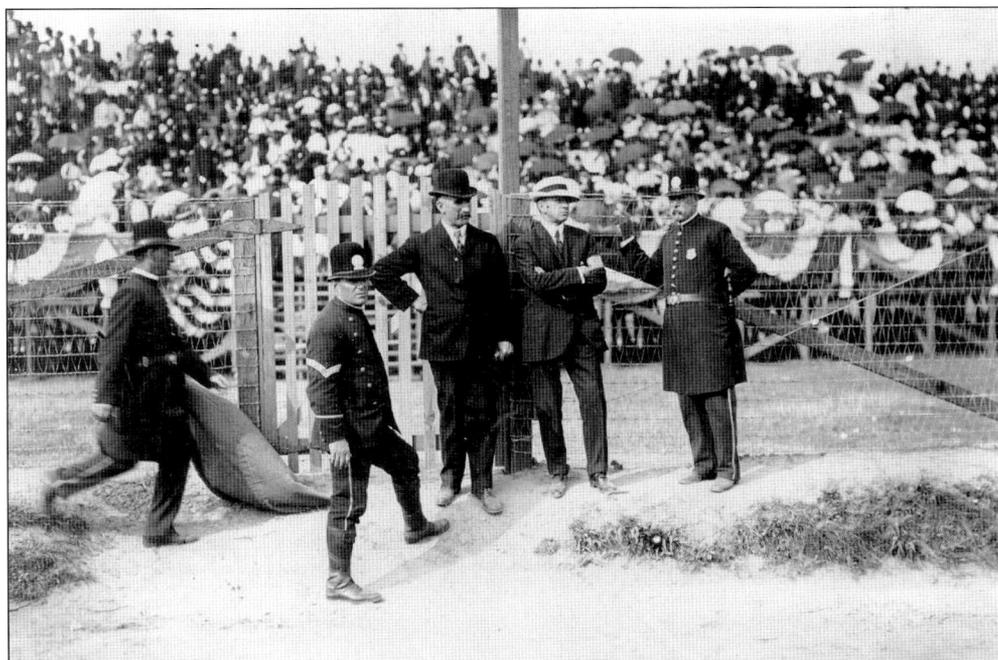

While in Savannah the drivers were told that the city speed limit would be strictly enforced. Most police officers were not using automobiles, and the ones who may have been could not catch a speeding racer. Except during the race, drivers had to drive 15 miles per hour on all city streets. The gentleman in the center of this photograph (with hand on hip) is George Tiedeman. He was mayor of Savannah and was instrumental in bringing the races to the city.

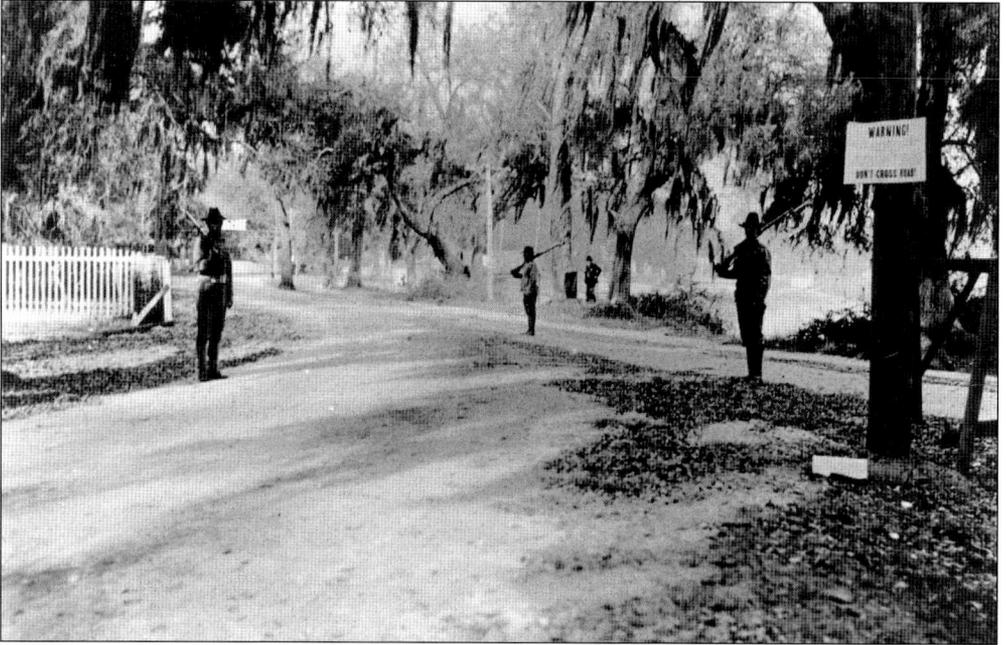

The race course was guarded by military personnel to insure the safety of the drivers and the spectators. There were 10 positions assigned along the course, and each position was required to have 15 men guarding that area, giving the course a total of 150 military guards at any one time. The guards in this picture are guarding the course along LaRoche. This is most likely the intersection of Norwood and LaRoche.

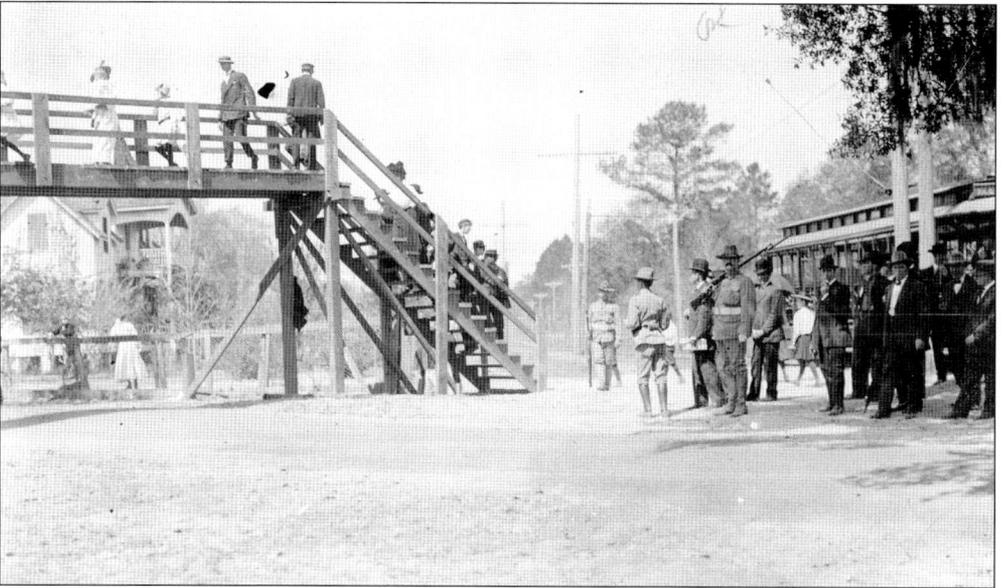

The positions of the guards were printed in the *Savannah Morning News* of March 15. Positions one, two, and three began at White Bluff Road and Estill Avenue and extended to Montgomery Crossroads. Positions four, five, six, and seven extended from Montgomery Crossroads through Sand Fly and Isle of Hope. Position eight extended to Bona Bella and position nine through Thunderbolt. The tenth position extended down the home stretch to the finish.

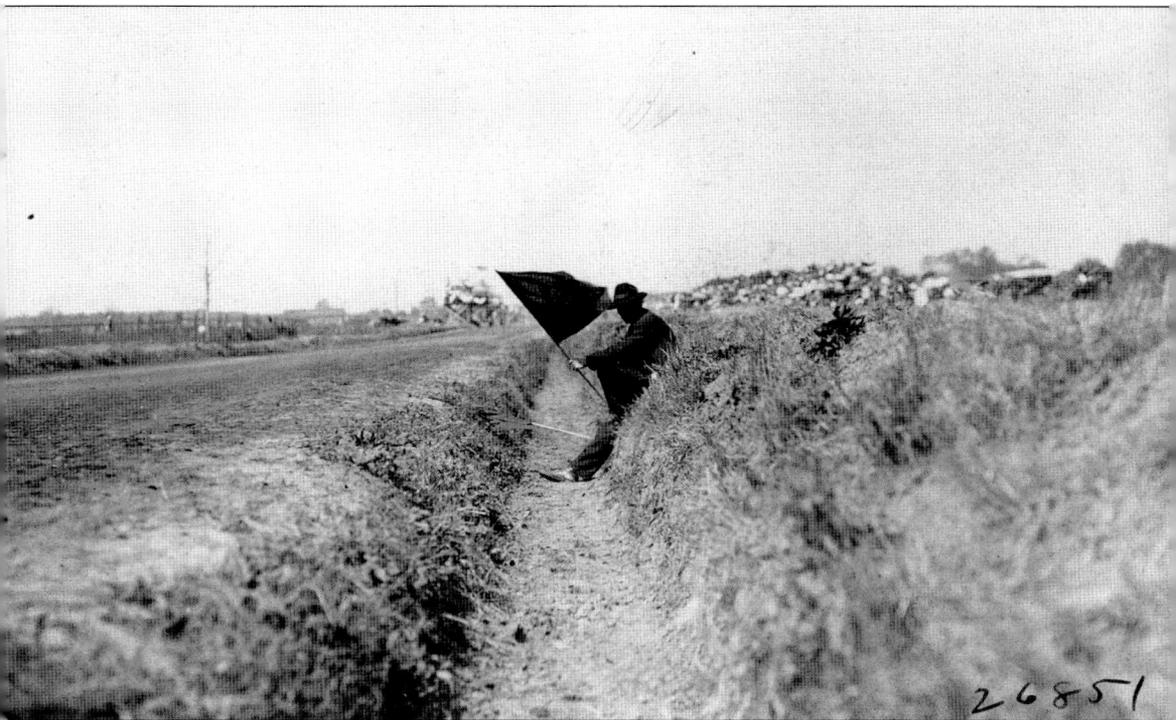

Signs were placed on the course providing the drivers with instructions. The signs signified left and right turns, as well as other information valuable to the racers. In addition, red and yellow flags were used for signaling. A red flag was used for indicating a clear course and a yellow flag indicated danger. This is opposite of the signaling system used by the railroad. The drivers crossed numerous tracks and the flags served to signal engineers and drivers. Some of the drivers, and at times even the flagmen, became confused by the opposite signals and a few escaped near disaster.

The judges were positioned at the start/finish line, across Estill Avenue from the grandstand. An announcer using a megaphone would announce changes in auto positions, wrecks, or mechanical failures as the racers were on the rural parts of the track. The information on the racers was obtained through a series of telephones around the course.

The judges for the race were selected on March 14, 1908. They were Emory Speer, Walter G. Charlton, Paul E. Seabrook, Davis Freeman, George T. Cann, and W.W. Osborne. The judges were positioned at the start/finish line opposite the grandstand on Estill Avenue. Each judge wore an armband and was faced with the responsibility of ensuring a safe and fair race.

A racing chart was constructed opposite the grandstand on Estill Avenue (Victory Drive). This chart is for the Savannah Challenge Cup. Not only does it provide times and position, it also indicates if the car has been wrecked. As indicated here, William McCulla, driving an Apperson, flipped his car over on Isle of Hope in the third lap. He was a feared driver, as he had won races in Australia, America, England, Ireland, and Scotland.

On March 18, the high-powered cars raced. They were the standard stock chassis, and according to the *Savannah Morning News* were equipped with racing bodies and engines with a maximum engine displacement of 575 cubic inches. They raced 18 laps on the 10-mile course for a total of 180 miles. There were five cars scheduled for the high-powered race. The winner received a silver cup, known as the Southern High-Powered Cup, which was valued at $1,000. The winner was George Salsman, driving the Thomas owned by Mr. John F. Kiser of Atlanta.

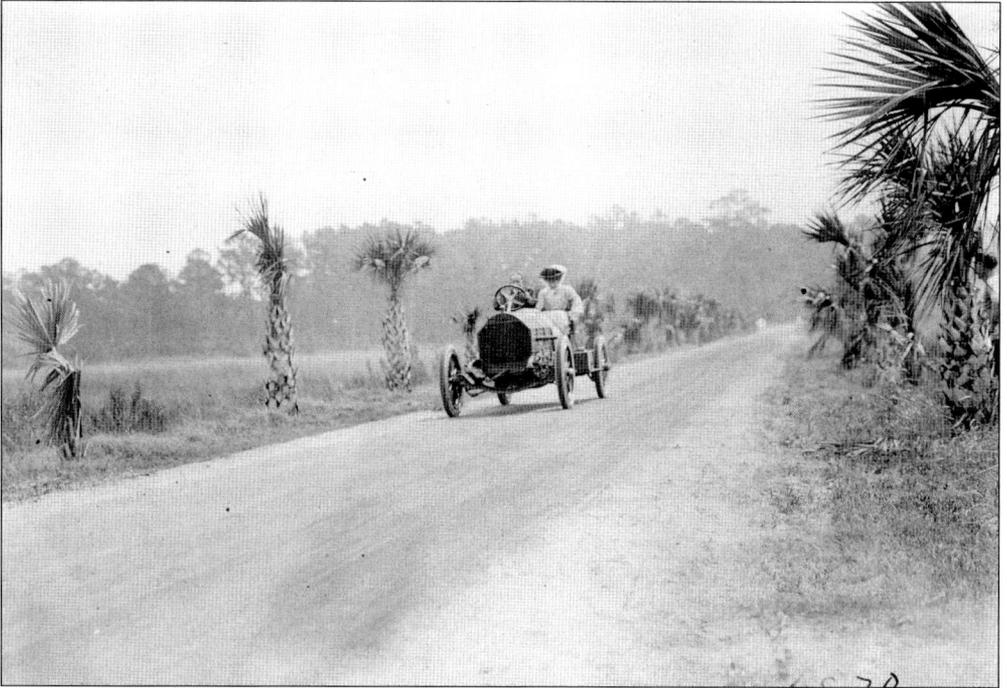

Mrs. A.H. Shapiro of New York holds the distinction of being the first woman to ride in a racing car at racing speed. She was veiled and goggled as she was driven by Herbert Lytle in the Jackrabbit car he drove in the Challenge Cup Race. These two photographs picture Mr. and Mrs. J.F. Kiser of Atlanta in a car Mr. Kiser had entered in the races. The top photograph was taken as they sped down the causeway from Sand Fly to Isle of Hope. The bottom photograph shows the car passing the grandstand. Note that in the bottom photograph Mrs. Kiser was behind the wheel.

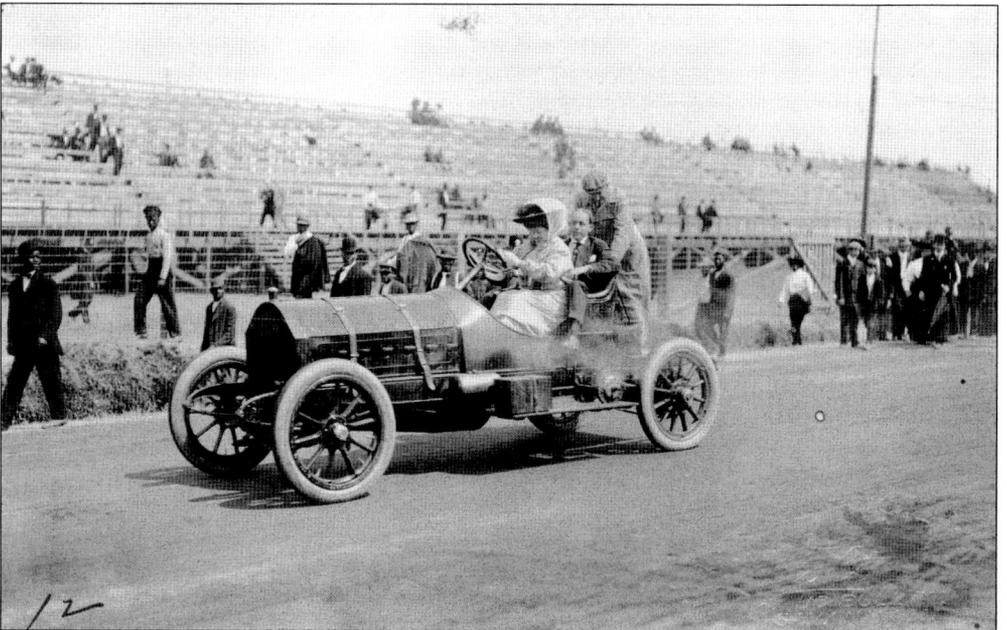

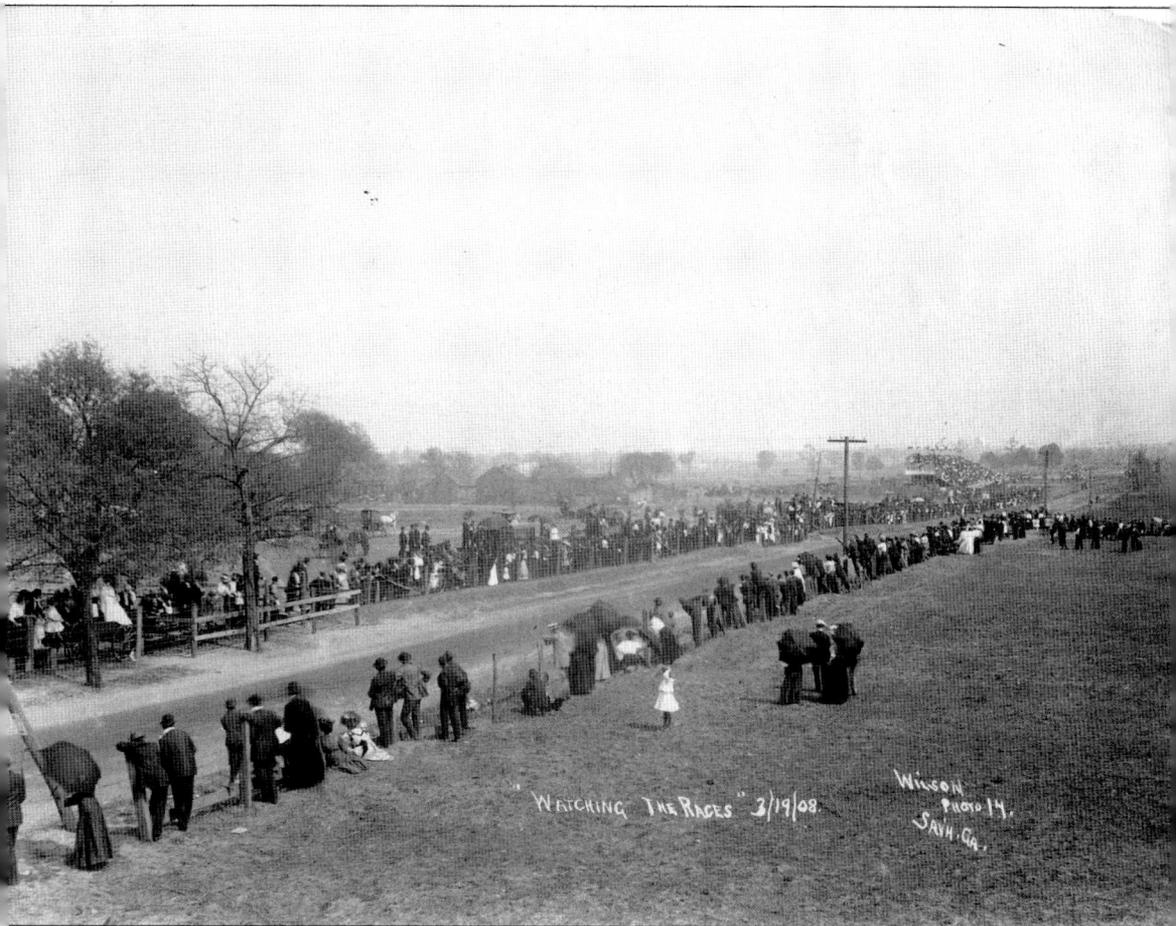

"WATCHING THE RACES" 3/19/08

WILSON
PHOTO 14.
SAVH. GA.

The Savannah Automobile Club appealed to spectators to purchase tickets and financially support the races. Many were planning to bypass the ticket price and view the race from a variety of vantages along the course. F.C. Battey, president of the Savannah Automobile Club, asked people to show their "patriotic spirit." Here fans line the course along Estill Avenue (Victory Drive) beyond the grandstand. The grandstand is evident in the distance. The drivers continued down this straightaway from the start/finish line and the grandstand. Once they passed this area, the drivers would turn left onto White Bluff Road and a long straightaway toward Montgomery Crossroads. This area along Estill Avenue provided spectators with the longest view of the course.

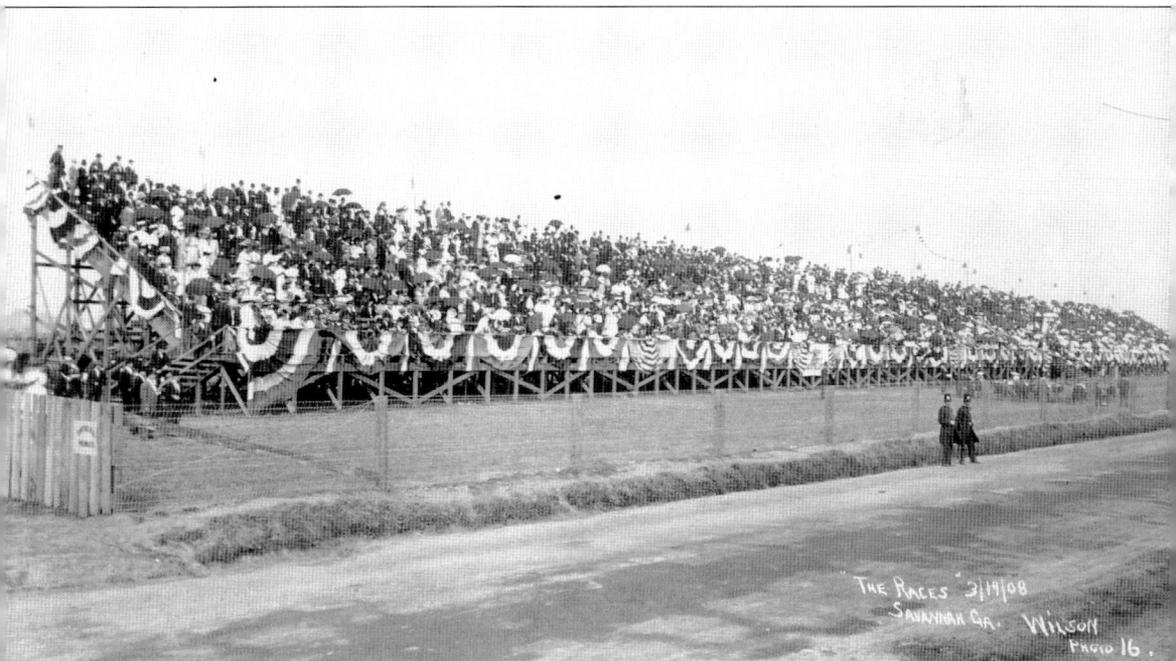

From the grandstand, spectators could view the cars a mile away as the drivers approach from Thunderbolt and Dale Avenue. The cars could also be viewed for a mile or more as they went left and down White Bluff Road. The grandstand was the only place along the course where 2 miles of racing could be seen.

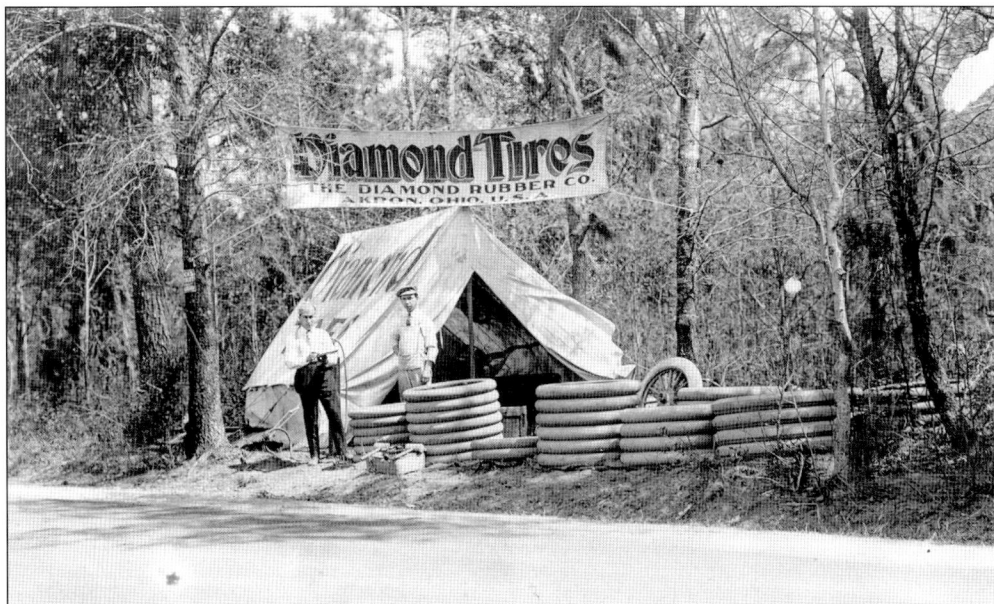

At various points along the course one could find tires, gasoline, etc. After the March 1908 events, it became necessary to place military guards at these tire centers. Manufacturers such as the Diamond Rubber Company of Akron, Ohio, were provided the opportunity to advertise their merchandise. There were many other car and car part companies that took advantage of the public's fascination with the racers.

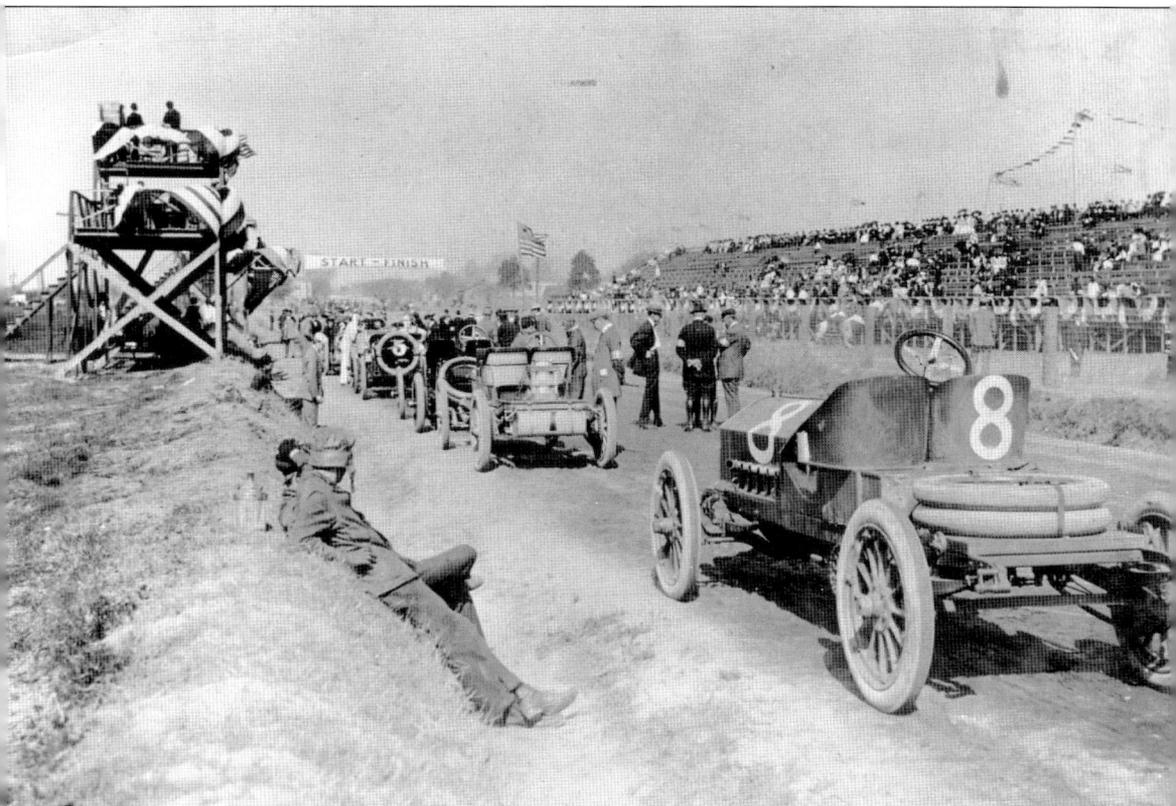

On March 19, the Savannah Challenge Cup was run. As stated in the *Savannah Morning News*, "This race was for stock chassis equipped with racing bodies and an engine displacement not to exceed 575 cubic inches." The race covered a total of 360 miles, as it was 20 laps over an 18-mile course. There were eight cars entered in the event. The prize for this event was the silver cup known as the Savannah Challenge Trophy. The cup was valued at $1,800 and was won by Louis Strang, driving the Isotta-Fraschini. He completed the race in 6 hours, 21 minutes, and 30 seconds. Strang was in car number 2. Car number 8, an Acme, was driven by M. Newstetter.

The other race on March 18 was for stock chassis, runabout class, equipped with racing bodies and engines limited to a maximum engine displacement of 375 cubic inches. The race was 18 laps over a 10-mile track for a total distance of 180 miles. Six cars were entered in the second event. The prize was a silver cup known as the Southern Runabout Cup, valued at $1,000. The event was won by Herbert Lytle, driving an Apperson. Lytle had come in second in the Savannah Challenge Cup

Two roads along the course were cut through the yards of houses along the way. The first was the first left turn at Isle of Hope, which was banked through the flower garden of the Solomon property. The second was the left turn leaving Isle of Hope, which ran through the lawn of the Wylly place. Pictured here is Newstetter, driving the Acme during the Savannah Challenge Cup. He finished third with a time of 6 hours, 47 minutes, and 5 seconds.

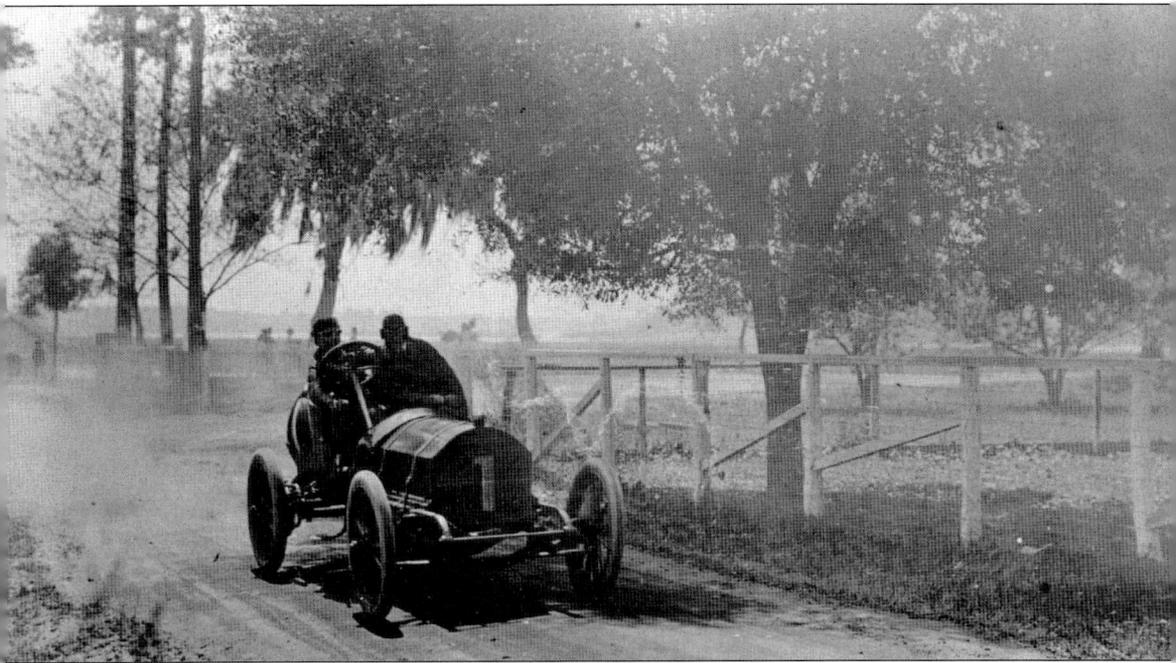

As stated in the *Savannah Morning News*, the drivers worked extremely hard. "There is a constant pounding that a weakling could not survive for an hour, and the men who will handle the machines have reached their dangerous positions only after years of practice and study." This photo is of the Challenge Cup and was taken along Isle of Hope or LaRoche. In the background is a shack that was used by the military along the course and served as a telephone relay point.

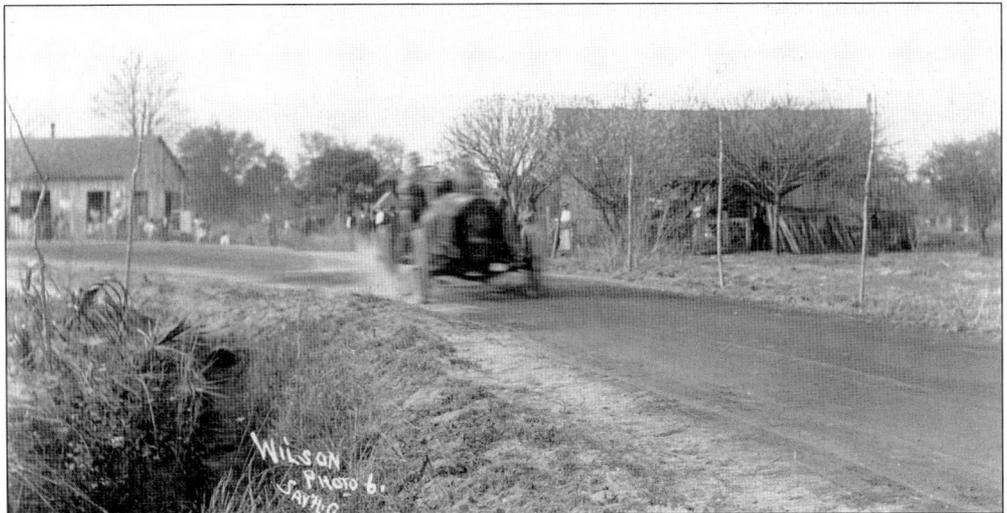

Roads were oiled three weeks in advance of the race in an attempt to reduce dust. The oil was shipped to Savannah in tank cars and was pumped into sprinkling wagons at the intersection of Estill and Bull Street. The sprinkler covered the course and then followed with a rinsing with water. In some cases the roads were reoiled. A thoroughly oiled road would remain dustless for about a year. One of the downsides to oiling the roads was the dangerous speeds at which some racers entered the curves.

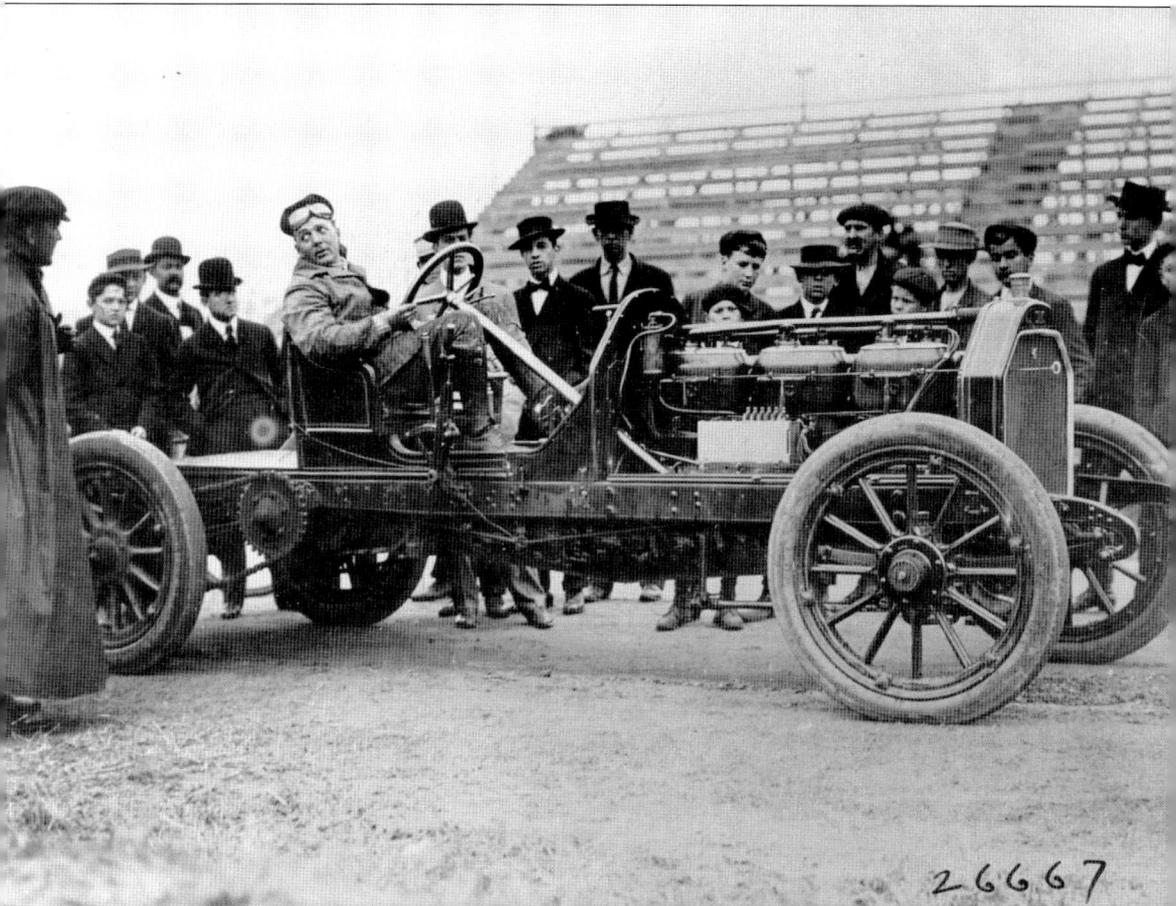

There was a local entry that drew a lot of interest. It was a Stearns car owned by F. Ross Guerard and driven by F.W. Leland in the Southern High-Powered Cup Race. Mr. Leland had won all of the races he entered the year before and it was believed he made the Stearns car a formidable entry. The Stearns car added a little excitement when it rounded the curve onto Dale Avenue and went off the road and into a group of picnickers. No one was hurt. This area of the course was considered the most dangerous by the drivers.

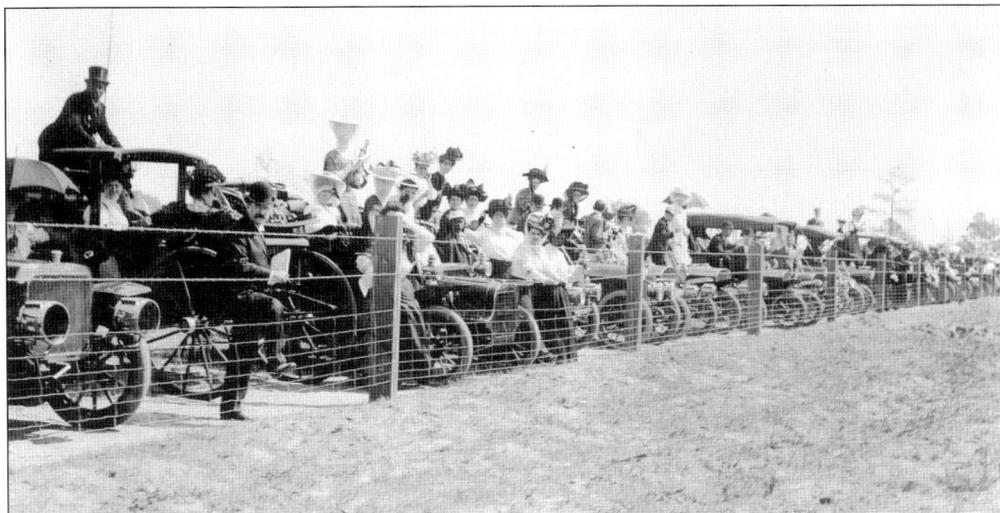

Promoters of the Northern races were extremely impressed with the course in Savannah. In New York the course was not altered to increase safety. There were constant problems with spectators entering the course and as one newspaper article states, "a man entered the course and was thrown over a telephone post, minus a leg." These spectators line the course on Estill Avenue, as this was obstruction-free and all were given a wide view. As is obvious in this photo, the races were quite a social event.

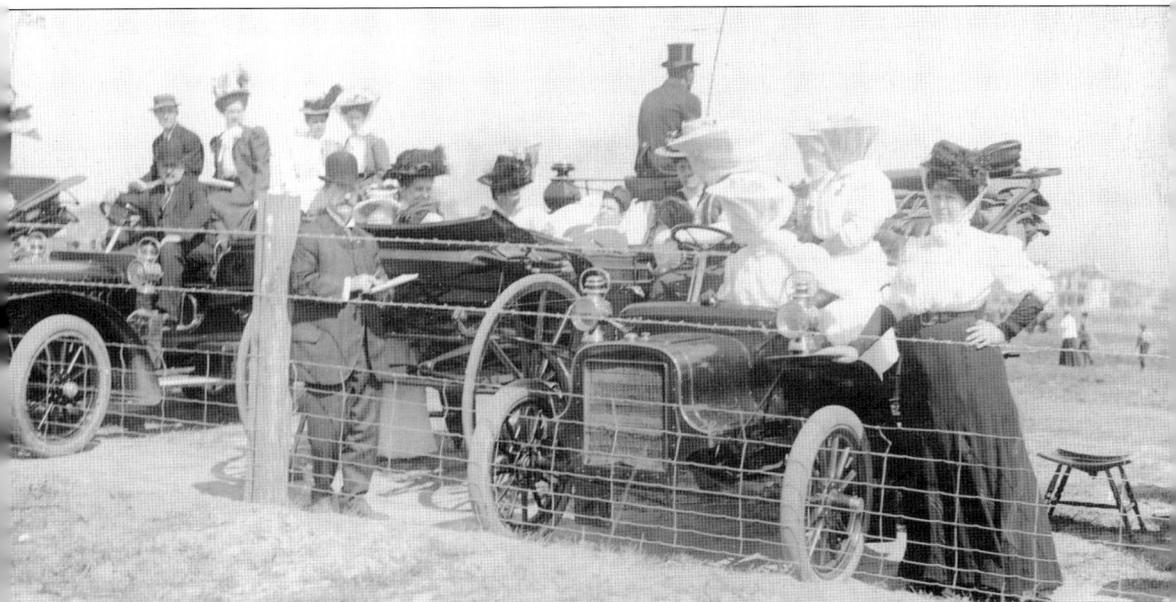

Motorists were intrigued by the course and were allowed to drive on it when the racers were not practicing. The day before the race, Tom Barber was driving the course and took the corner at White Bluff and Montgomery Crossroads too fast. He flipped the car over and broke his leg. Spectators came to see the daring drivers attack the course at high speeds. Cars, especially racing cars, were a new phenomenon in Savannah and, as written in the newspaper, not everyone approved. Some looked at it as a passing fad. When the mayor of Thunderbolt purchased an automobile a few years before the races, he publicly apologized, as he was ridiculed by many.

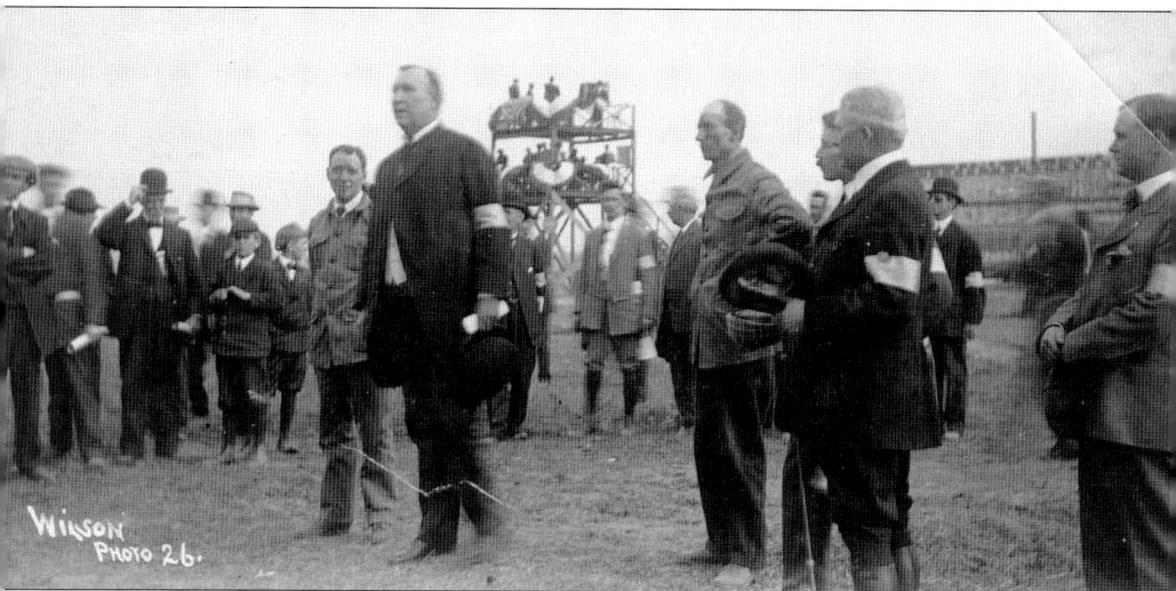

William K. Vanderbilt Jr. and Georgia Governor Hoke Smith were both invited to be guests of the Savannah Automobile Club during the March races. Both were to be honorary referees and it was assumed would both be in attendance. However, Vanderbilt was unable to attend. Luring the Vanderbilt Cup Race to Savannah was the ultimate goal of race organizers. It was considered to be the most respected race held in the United States, and the Savannah Automobile Club felt that if Vanderbilt would visit the city during the March 1908 races, he would surely want to move his race from Long Island. Pictured in both of these photographs is Georgia Governor Hoke Smith addressing the crowd and presenting the winners with their trophies. The inaugural Savannah races were completed and were an overwhelming success.

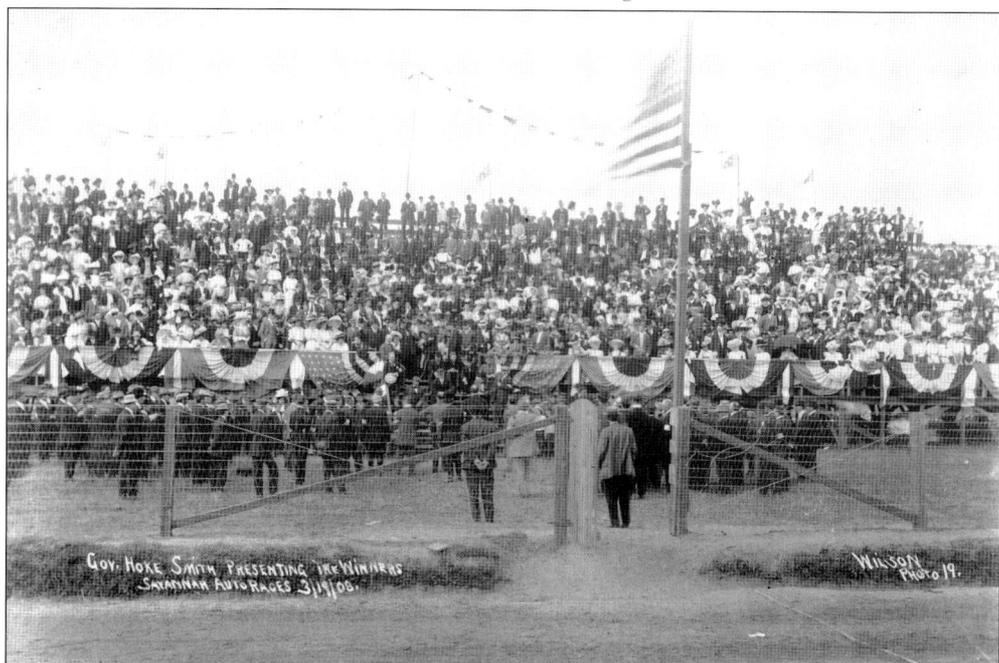

Two

NOVEMBER 1908

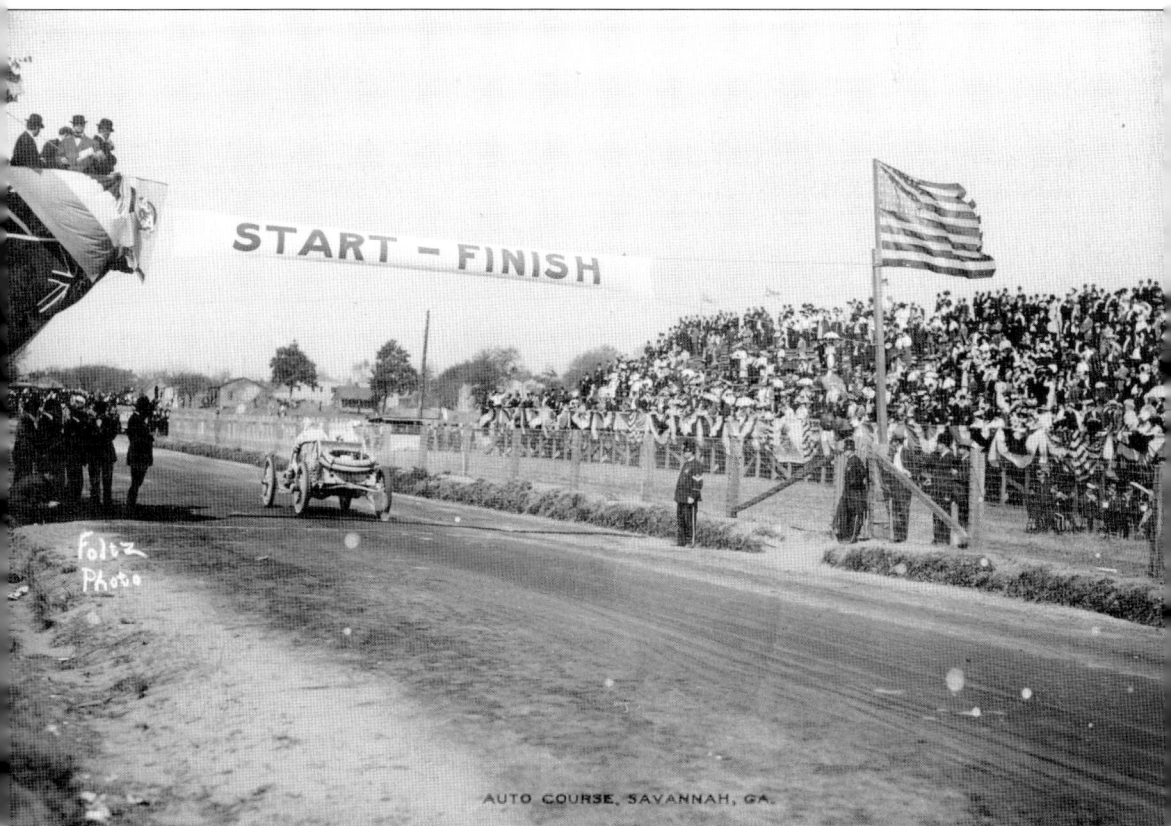

Spectators arrived from all corners of the country. Savannah society purchased reserved boxes and threw parties at the races. There was a train from New York called the "Wall Street Special," which ran directly to Savannah. This was joined by the estimated hundreds of rail cars descending on the city. In addition, the list of parties and the people attending each race party were listed in the "society" column of the *Savannah Morning News*.

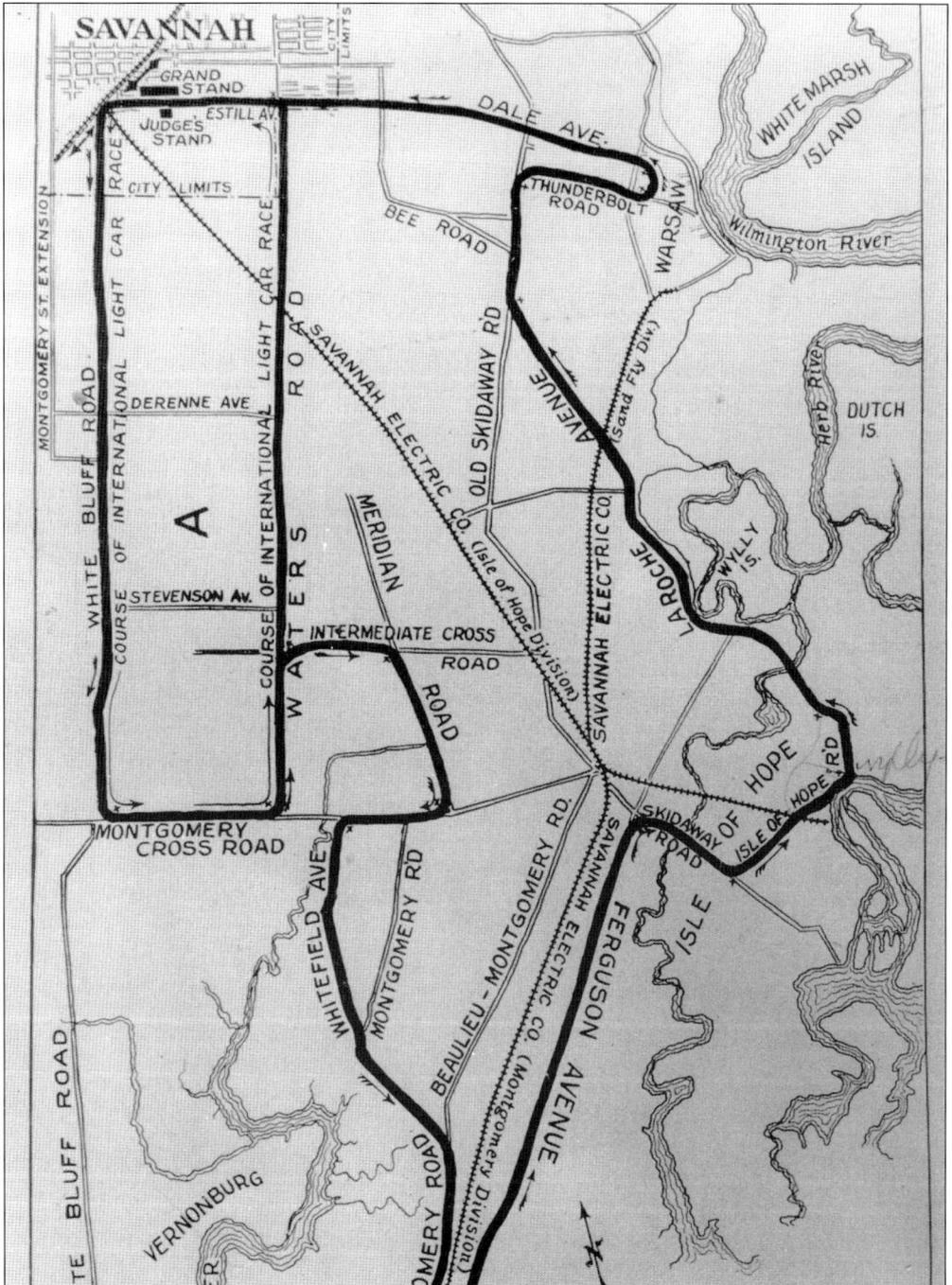

The Automobile Club of America was organized in 1908 and desired to develop a race that was larger in magnitude than the Vanderbilt Cup Race. This race was held in Savannah in November 1908 and was originally called the International Race for the Grand Prize of the Automobile Club of America. The race was later called the American Grand Prize Race. The winner of the Vanderbilt Cup received a cup valued at $2,500, and the winner of the Grand Prize Race won a gold cup valued at $5,000.

(24) CAUSEWAY, LA ROCHE AVE. AUTOMOBILE RACE COURSE SAVANNAH GA.

There were two races held in November 1908. On November 25, the International Light Car Race was held, and on November 26, the Grand Prize Race of the Automobile Club of America took place. These two photographs show the Causeway as it appeared in 1908 and 1998.

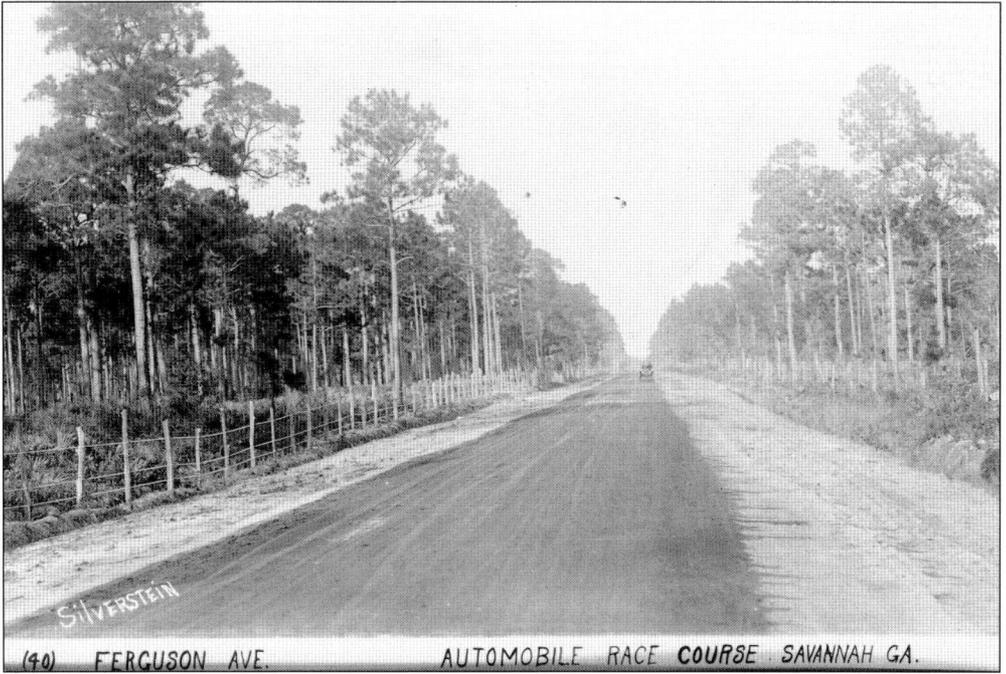

(40) FERGUSON AVE. AUTOMOBILE RACE **COURSE** SAVANNAH GA.

Ferguson Avenue was cut for the November 1908 races. Now, instead of continuing down Montgomery Crossroads to Sand Fly, the drivers were to turn off of Montgomery Crossroads onto Whitefield Avenue and follow this before turning on Ferguson. The curves on Ferguson Avenue were straightened, thus providing the drivers with a very long straightaway on which they could reach maximum speeds. The roads were paved with Augusta gravel, a coarse sand used in road building.

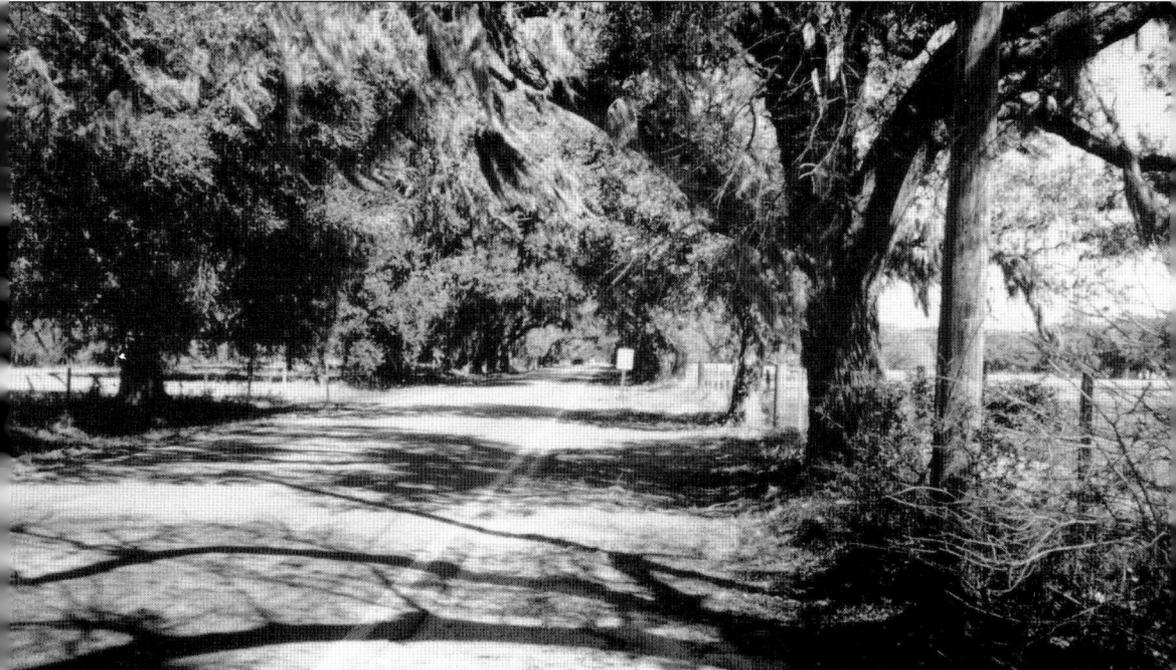

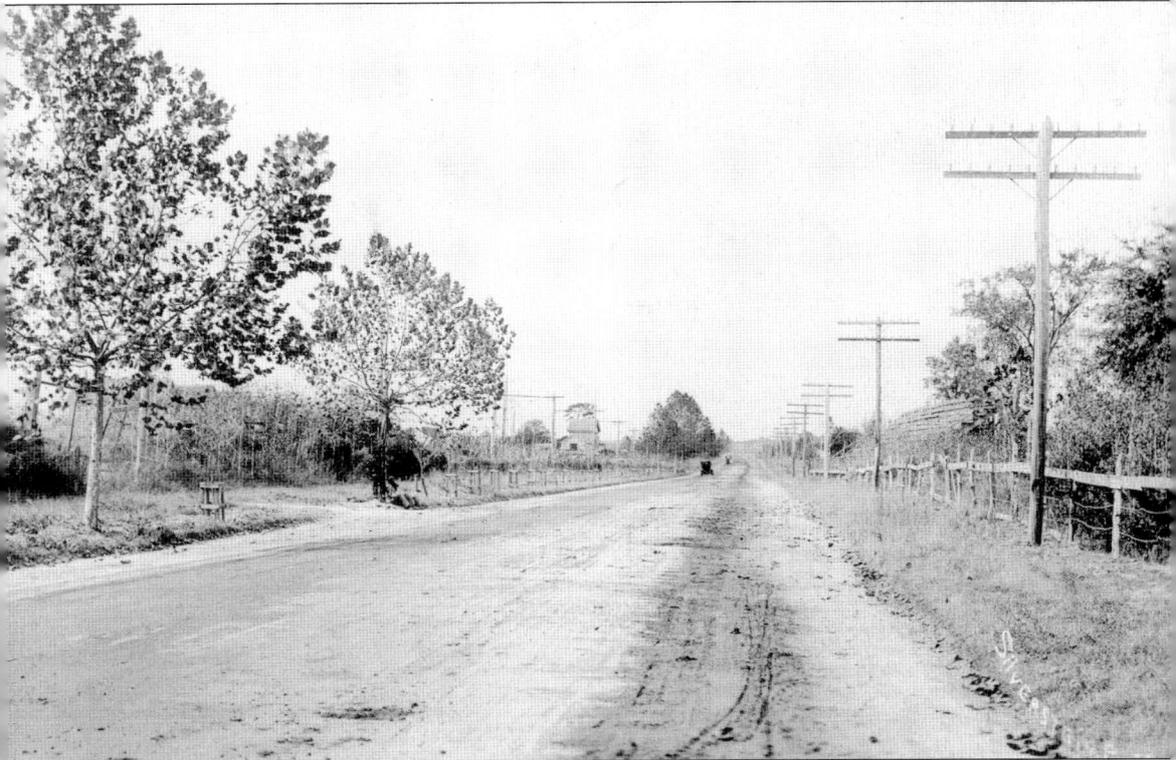

As in the March races, Estill Avenue (Victory Drive) provided spectators with the longest view of the racers. Estill Avenue was also the site of the grandstand, scoreboard, and judges stand. Due to the popularity of the races, 5,000 additional seats were added the night before the Grand Prize Race. Pictured here are Estill Avenue in 1908 and Victory Drive in 1998.

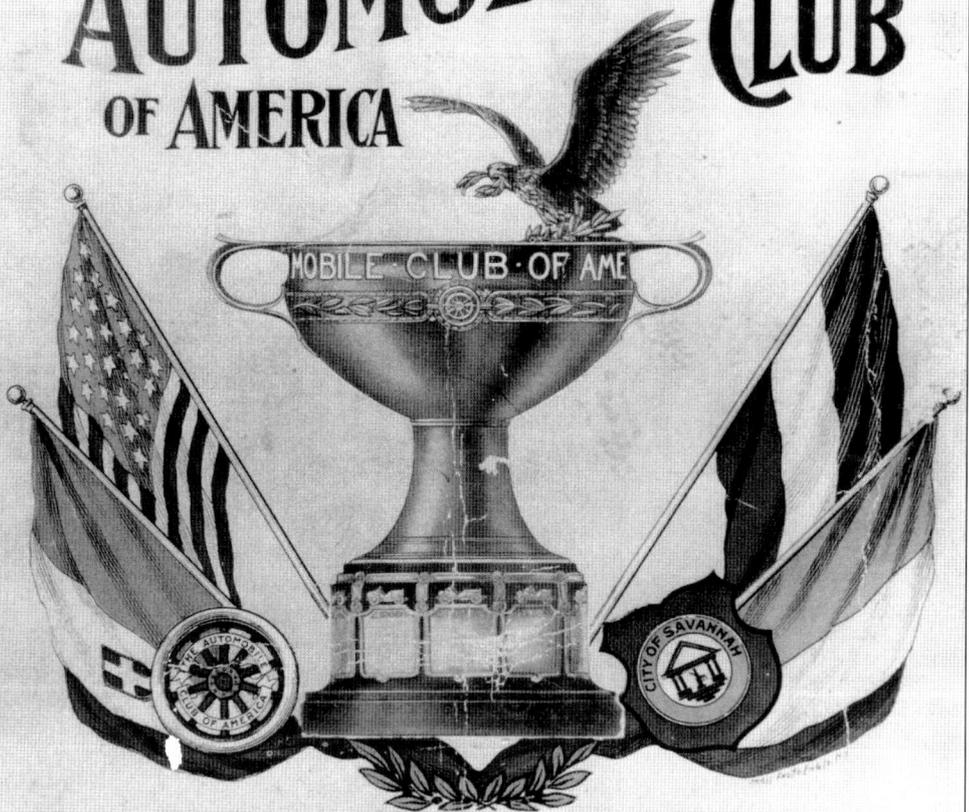

OFFICIAL
PROGRAM, SCORE CARD AND GUIDE
FOR THE
GRAND PRIZE
OF THE
AUTOMOBILE CLUB
OF AMERICA

MOBILE · CLUB · OF · AME

INTERNATIONAL ROAD RACE
SAVANNAH GA. NOV. 26 1908

25 CENTS

In addition to the typical information found in a racing program, there was a score sheet used to track each driver lap by lap. This program is part of the Julian Quattlebaum Collection.

This photograph is of W.M. Hilliard, driver of the Lancia in the International Light Car Race. Hilliard won the race after being in third after the first lap. In the second lap he took second place and in the tenth lap he took first place. He remained in first through the 20th lap. Seventeen cars entered the race.

Cars were weighed in Savannah at the Gorrie Ice Works. Cars entered in the Grand Prize Race had to weigh at least 2,420 pounds in running trim. This weight was taken without water, gasoline, tools, spare tires, spare parts, or spare oil. Cars in the Light Car Race (referred to as the "Mosquito Fleet") were weighed in the same manner but could not exceed 950 pounds.

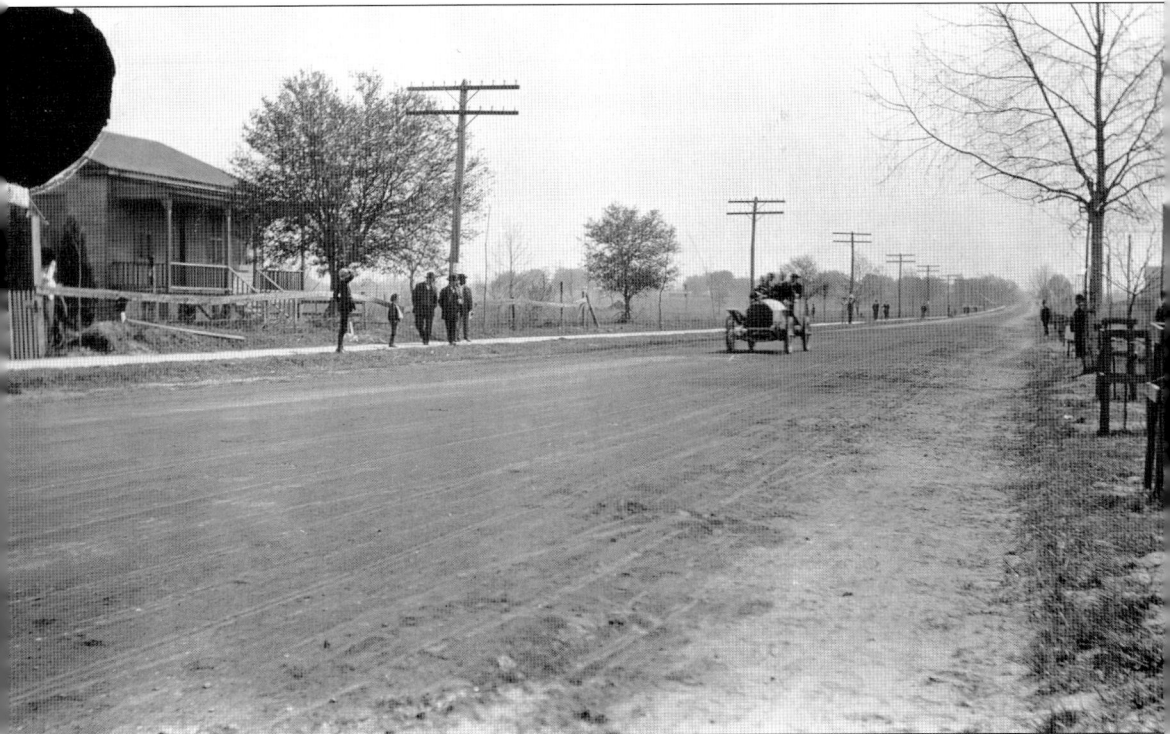

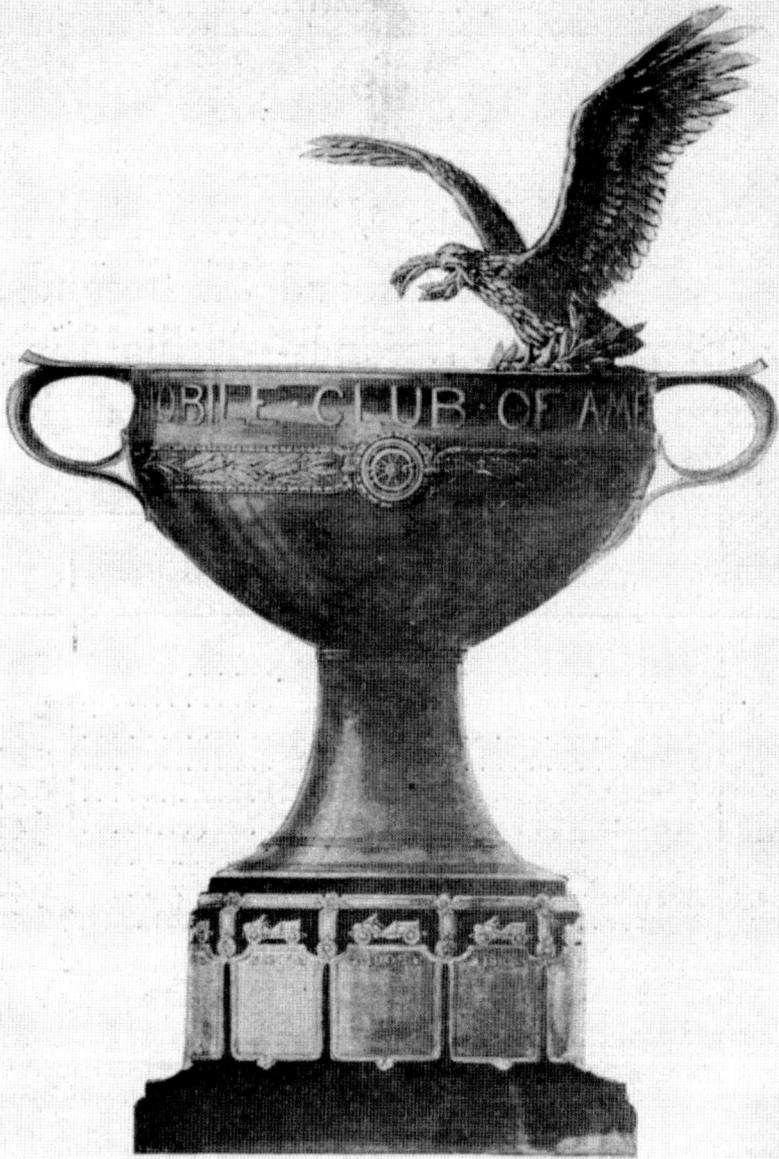

GRAND PRIZE OF THE AUTOMOBILE CLUB OF AMERICA

This was the coveted trophy of the November 1908 races, the Grand Prize of the Automobile Club of America. The trophy was won by Louis Wagner in a Fiat in a very exciting race. He averaged a speed of 65 miles per hour. Starting the race were five entries from France, six from Italy, three from Germany, and six from America. Nine of the 20 cars finished the race. Three were still running when the race ended. No American driver finished the race.

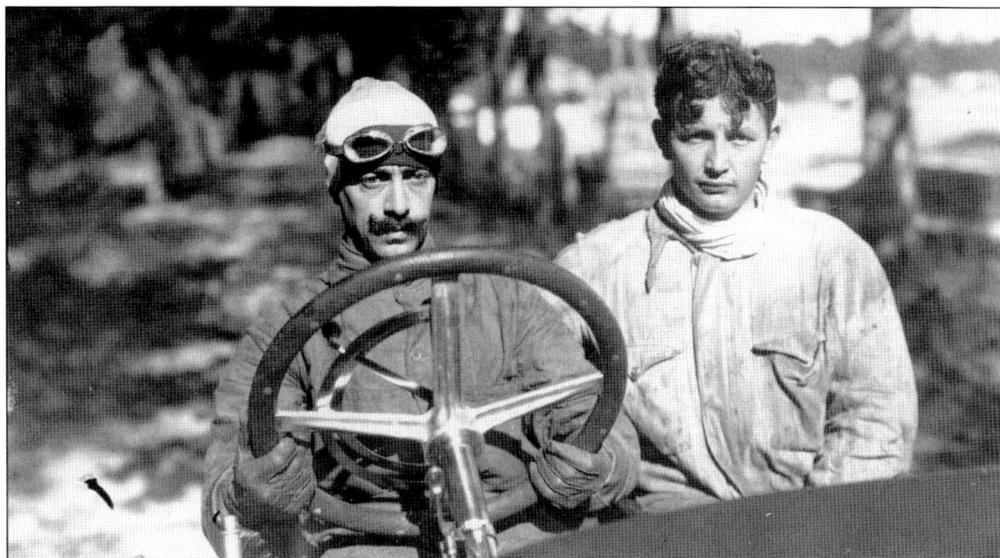

The drivers were very dashing. They were the heartthrob of Savannah ladies and the envy of Savannah men. Some of the European drivers were resented by other drivers. Most of the Europeans were wealthy, which was in contrast to the American drivers. Numerous European drivers designed and paid for their vehicles with their own funds. Pictured here are Alexandre Cagno (left) and his mechanic, Marindo, for the Itala team.

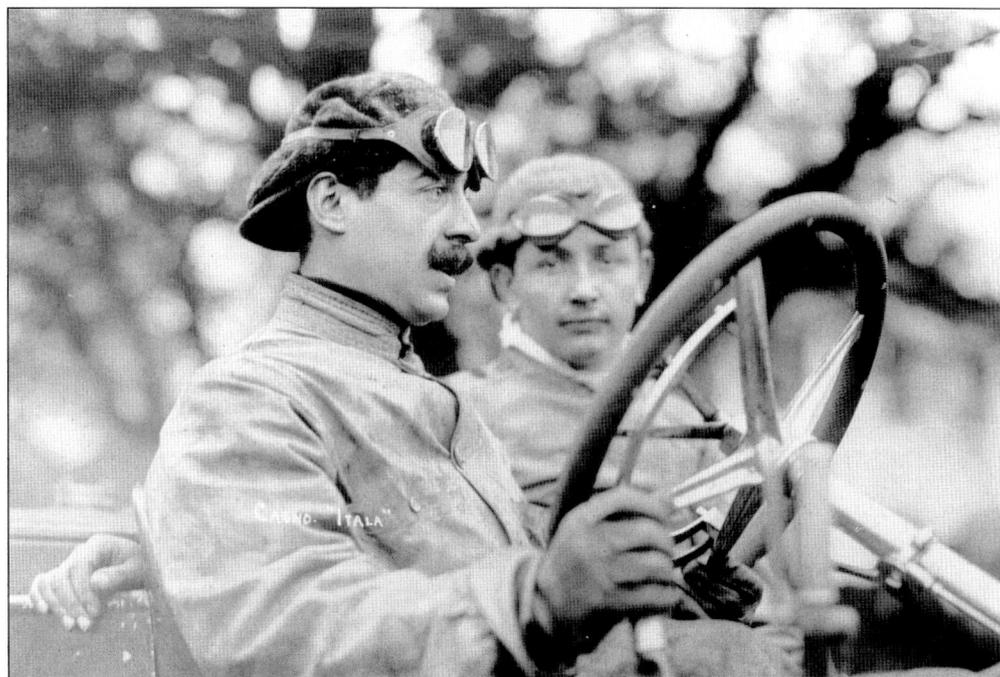

The Grand Prize Race was run over a course that was 25.13 miles. There were 30 major curves and many smaller ones. The race covered 16 laps and was a total of 402 miles long. The start and finish lines were identical for the International Light Car Race and the Grand Prize Race. The difference in the course was that the light cars ran down White Bluff and turned onto Montgomery Crossroads, and then turned onto Waters Avenue proceeding to Estill Avenue.

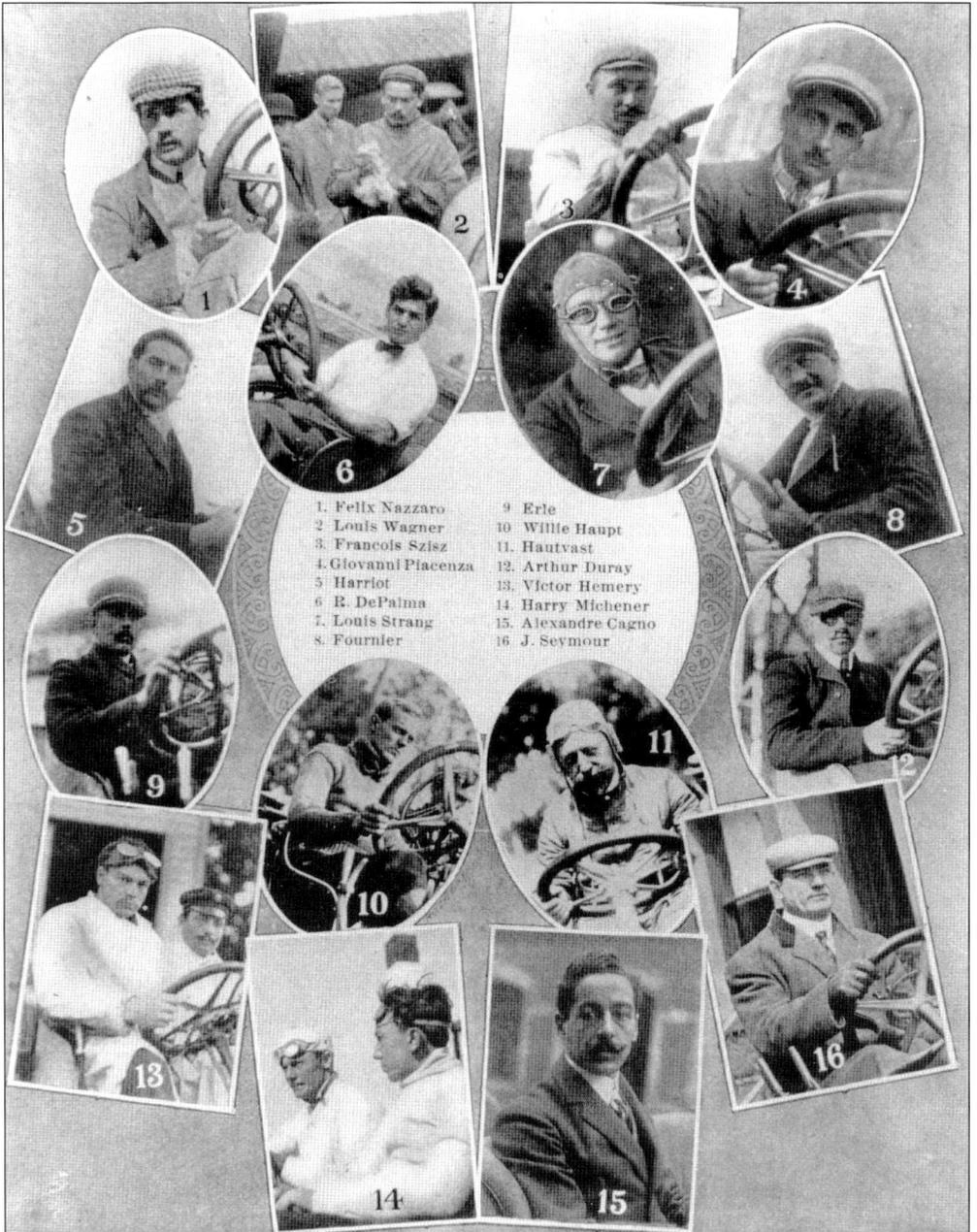

1. Felix Nazzaro 9 Erle
2. Louis Wagner 10 Willie Haupt
3. Francois Szisz 11 Hautvast
4. Giovanni Piacenza 12 Arthur Duray
5. Harriot 13 Victor Hemery
6. R. DePalma 14 Harry Michener
7. Louis Strang 15 Alexandre Cagno
8. Fournier 16 J. Seymour

Pictured here are drivers of the Grand Prize race.

This photograph is of Felice Nazzaro of the Fiat team. He won third place in the Grand Prize Race with a time of 6 hours, 18 minutes, and 47 seconds. It might make more sense to say that instead of winning third place he lost first place. He came from seventh place in the second lap to first place through the 15th lap. He was passed in the final lap by Louis Wagner and Victor Hemery. Nazarro's mechanic was Gagnano.

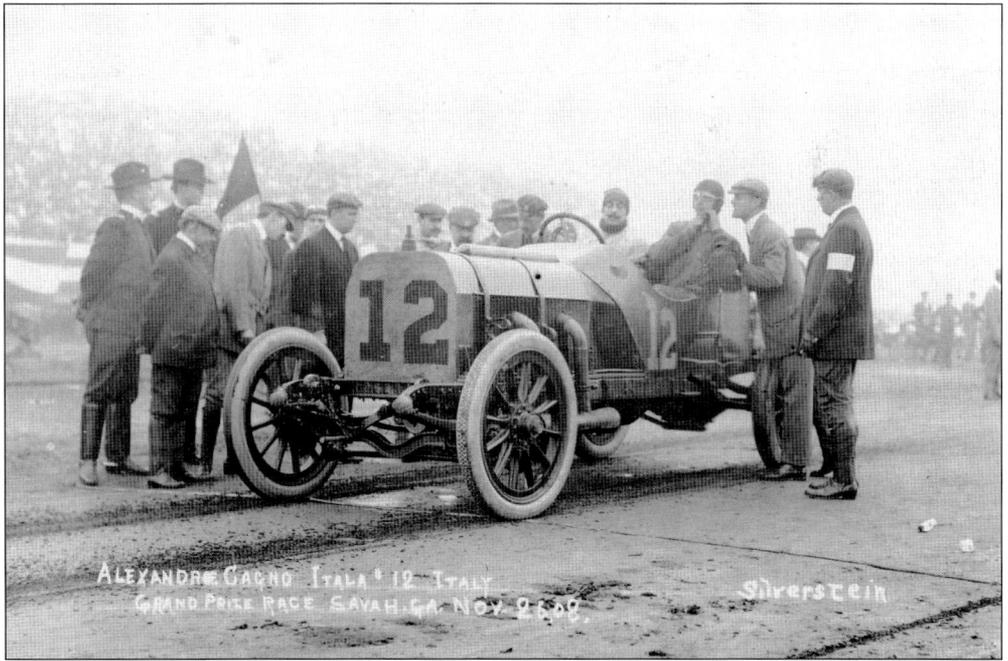

This photograph is of Alexander Cagno and his mechanic, Marindo. They were driving for the Itala team and did not complete the race. They completed lap 10 in 10th place and did not complete the 11th lap, as they had broken their rear spring.

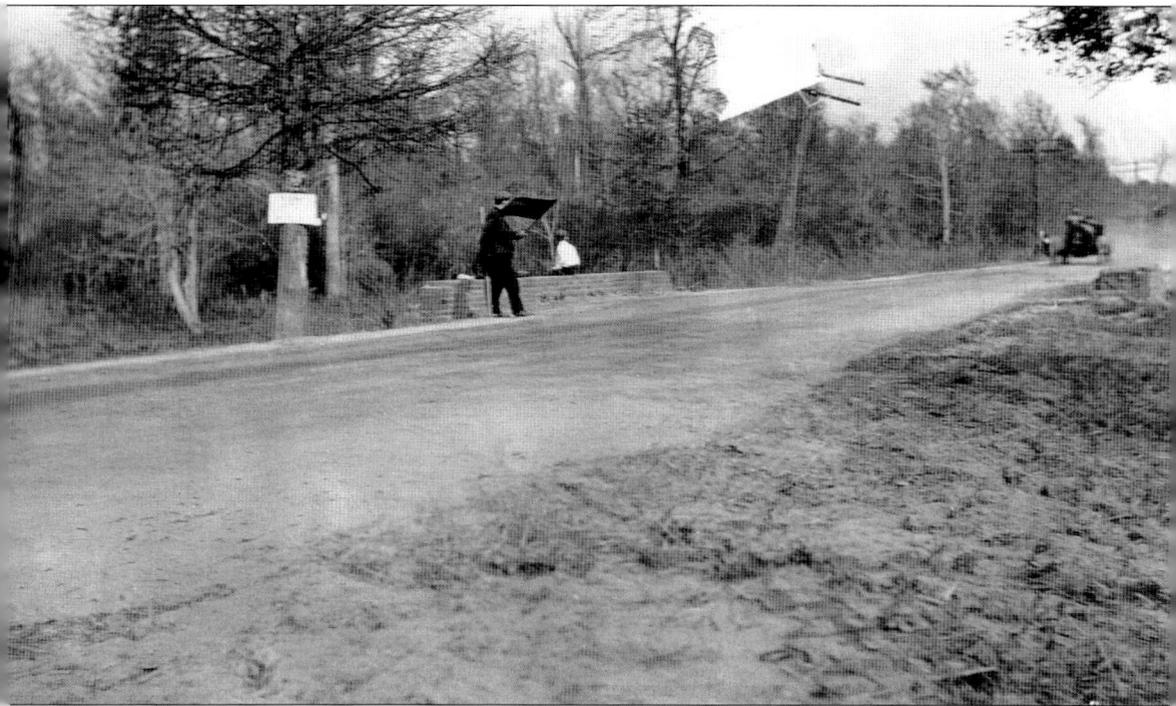

The drivers were not hampered by people on the course. The problem was animals; chickens and dogs were the primary culprit. Drivers were told to not avoid hitting the animal because it could prove more dangerous to avoid and lose control. Flagmen and soldiers along the course were told to kill any animals that might stray onto the course.

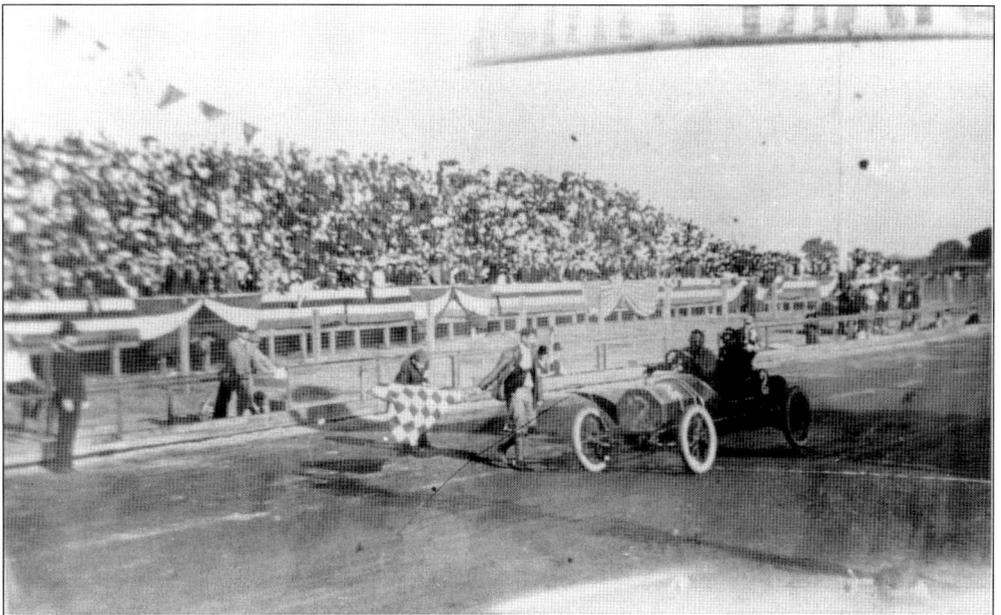

Shown here is a picture of W.M. Hilliard crossing the finish line of the Light Car Race in his Lancia. He completed the 20 laps in 3 hours, 43 minutes, and 33 seconds. He finished 6 minutes and 12 seconds ahead of Robert Burman in the Buick.

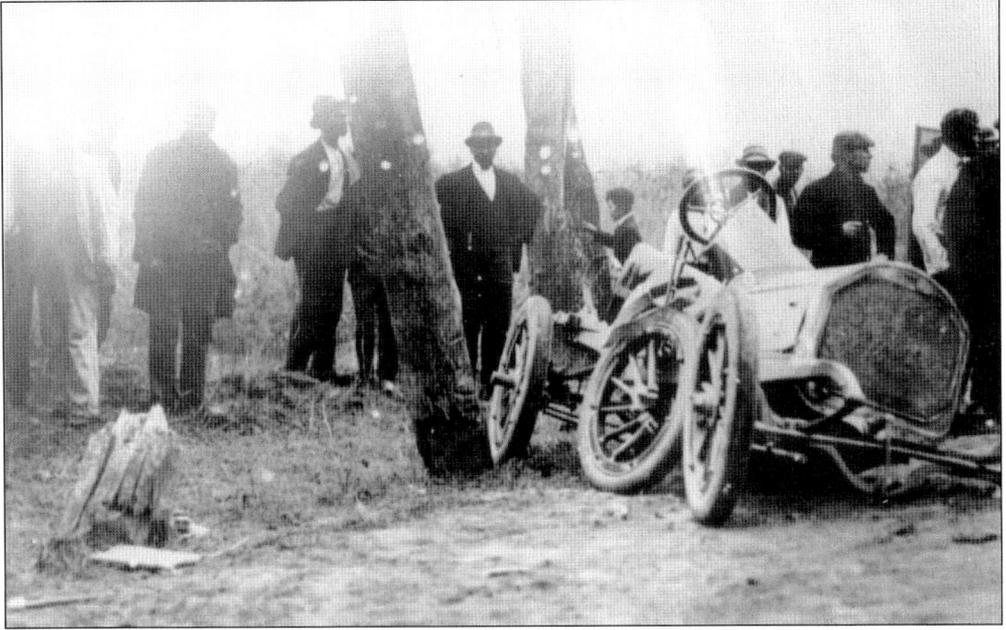

In the 14th lap of the Light Car Race, a Buick driven by Easter lost its rear wheel and flipped over several times. The car was at the curve from Waters Road to Estill. The mechanic was severely hurt, but his life was probably saved since he was thrown clear of the car and practically landed on Dr. Sigman and Dr. R.V. Martin. This photograph is not Easter's wreck. This was the car driven by Jean Juhasz in a wreck resulting in a fatality.

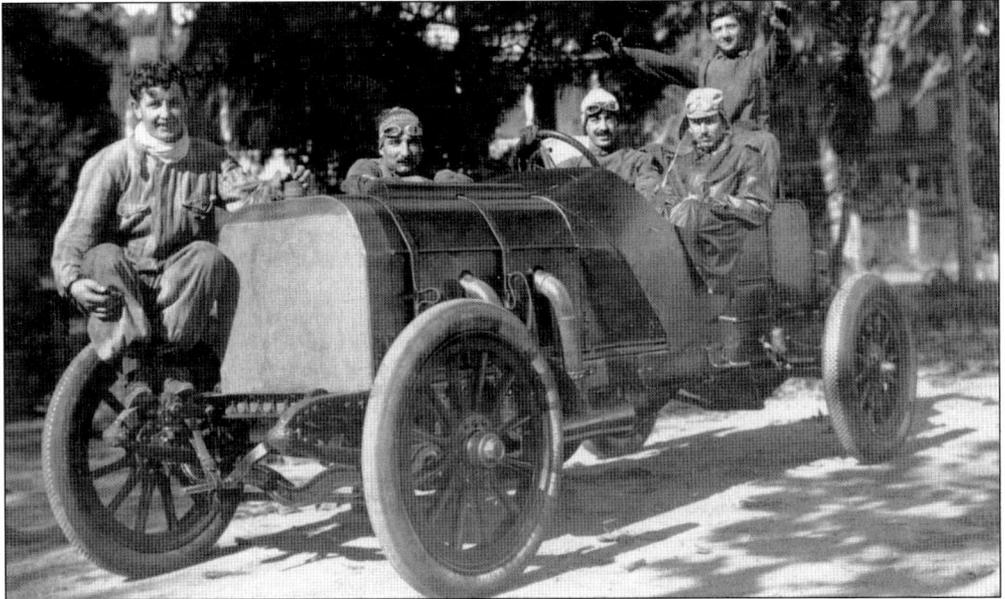

Suggestions were made concerning insurance for the drivers and mechanics. They felt it would be a good idea to have the entrant take out policies on the driver and mechanic and to require the promoters to also insure the men. They felt that the insurance would be expensive, but that it would put everyone's mind at ease knowing that the families of the drivers and mechanics would be cared for.

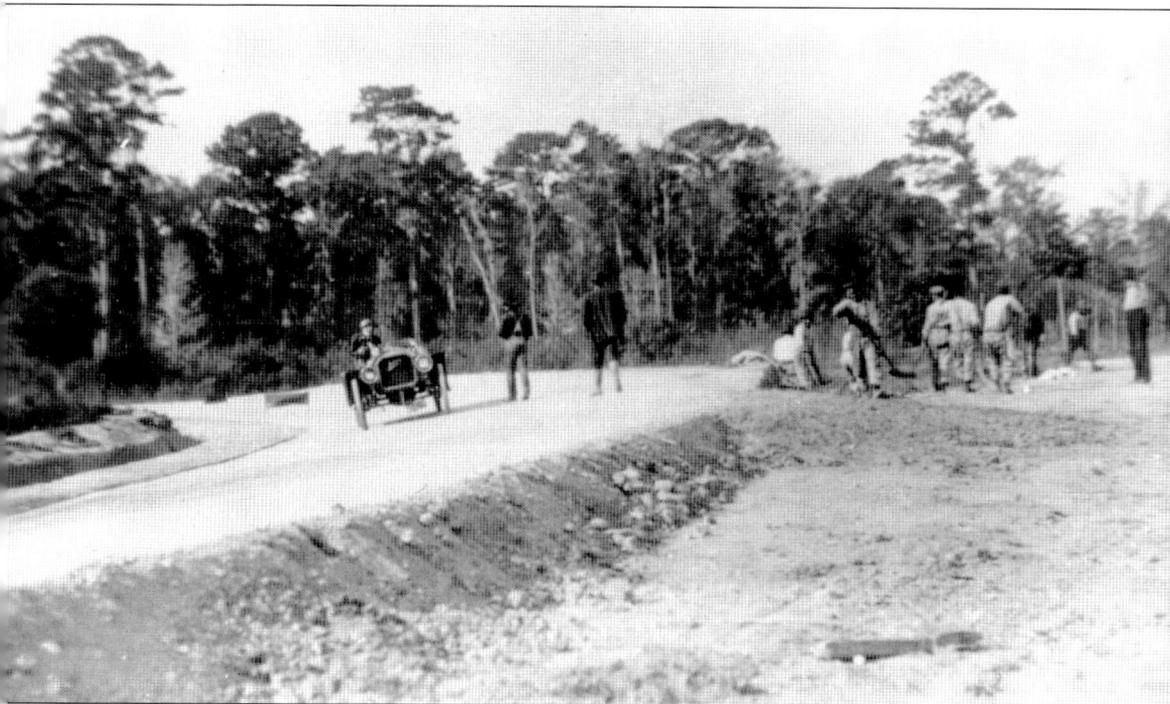

Locals were so excited over the fast times recorded during practice that they raised $2,500 to give to the driver who could break the record of 74 miles per hour set by Coppa Florio. The roads were improved and curves banked to allow a good combination of speed and safety.

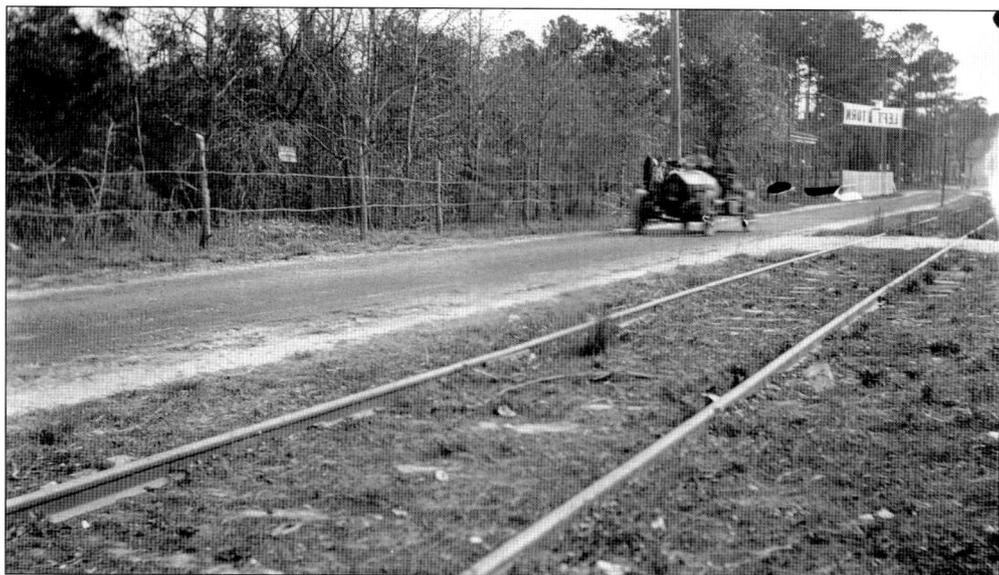

Each team established a camp along the course. The camps consisted of housing for the drivers, mechanics, manager, and any other team personnel. There were also buildings for working on the cars and storage buildings for tires, gasoline, etc. The Benz camp was located in the German Society's place at Bona Bella, the Fiat camp was at Doyle's race track at Thunderbolt, the Itala camp was on Isle of Hope, and the Buick camp was on White Bluff Road.

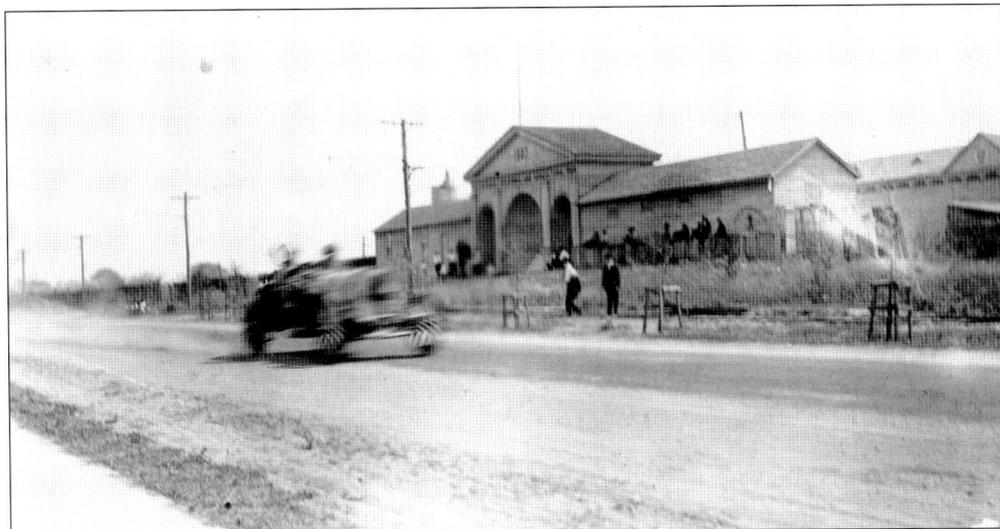

The Benz driven by Hanriot (#15) ran out of gas on the home stretch of the Grand Prize Race and coasted to a stop approximately 200 feet from the finish. The mechanic and driver slowly pushed the car forward and preserved fourth place. He had been in fourth place, just 9 minutes ahead of Hautvast in the Clement-Bayard. By the time the Hanriot car was pushed across the finish line he was only 7 minutes ahead.

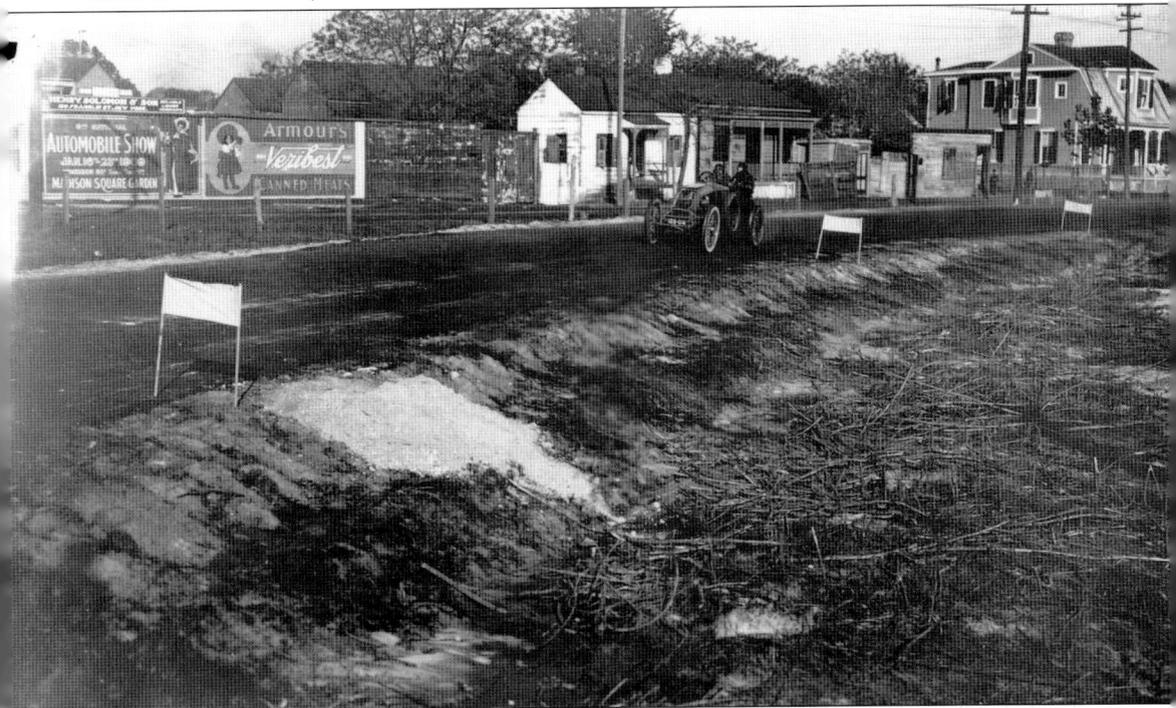

The soldiers guarding the race course were given very specific orders by Major William B. Stephens. Each man was issued 10 rounds of riot ammunition. The Chatham Artillery was armed with revolvers and 12 rounds each. During the race someone tried to drive a horse and buggy across Thunderbolt Road. The soldiers meant business and the violator received a bayonet wound in the chest.

Grand Prize Race at Savannah

Automobile Topics

ILLUSTRATED

The Only Weekly
Published for
Automobile Owners

EVERY SATURDAY
TERMINAL BUILDING,
PARK AVE. AND 41st ST.

[No. 424.] 9th YEAR.

PRICE TEN CENTS

Vol. XVII NEW YORK, NOVEMBER 28, 1908 No. 8

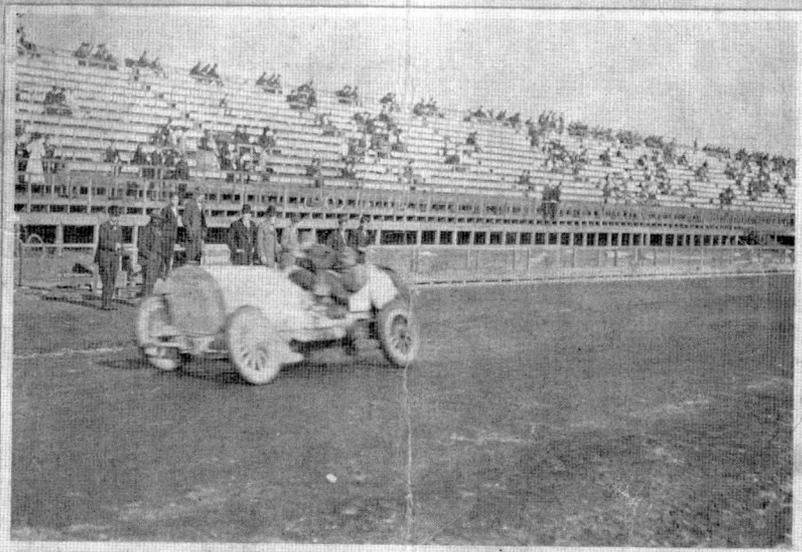

HEMERY DRIVING A BENZ CAR IN PRACTICE PAST THE GRAND STAND AT SAVANNAH

This magazine, published in New York, praises the city of Savannah and race planners. This issue is part of the Julian Quattlebaum Collection.

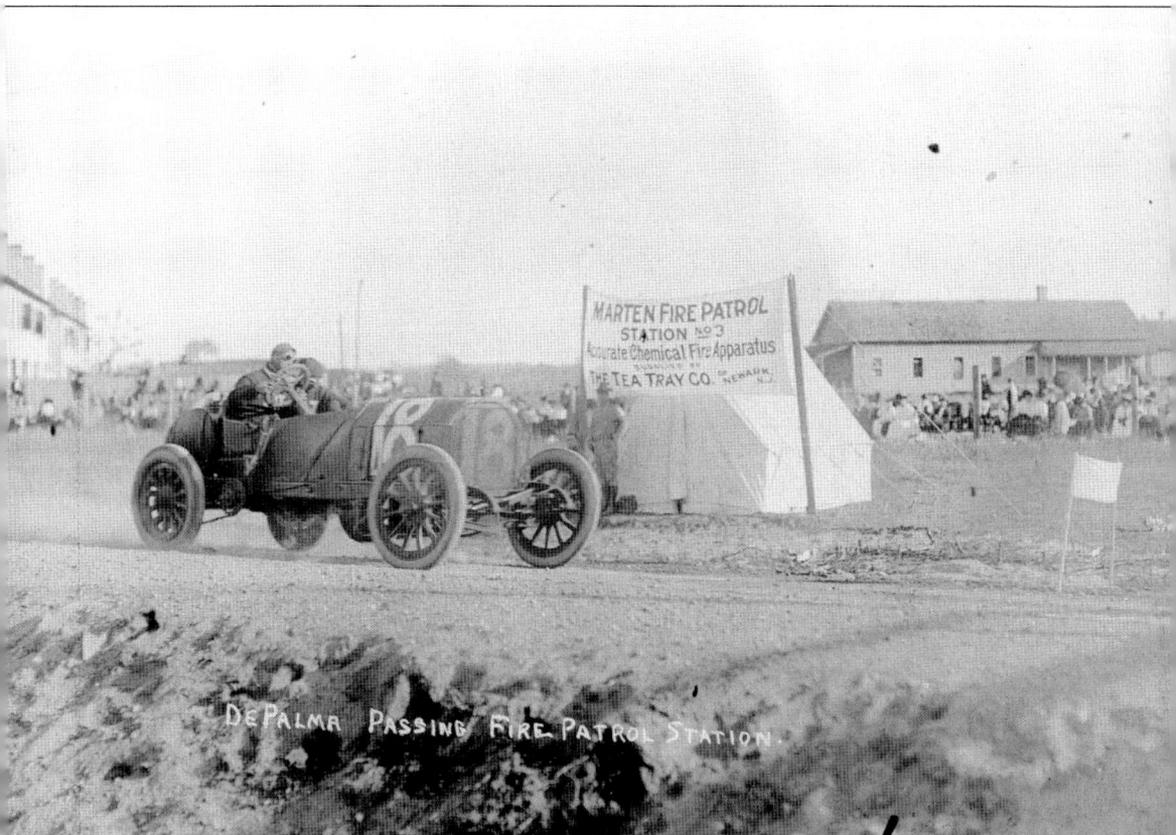

DePALMA PASSING FIRE PATROL STATION.

Pictured here is DePalma, driving a Fiat in the Grand Prize Race. His mechanic was Bordino. DePalma was in first place for the first two laps of the race. He then suffered mechanical problems and in the third lap fell to 16th place. He spent 47 minutes and 54 seconds to complete lap three. The remainder of the race, he maintained a fairly consistent lap speed and advanced to ninth place by the end of the race. He was the last driver to finish.

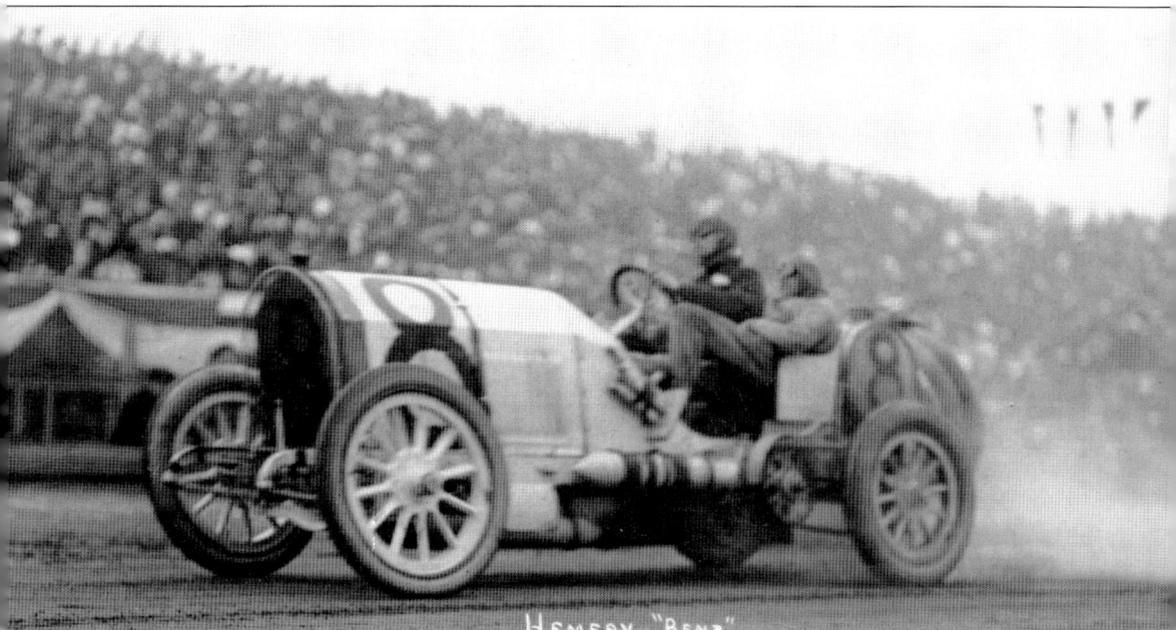

Pictured here is the car of Victor Hemery. He finished the Grand Prize Race in second place. Hemery drove for the Benz team and posted some very impressive lap times. He completed the first lap in 8th place then fell to 12th place in the second lap. By the 6th lap he was among the top three drivers, even leading the race in the 9th and 10th laps. His total time was 6 hours, 11 minutes, and 27 seconds.

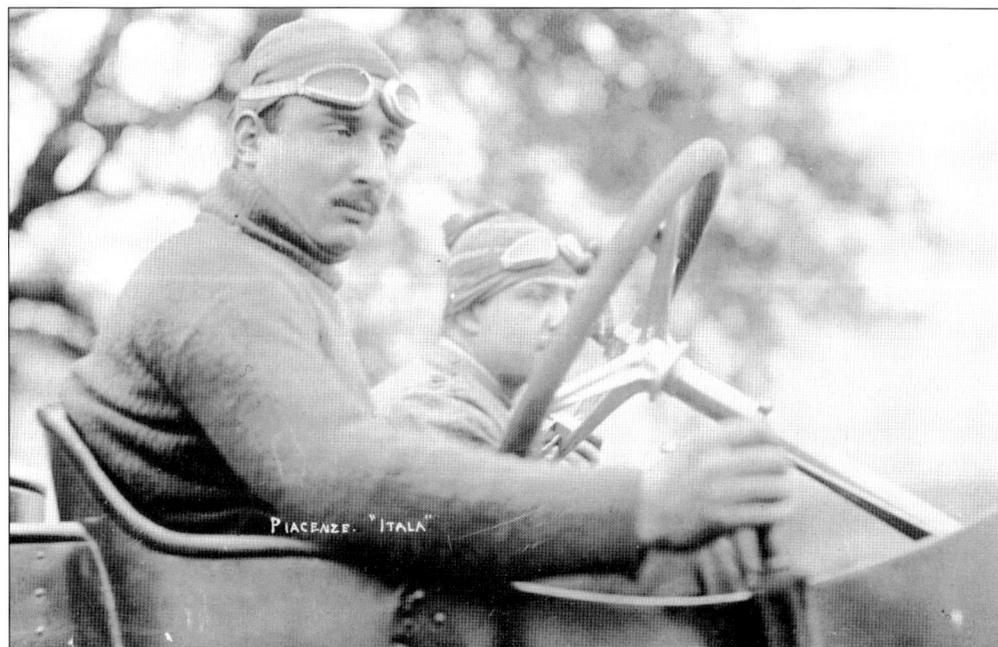

This photograph is of Piacenze of the Itala team. He completed five laps and left the course on Isle of Hope in the sixth lap. By the time he was out of the race he had risen from 14th place to 11th place.

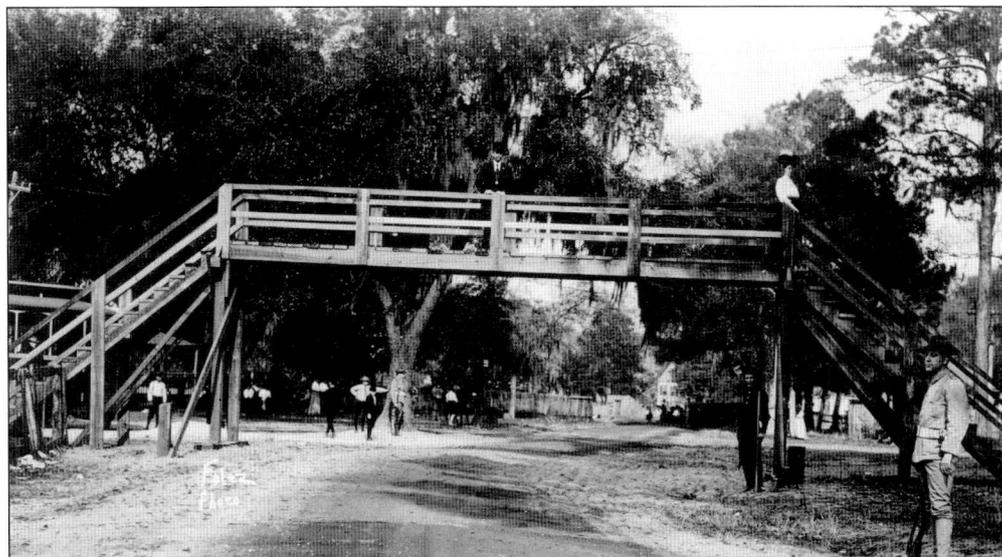

At the end of the race the soldiers were not alerted to open the streets. Hanriot had already returned to the course and was heading to his camp when several groups of soldiers attempted to stop him. Captain Davant ordered the car to halt and when it didn't, he emptied his pistol into the back of the car. The gas tank and both rear tires were punctured.

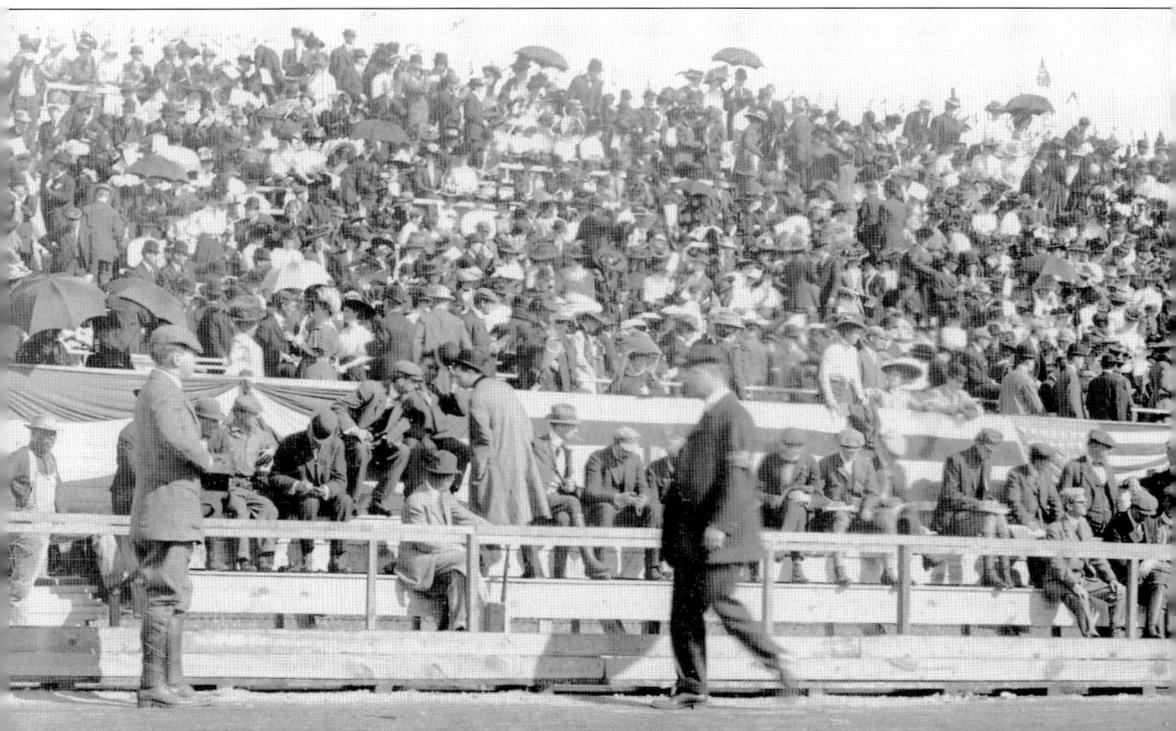

The grandstand was the site of the pits. This area allowed for refueling, re-watering, reoiling, and minor repairs. The team had helpers in the pit, but only the driver and mechanic were allowed to touch the car. The mechanic was to handle any mechanical problems or tire problems while the car was on the course.

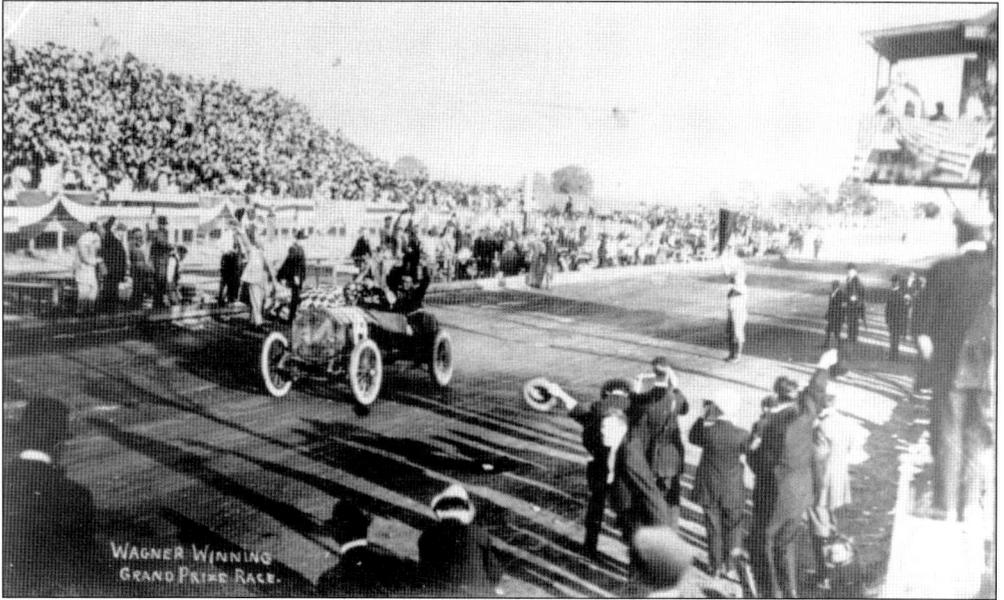

Louis Wagner was victorious in the Grand Prize Race. He crossed the finish line having made up a tremendous amount of time in the final lap. At the end of the 15th lap he was in third place but posted a final lap in 21 minutes and 53 seconds to jump past Hemery and Nazarro. Wagner also posted the fastest lap of the day. He completed the eighth lap in 21 minutes and 50 seconds.

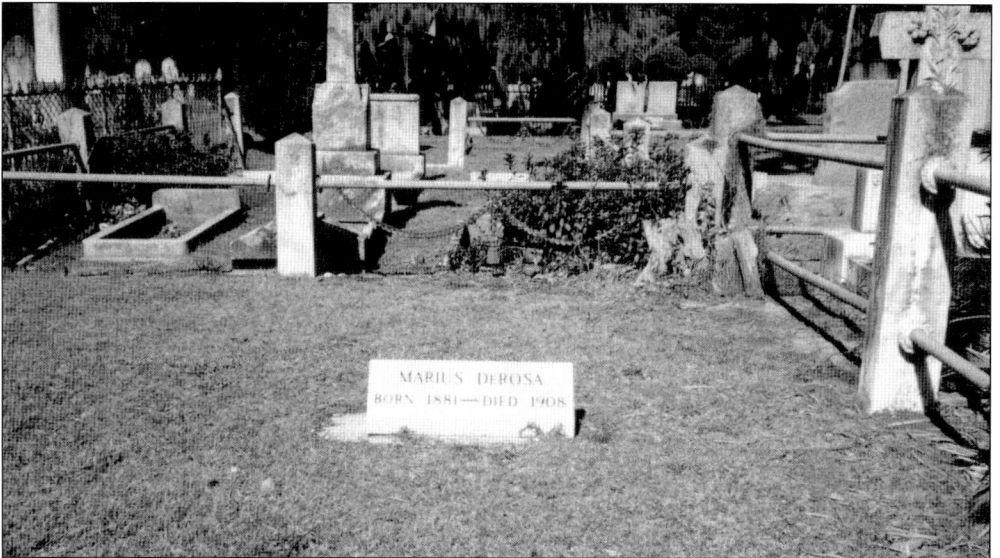

During practice runs the S.P.O. driven by Jean Juhasz was involved in a fatal crash. Traveling at a high rate of speed down White Bluff Road, the driver lost control while trying to avoid a dog on the course. The driver was injured but the mechanic, Marius DeRosa, was killed instantly. DeRosa was buried in Laurel Grove Cemetery, in lot 911. All racing officials attended his funeral, and the procession from church to cemetery was the first in Savannah, and probably Georgia, to be in automobiles. He was buried almost ten days after his death, as race and S.P.O. team members had tried unsuccessfully to locate his family in Europe before the burial.

Three

NOVEMBER 1910

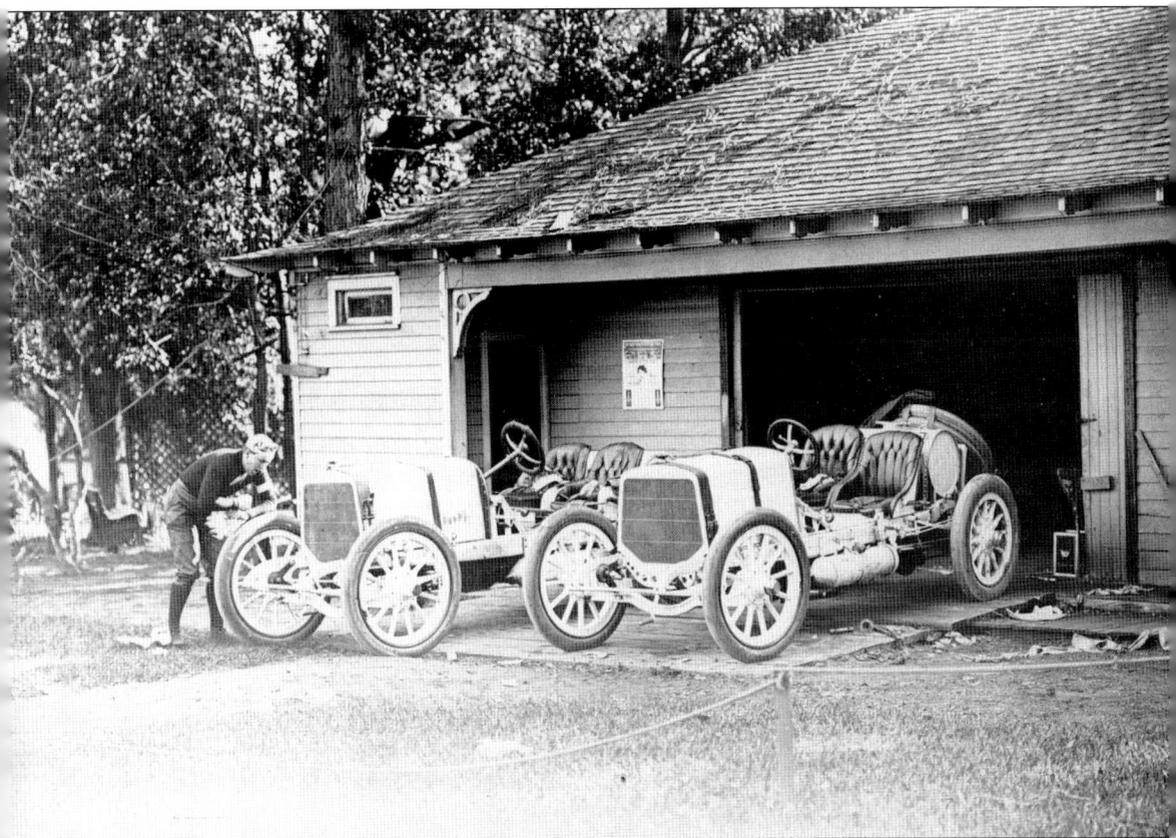

The American Automobile Association and the Automobile Club of America resolved their differences and decided to return all races to Long Island in 1909. There were no races in Savannah, and the Grand Prize Race was to follow the Vanderbilt Cup in 1909. However, due to a driver running over numerous spectators in the Vanderbilt Cup, the Grand Prize Race was canceled on Long Island.

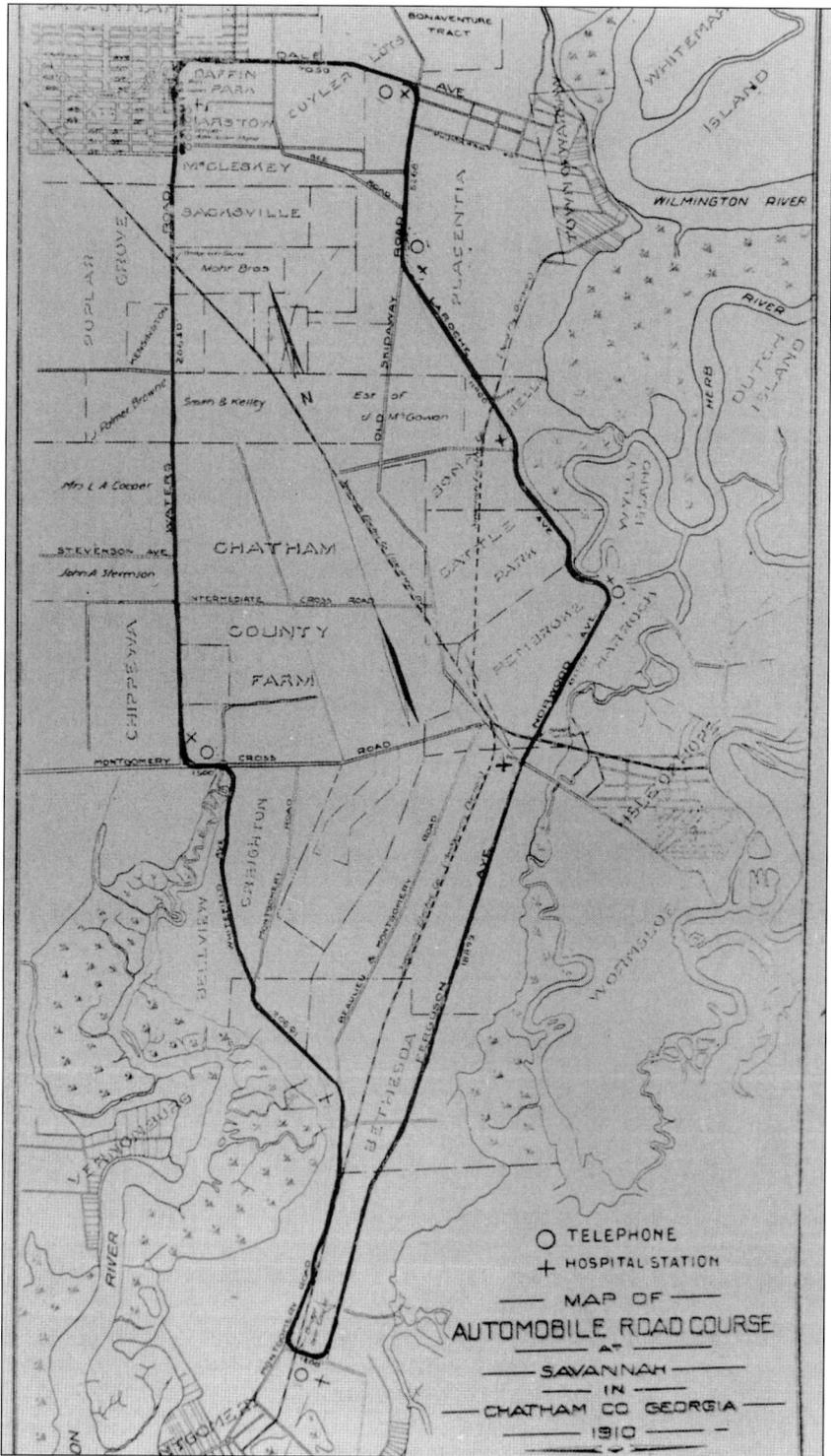

The Savannah Automobile Club saw an opportunity to bring the races back to Savannah. They made a strong bid for the races and won.

Due to the large number of entries, the light cars were divided into two races. The Savannah Challenge Cup was for cars with engine displacements of 231 to 300 cubic inches. The Tiedeman Cup was established in honor of the mayor responsible for getting the races to Savannah and this was for cars with piston displacement of 161 to 231. Pictured here is one of the storage areas for tires. These areas were guarded by the military.

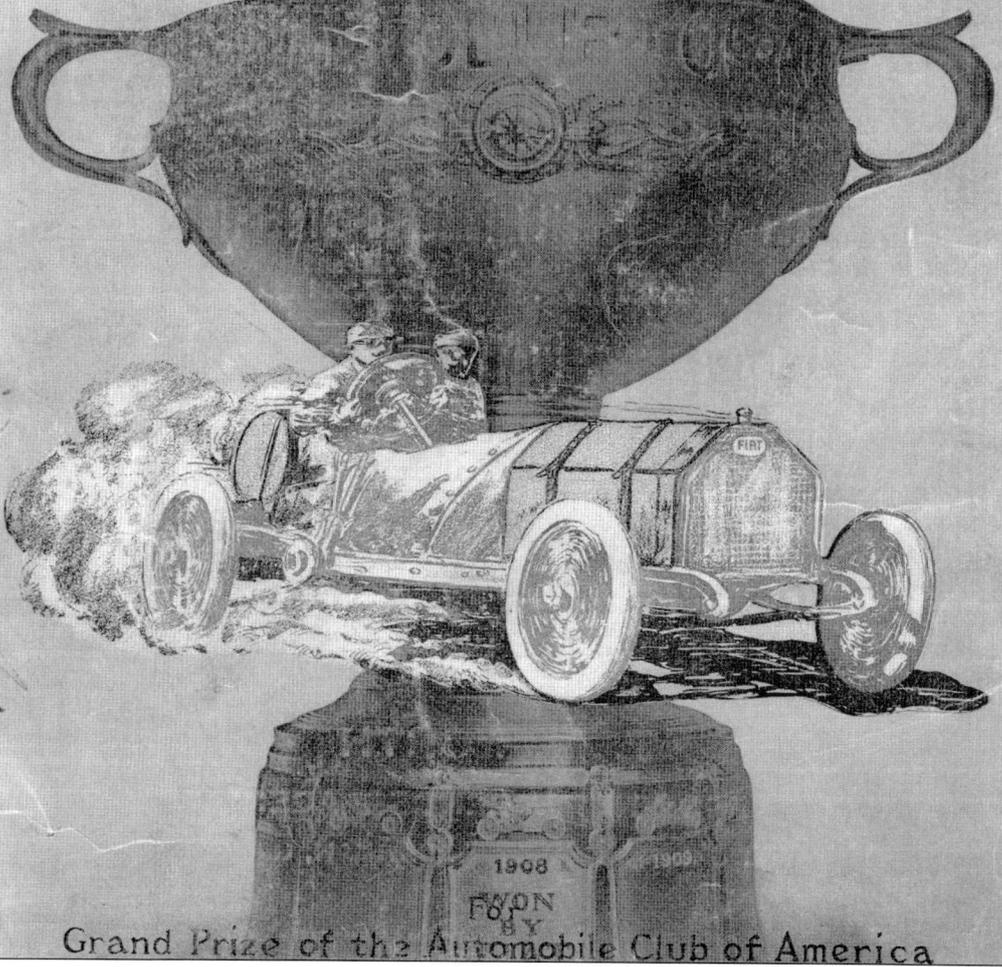

OFFICIAL PROGRAM
INTERNATIONAL ROAD RACES
of the Savannah Automobile Club
at Savannah Georgia

Price Twenty Five Cents

1908 1909
WON BY

Grand Prize of the Automobile Club of America

The 1910 races consisted of three events. On November 11, there were two races, the Tiedeman Trophy and the Savannah Trophy Race. On November 12, the Grand Prize Race for the Automobile Club of America was held.

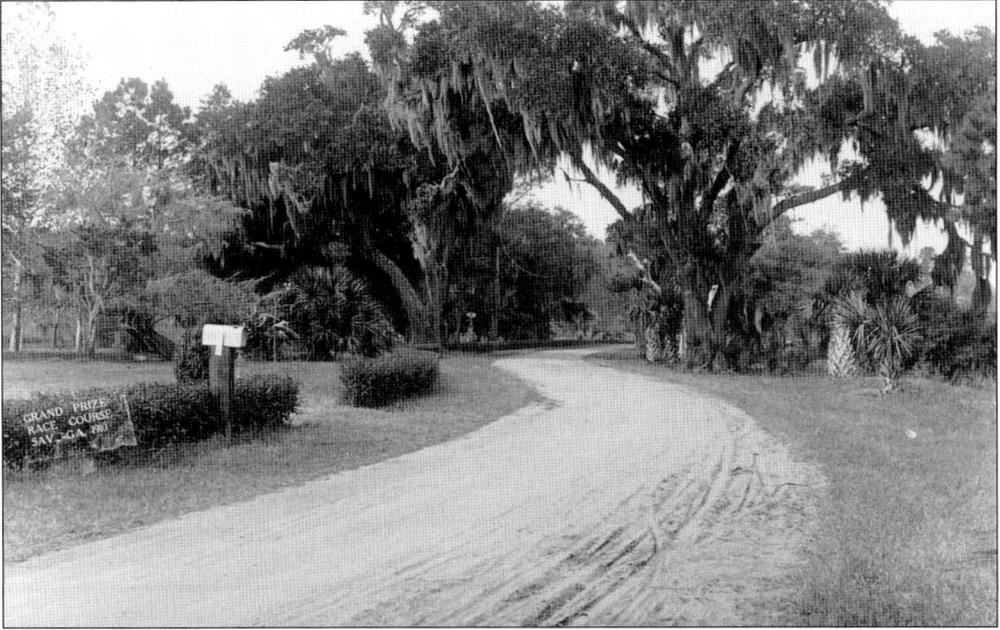

Given the speed with which the course needed to be reconstructed, Newell T. West, superintendent of roads, at first used 50 convicts and 12 loads of gravel. He soon went to 150 men and 200 carloads of gravel. Some of the curves were not banked as in the previous races. As a result, it was decided to eliminate some of the curves, making the race faster.

TURN NEAR COUNTY FARM

AUTO RACE COURSE SAVANNAH.

After the announcement in early 1909 that the Automobile Club of America was holding future races on Long Island, Savannah went through a period of disappointment. The Savannah Automobile Club debated developing and staging their own race. What developed were endurance races from Savannah to other cities. Through these cross-country races the Savannah Automobile Club took the lead among clubs in the southeast in the development and construction of roads.

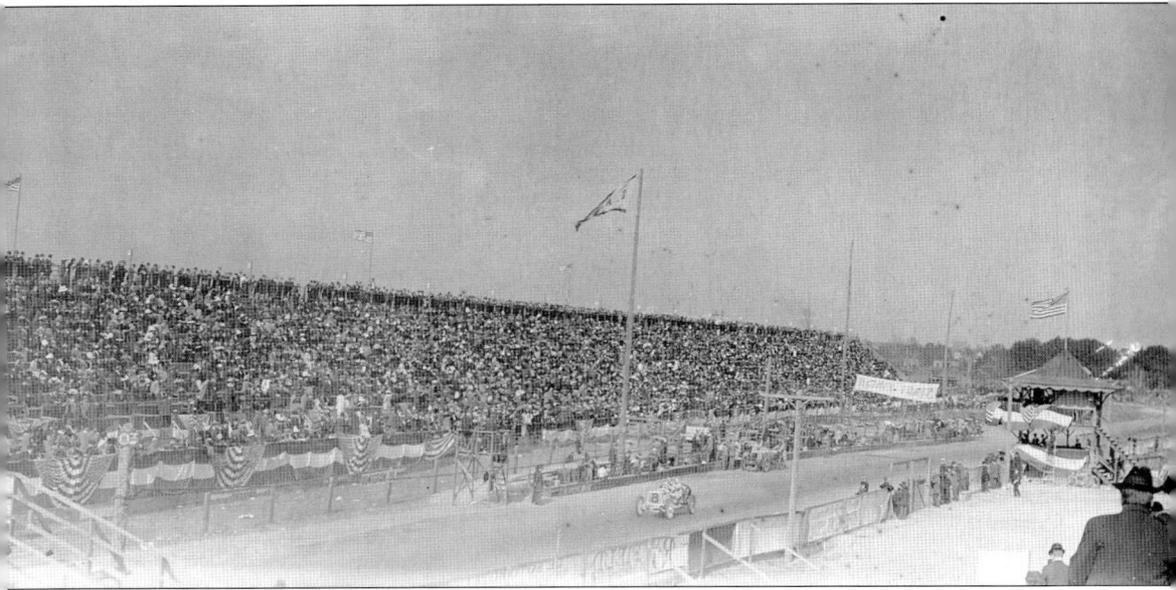

Following the announcement that the races were not returning to Savannah, the city demolished the grandstand on Estill Avenue (Victory Drive). Soon this road was lined with homes, which Dr. Quattlebaum called "pretentious." The new grandstand and the start/finish line were constructed on Waters Avenue, around Forty-Sixth Street.

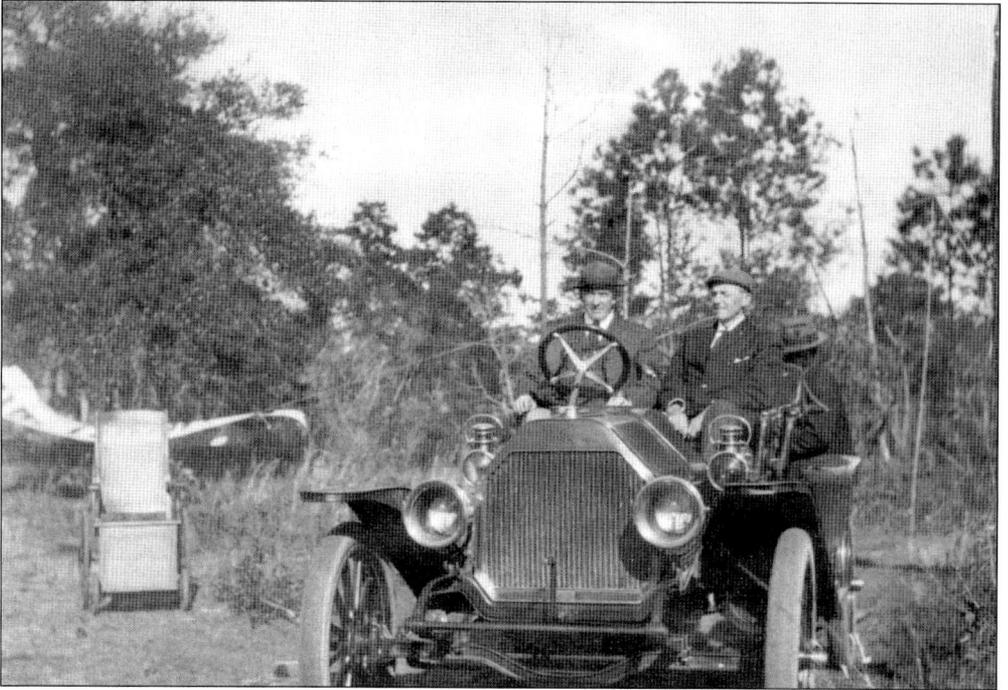

Immediately following the announcement of the races returning to Long Island, the Savannah Automobile Club sent a delegation to New York in an attempt to secure the race. They were successful in their attempt and had a very short period in which they needed to obtain entries and build and secure the course.

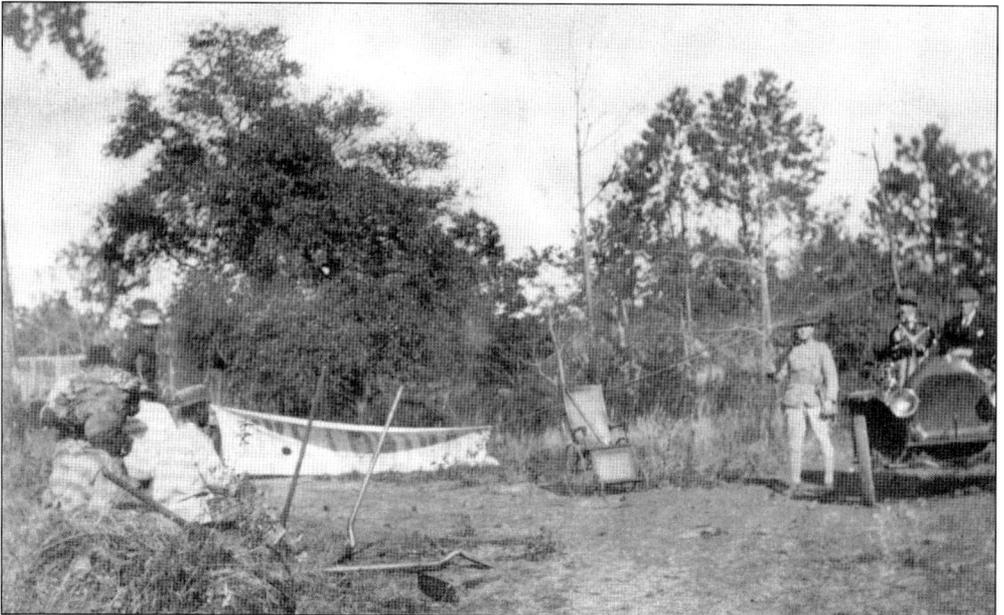

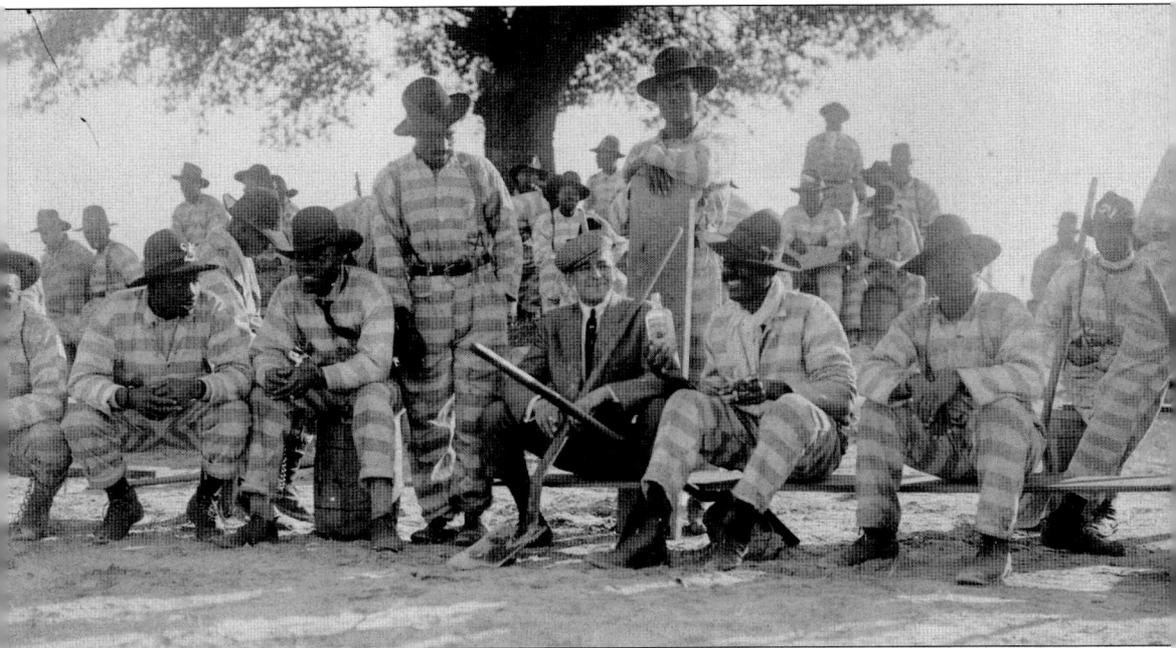

The prisoners who helped to rapidly construct the course were allowed to view the race. They sat in the shade of a large oak tree near the press stand and were allowed to see the cars as they drove along Dale Avenue and Waters Avenue. As reported in the newspaper, "the striped prisoners seemed to be as happy as the more fortunate individuals who had seats in the grandstand. They were guarded by an armed detachment and the event went off without a disturbance from the prisoners." Some of the prisoners danced, sang, and cut high jinks. They were proud of their contribution.

This is a photograph of Washington Roebling II, who finished in second place in the Savannah Challenge Trophy Race driving a Mercer, with Felix Geschevantner as his mechanic. Roebling completed the first lap in fourth place but was able to climb to second by the end of the fourth lap. He remained in second place for the entire 16-lap race. He finished 12 minutes behind the winner. Roebling was killed on the *Titanic*.

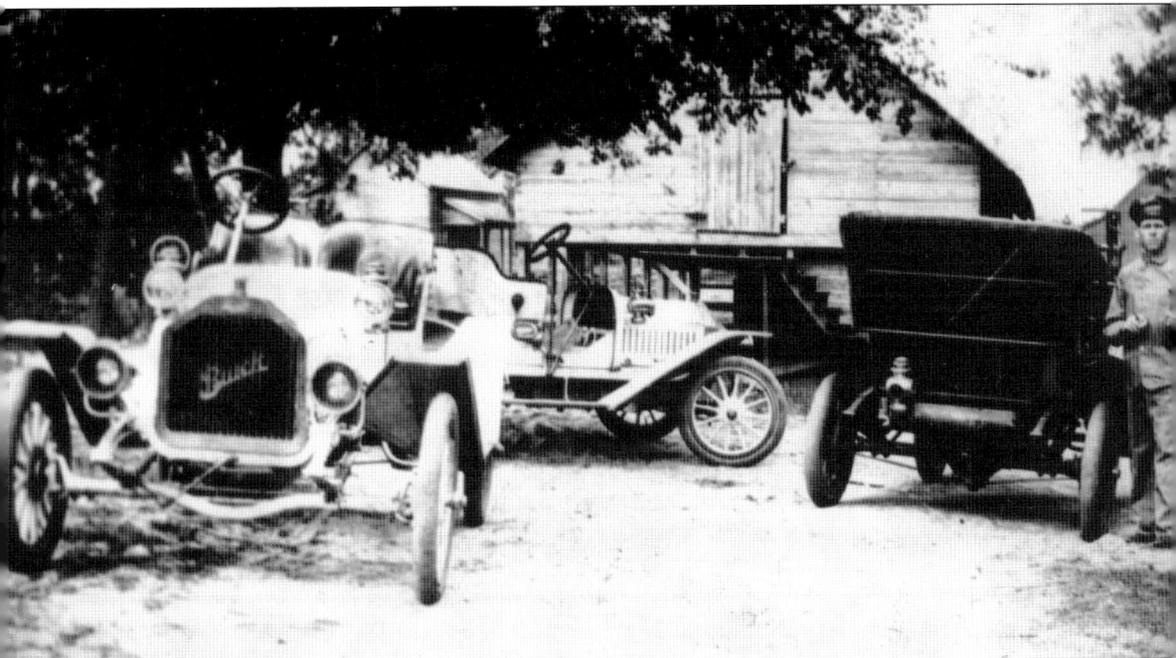

Pictured here is the Buick team camp. A car from the Marquette-Buick team, driven by Bob Burman with Hall as the mechanic, finished the Grand Prize Race in third. Burman drove a spectacular race, but finished almost 20 minutes behind the winner.

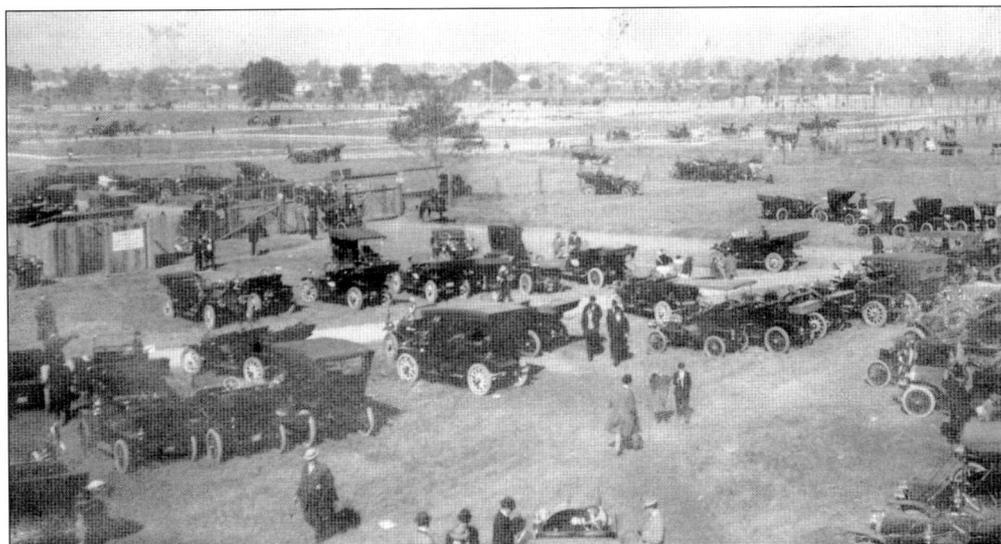

Many of the European drivers were happy with the race being moved from Long Island to Savannah. As stated by Victor Hemery, "It will be grand. Not even Europe has ever furnished a more perfectly patrolled course. I shall be happy on the day I get back to Savannah. I wonder if they will give us any more of those fish dinners?"

Official Score Card for the International Light Car Race, Savannah Trophy

Course Measures 17.3 miles—16 laps. Total Distance 276.8 miles.

No.	CAR	DRIVER	1	2	3	4	5	6	7	8	9	10	11	12	13	14	15	16
31	F. A. L.	Hughes																
32	Marmon	Heineman																
33	Mercer	Roebling II.																
34	Pullman	Gillard																
35	F. A. L.	Gelnaw																
36	Marmon	Dawson'																
37	F. A.L.	Pierce																

This is a scorecard for the International Light Car Race. The *Savannah Morning News* also ran a blank scorecard prior to the race and printed a completed copy in the paper the day after the race.

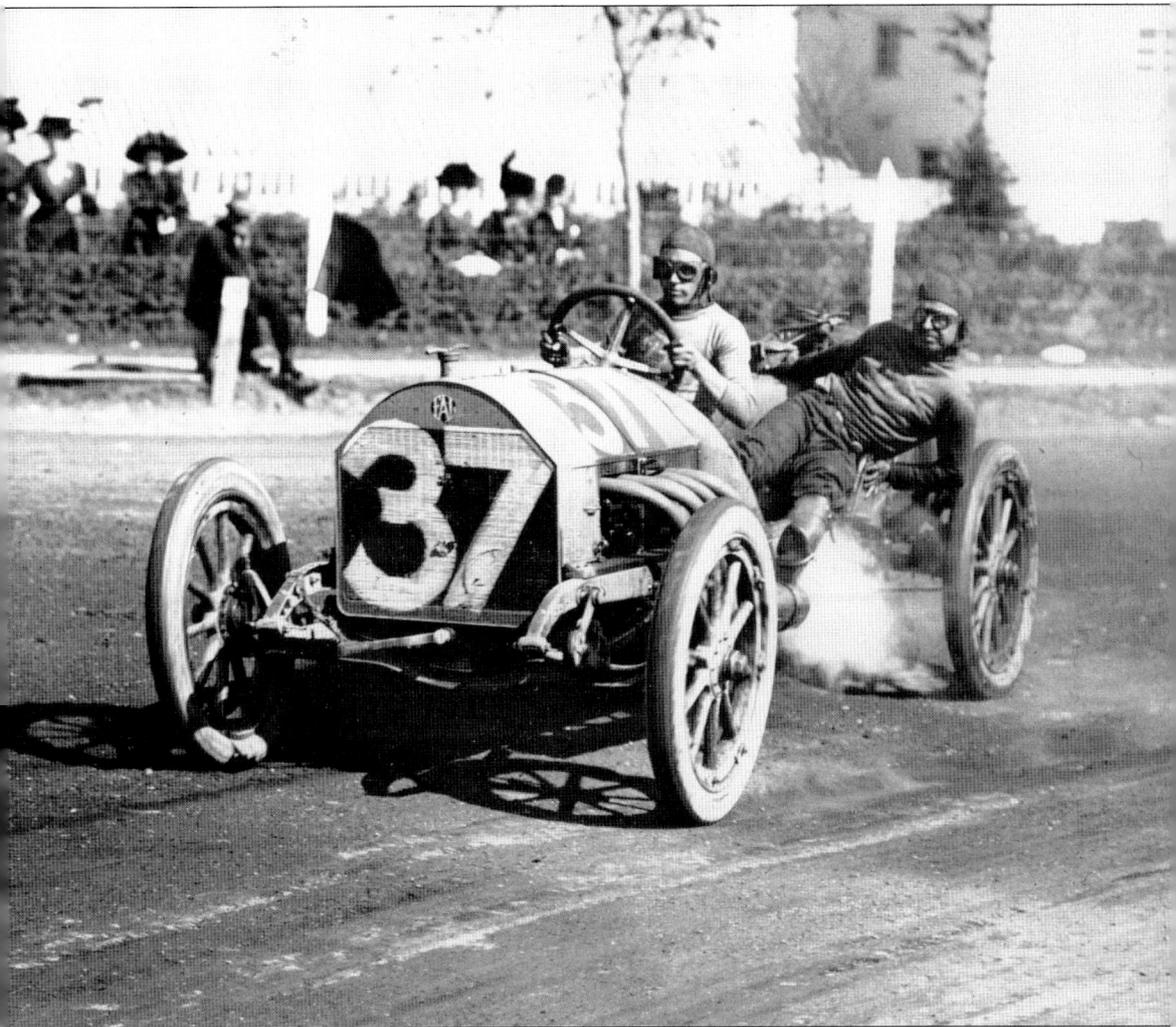

This photograph is of Pierce, driving one of the three Falcar team cars entered in the Savannah Challenge Trophy Race. He is rounding the curve and heading into the home stretch. He was running in fourth place when, in the ninth lap, he broke an axle turning onto Ferguson Avenue.

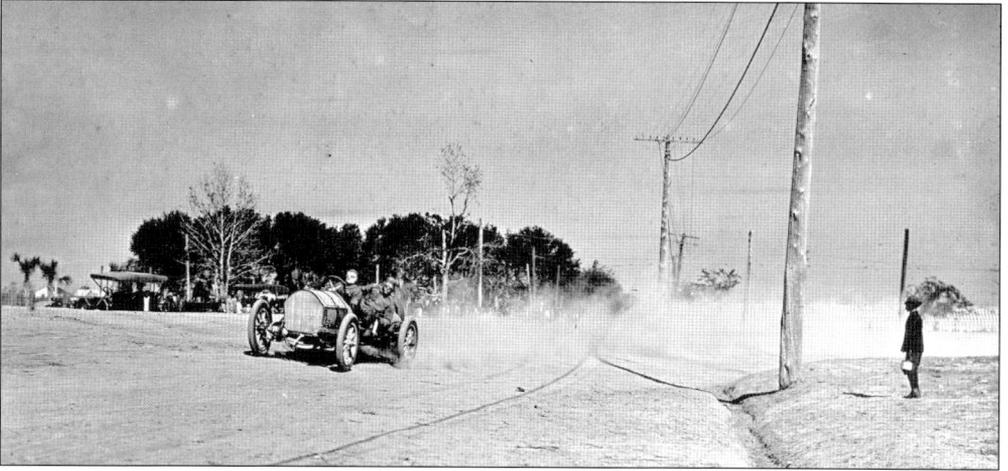

The Savannah Challenge Race was for 16 laps on a 17.3-mile course for a total of 276.8 miles. Six cars started the race and only three finished. Of the three cars that did not complete the race, two were Falcar team entries and one was a Marmon team entry. Both of the Falcar entries left the course in the ninth lap with major mechanical difficulties. The Marmon team car was still running and was in the 15th lap when the race ended.

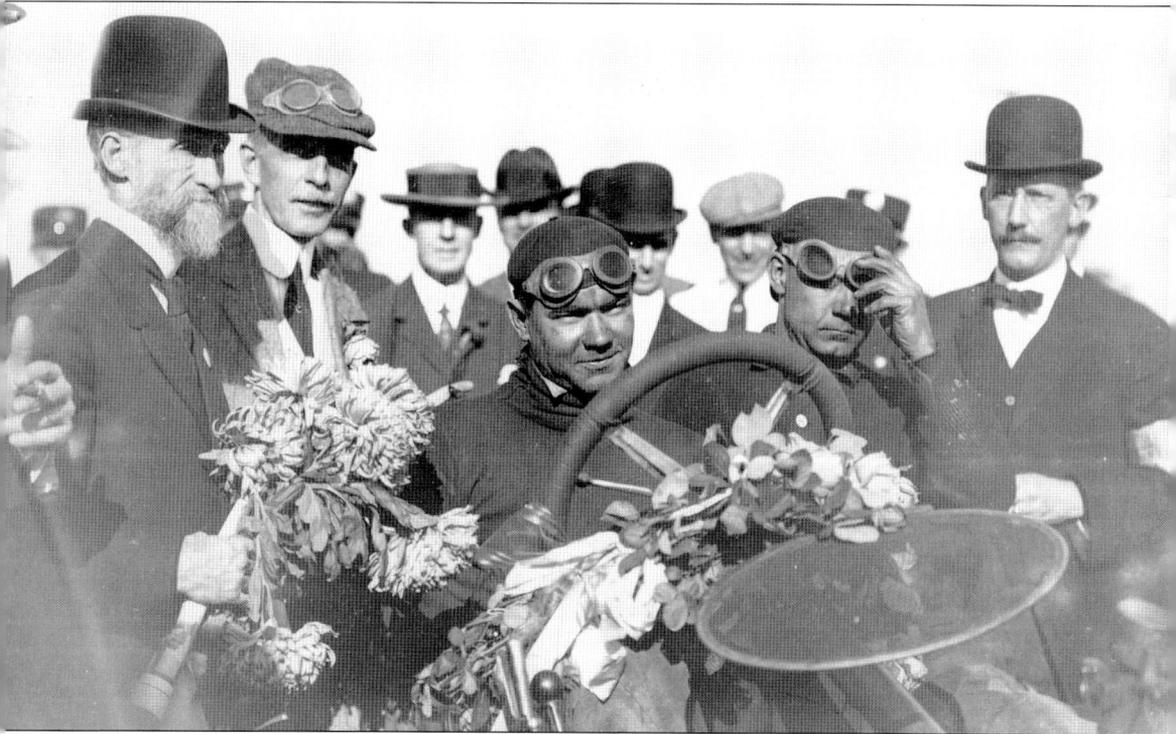

The Savannah Challenge Trophy Race was won by Joe Dawson, driving a Marmon. He led the race from beginning to end and completed the course in 4 hours, 23 minutes, and 39 seconds. The second-place finisher, Roebling, driving a Mercer entry, was close to the first position but experienced difficulties in the final lap. He finished 12 minutes behind Dawson. Pictured here is Joe Dawson being congratulated by Georgia Governor Joe Brown after the Savannah Challenge Trophy Race. Brown is the bearded gentleman on the left.

Official Score Card for the Tiedeman Trophy

No.	CAR	DRIVER	Course Measures 17.3 miles—11 laps. Total Distance 190.3 miles.										
			1	2	3	4	5	6	7	8	9	10	11
41	E. M. F.	Cohen											
42	Maxwell	Wright											
43	Cole	Knight											
44	Lancia	Knipper											
45	E. M. F.	Witt											
46	Maxwell	Doorley											
47	Cole	Endicott											
48	Maxwell	Costello											

MICHELIN TIRES
WIN ALL THE WORLD'S IMPORTANT CONTESTS.
More than one-half of all the cars in the world are equipped with Michelins. WHY?

The Tiedeman Trophy Race was 11 laps for a total of 190.3 miles. This race started after the Challenge Race but on the same track. It was hoped that both races would finish at the same time. The Tiedeman Race had eight entries and only five completed the race.

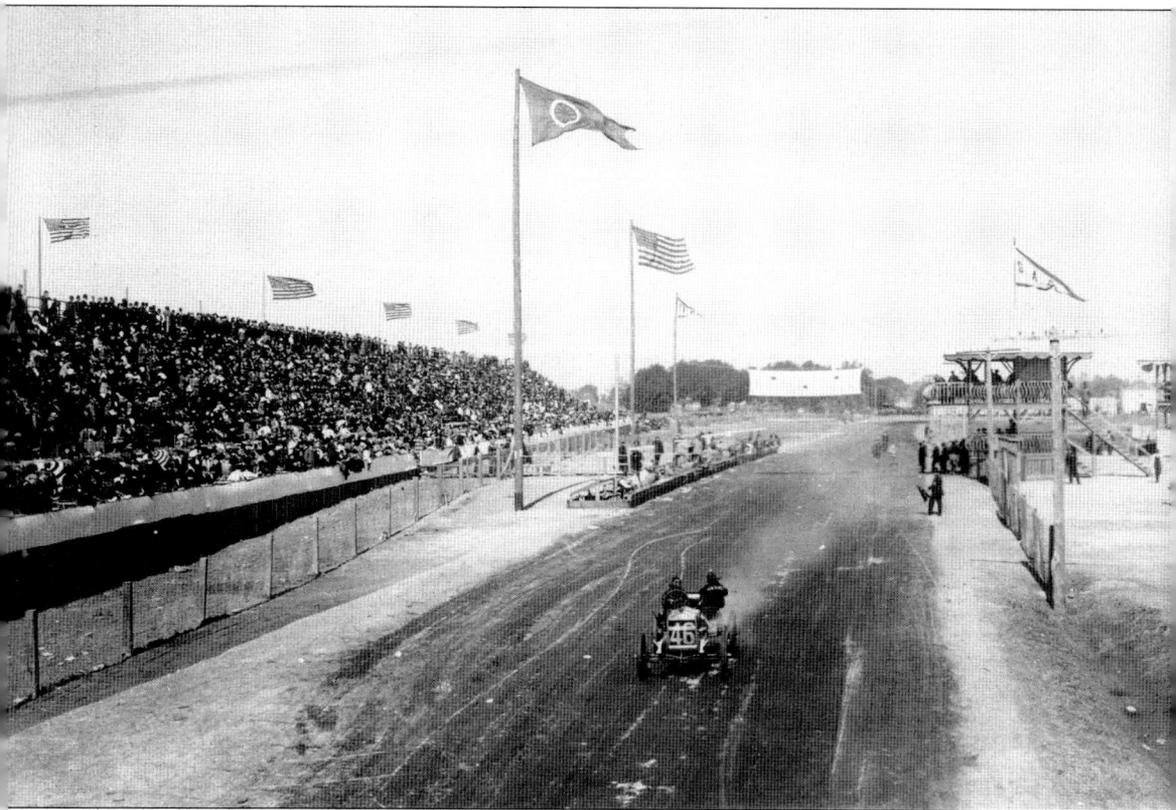

This photo shows Doorley driving one of the three Maxwell team cars entered in the race. The Maxwell cars finished third, fourth, and fifth. Doorley was the last car to finish the race. He is pictured here passing the grandstand, which was built on Waters Avenue.

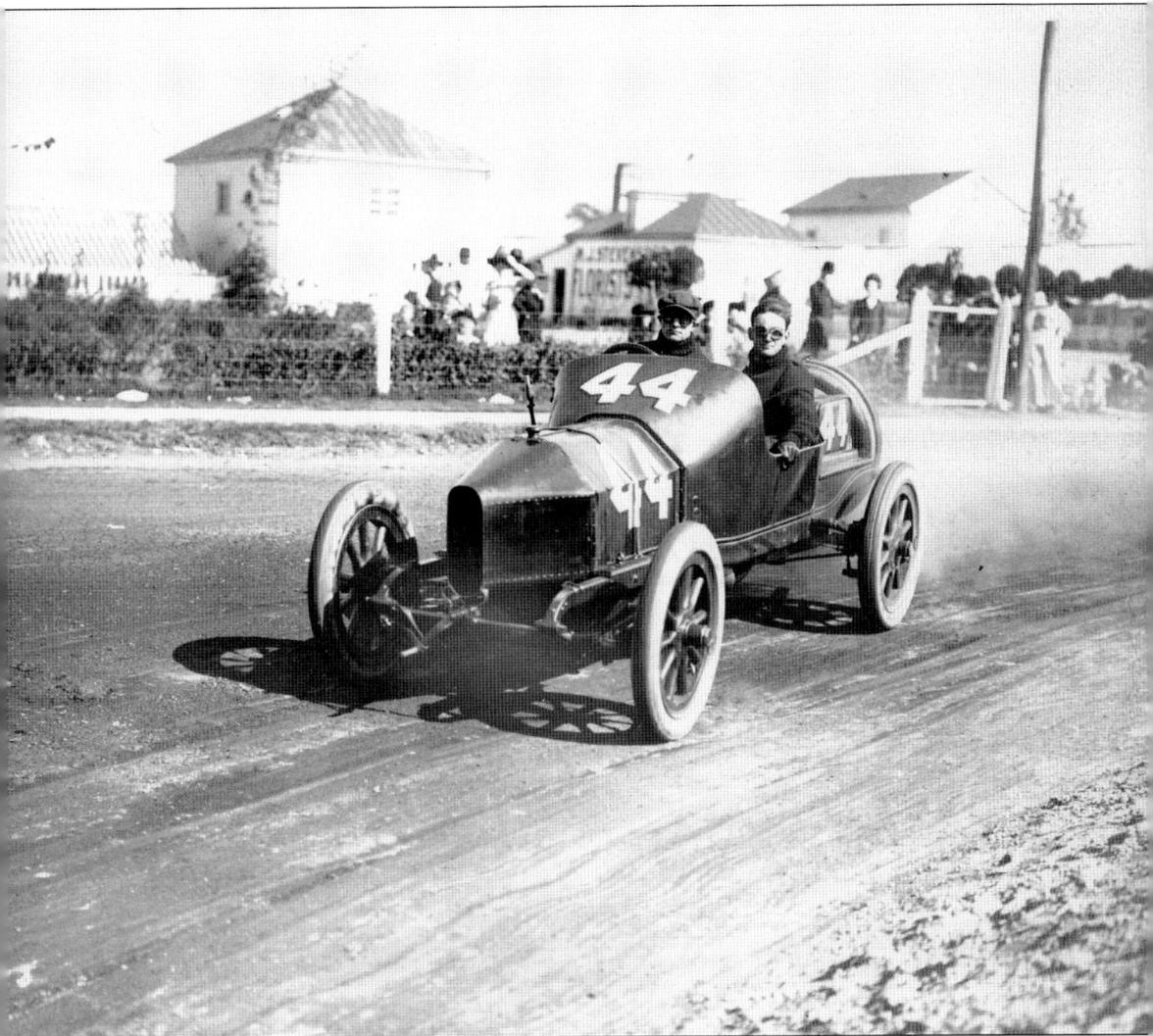

The Tiedeman Trophy Race was won by Billy Knipper, driving a Lancia team car. Knipper was in first place for the entire race and completed the course in 3 hours, 15 minutes, and 22 seconds. In this photograph Knipper is rounding the curve onto the Estill Avenue straightaway. The EMF car finished in second place, 11 minutes behind Knipper. Witt, driving one of the two EMF entries, was in second place for the entire race. The other EMF entry experienced engine trouble on Dale Avenue while in the third lap and did not complete the race.

Pictured here is the Cole car driven by Endicott. He and his driver appear eager to race and anticipate a victory. However, their excitement would not last for long, as they broke their crankshaft in the second lap. At the completion of the first lap they were in fourth place. The

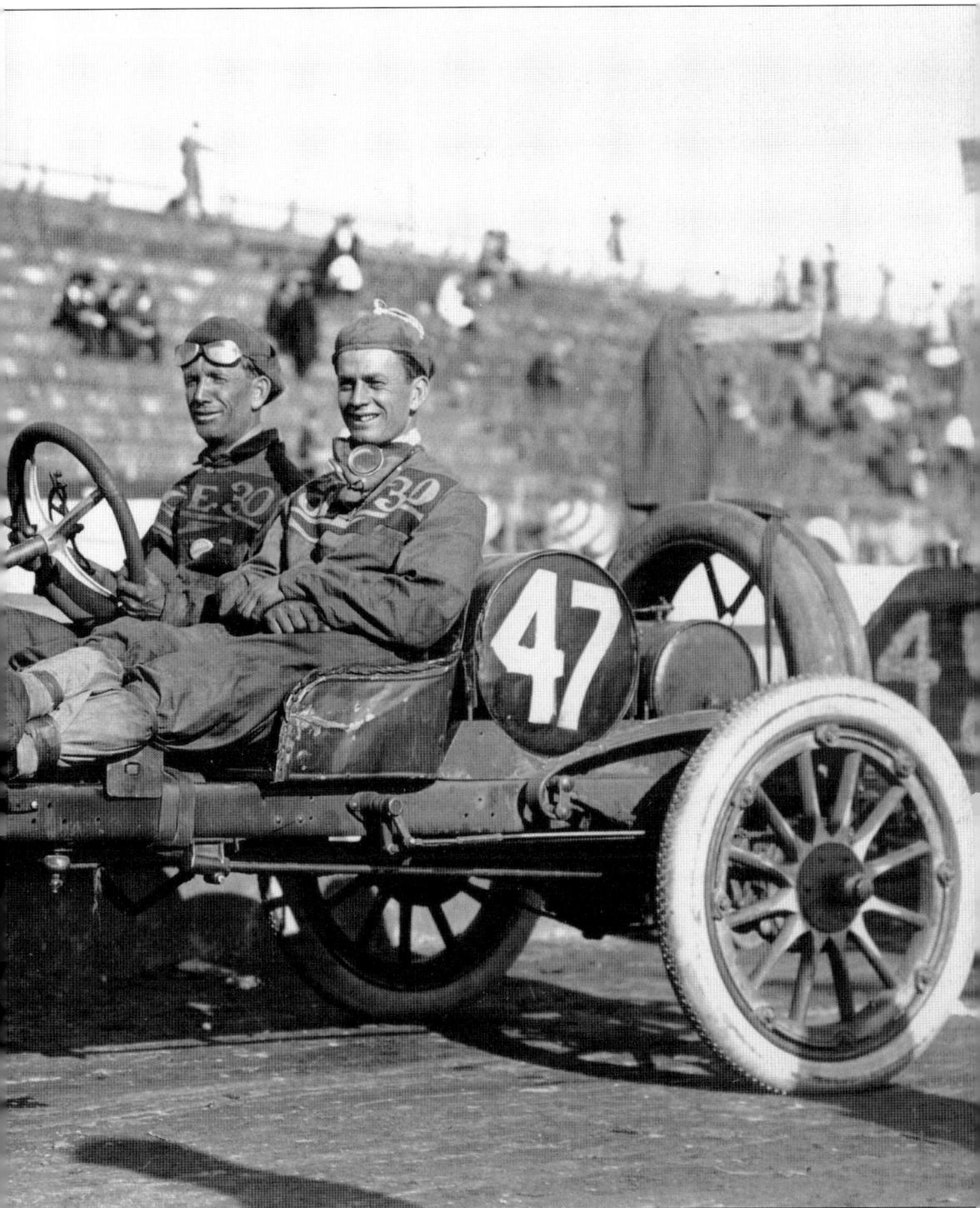

other Cole entry in the race cracked a cylinder at Dale Avenue and Bee Road in the third lap. Both the Cole entries were the first cars to fall from the race.

Official Score Card for the Inter

CAR	DRIVER	Oil Used	COURSE MEAS							
			1	2	3	4	5	6	7	8
Sharpe-Arrow	Sharpe	Monogram								
Roebling-Planche	Washington Roebling II	Monogram								
Marquette-Buick	A. Chevrolet	Monogram								
Lozier	Mulford	Monogram								
Simplex	Matson	Monogram								
Pope-Hartford	Basle									
Alco	Grant	Monogram								
Marmon	Dawson	Monogram								
Benz	Hemery	Monogram								
Fiat	Nazzaro	Monogram								
Marquette-Buick	Hughes	Monogram								
Lozier	Horan	Monogram								
Pope-Hartford	Disbrow									
Marmon	Harroun	Monogram								
Benz	Bruce-Brown	Monogram								
Fiat	Wagner	Monogram								
Marquette-Buick	Burman	Monogram								
Benz	Haupt	Monogram								

This is the official scorecard for the International Grand Prize Race, which was held on

ional Grand Prize Automobile Race.

17.3 MILES—24 LAPS. TOTAL DISTANCE 415.2 MILES.

10	11	12	13	14	15	16	17	18	19	20	21	22

November 12, 1910.

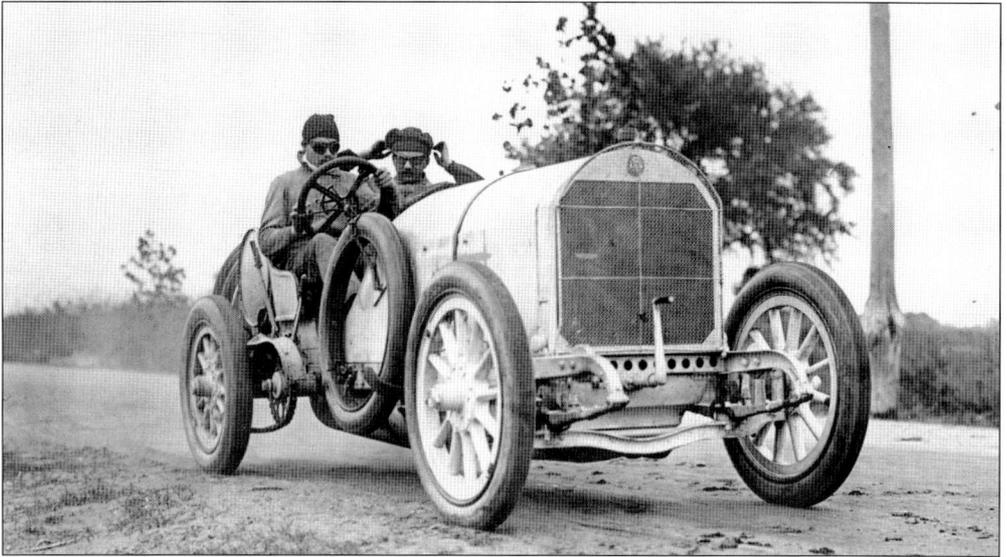

The Grand Prize Race of the Automobile Club of America was held on November 12, and covered 415.2 miles. The cars were to complete 24 laps around the 17.3-mile course. Fifteen cars started the race and only six finished. One of the most popular viewing areas for the Grand Prize Race was on Ferguson Avenue at Bethesda Orphanage. Rockers, chairs, and benches were rented for 25¢ and 50¢.

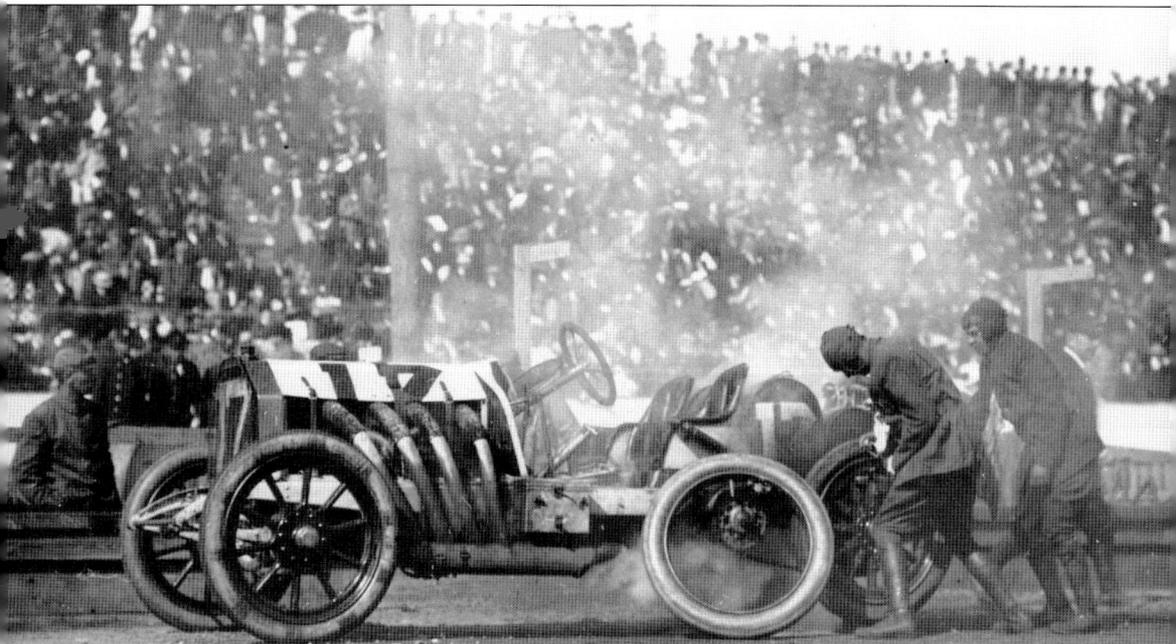

Pictured here is the Marquette-Buick team changing a tire in front of the grandstand on Waters Avenue. This car, driven by Bob Burman, finished third, having completed the course in 6 hours, 11 minutes, and 23 seconds. He completed the first lap in 10th place and gradually moved through the standings. He was almost 20 minutes behind the second-place finisher and 15 minutes ahead of the fourth-place finisher. This entry won $2,000 for being the first American car to complete the race.

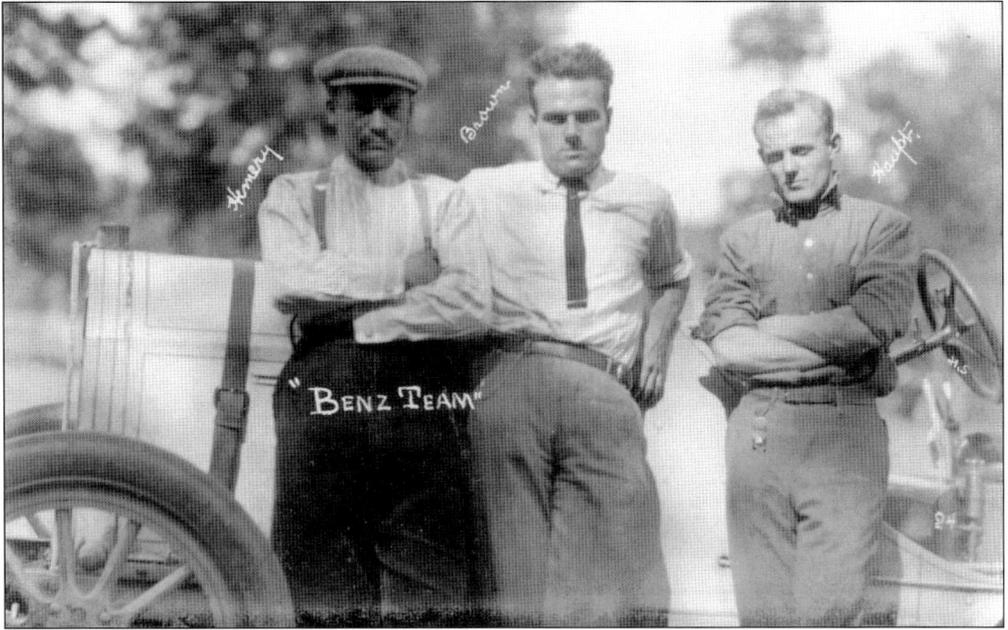

Pictured here are the Benz team drivers entered in the Grand Prize Race of 1910. From left to right are Victor Hemery, David Bruce-Brown, and Haupt. The Benz team was thought to be a major force in the race and this was correct. Each of the Benz team cars was in first place at some point during the race.

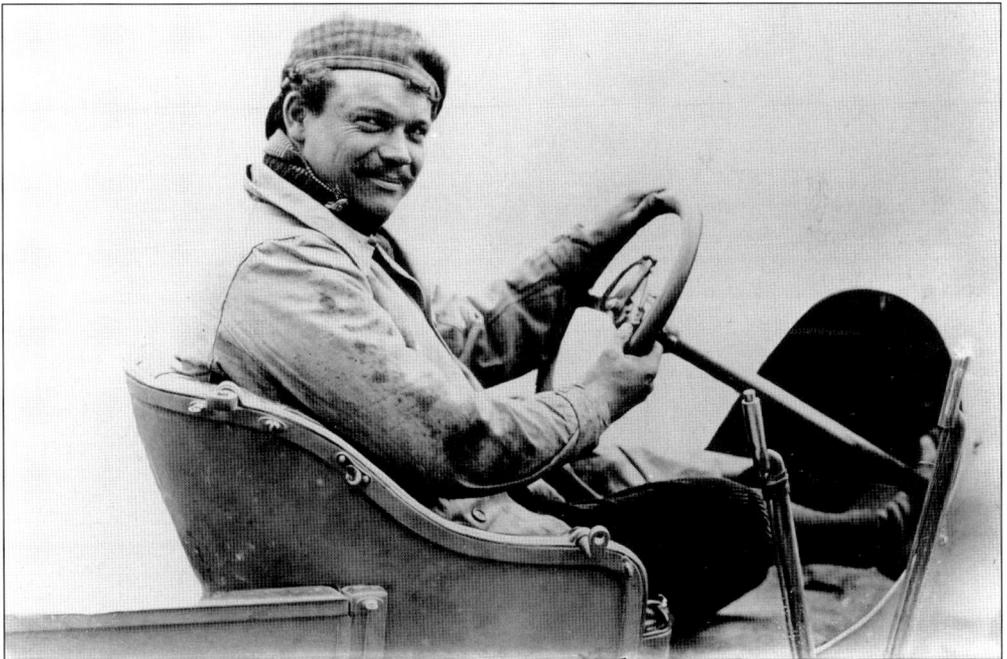

Pictured here is Victor Hemery, driver of one of the Benz team entries. He won second place in the most exciting race ever held in Savannah. Hemery was just 1.47 seconds behind the race winner. Hemery was in first place from lap one through lap eight. In lap nine he fell to fifth place. He made his way back within striking distance of the leader but ran out of track.

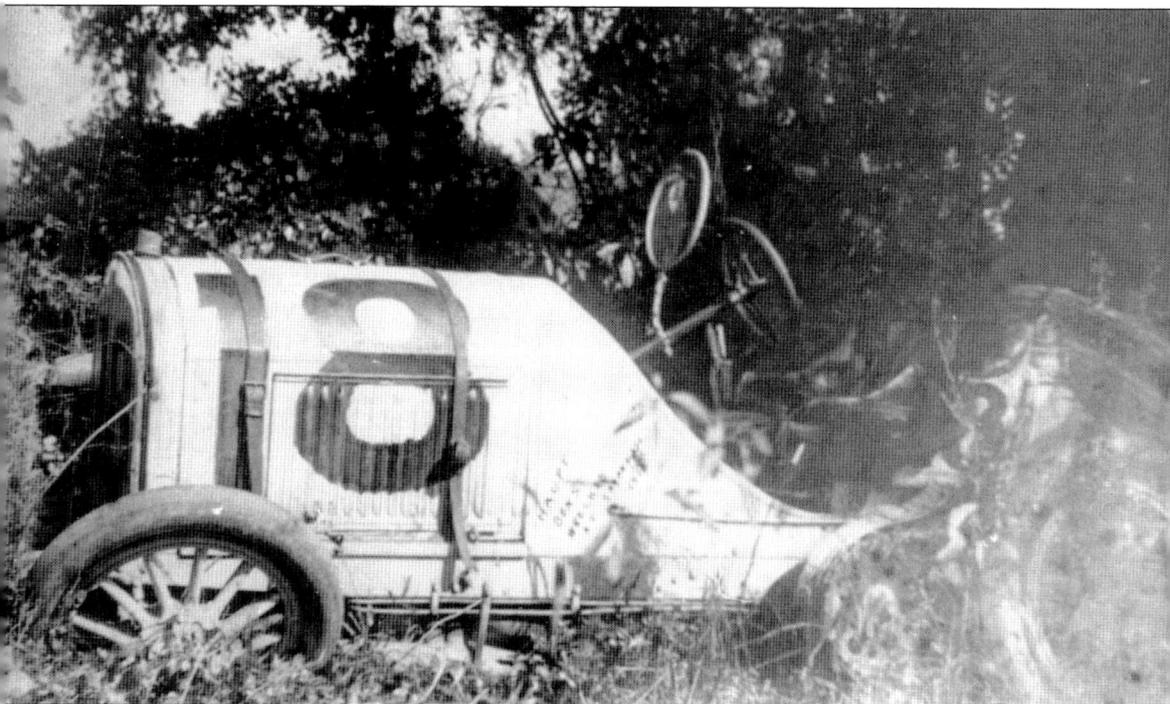

This picture shows the Benz driven by Haupt. He was in first place at the completion of the 12th lap and ran into a ditch on Montgomery Crossroads in the 13th lap, breaking his wheel. The score sheet for the Grand Prize Race incorrectly identifies car number 18 as the Pope-Hartford entry. When Haupt wrecked he was in first place, approximately 5 minutes ahead of the second-place car, a Fiat driven by Nazarro.

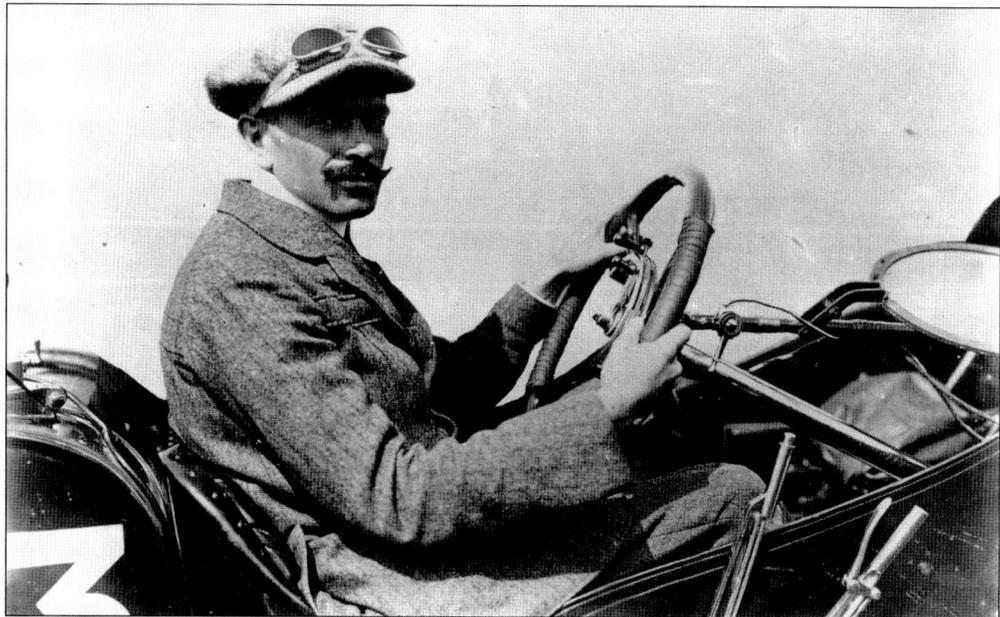

Pictured here is Felice Nazarro, driver of one of the three Fiats. He was in fourth place at the completion of the 18th lap and broke his chain while in the 19th lap.

This is a photograph of Louis Wagner and his mechanic, Ferro. Wagner drove for the Fiat team and left the race in the 17th lap. He was running ninth at the completion of the 16th lap, and then in the 17th lap he turned his car over on LaRoche Avenue. Wagner was in first place in laps nine and ten.

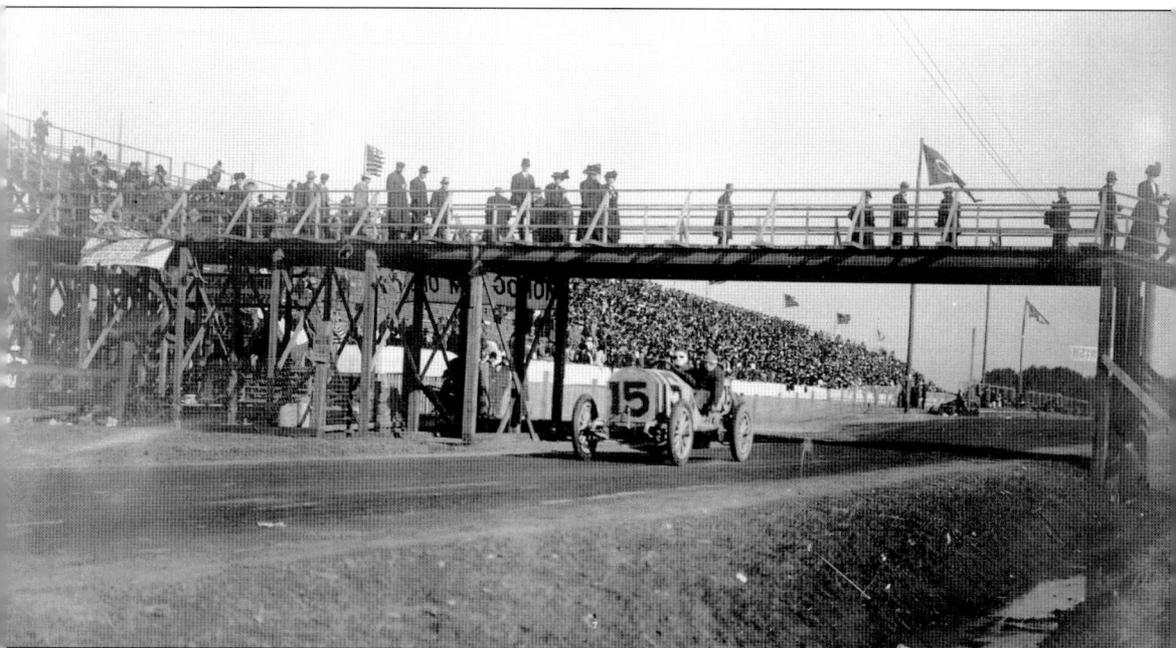

David Bruce-Brown, driving a Benz and pictured here, won the 1910 Grand Prize Race by 1.47 seconds. He averaged 70.17 miles per hour. Pedestrian overpasses were built along certain parts of the course. This overpass is on Waters Avenue in the vicinity of Forty-Sixth Street.

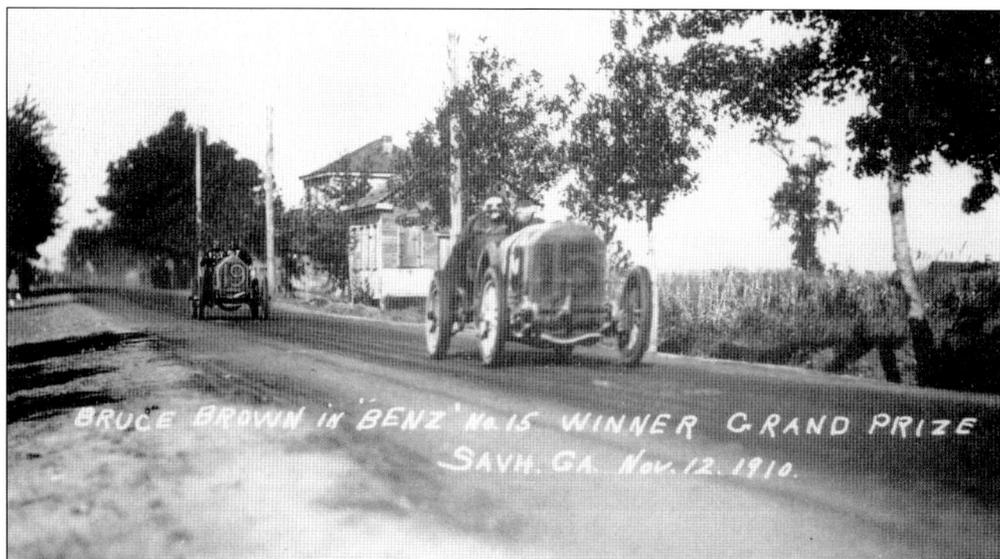

BRUCE BROWN IN 'BENZ' No.15 WINNER GRAND PRIZE SAVH. GA. Nov. 12. 1910.

In the Grand Prize Race, as with all of the races, the drivers were started with 30-second intervals between them. Therefore, it was the role of the judges to calculate the time and declare the winner based on the fastest course time. In some cases, as in the Grand Prize Race of 1910, the winner might not be the car to complete the course first. In this race, Hemery drove at a dangerous clip in an attempt to pass Bruce-Brown. Hemery finished ahead of Bruce-Brown, but after conferring over which of the Benz cars was first, the judges awarded Bruce-Brown the narrowest of victories.

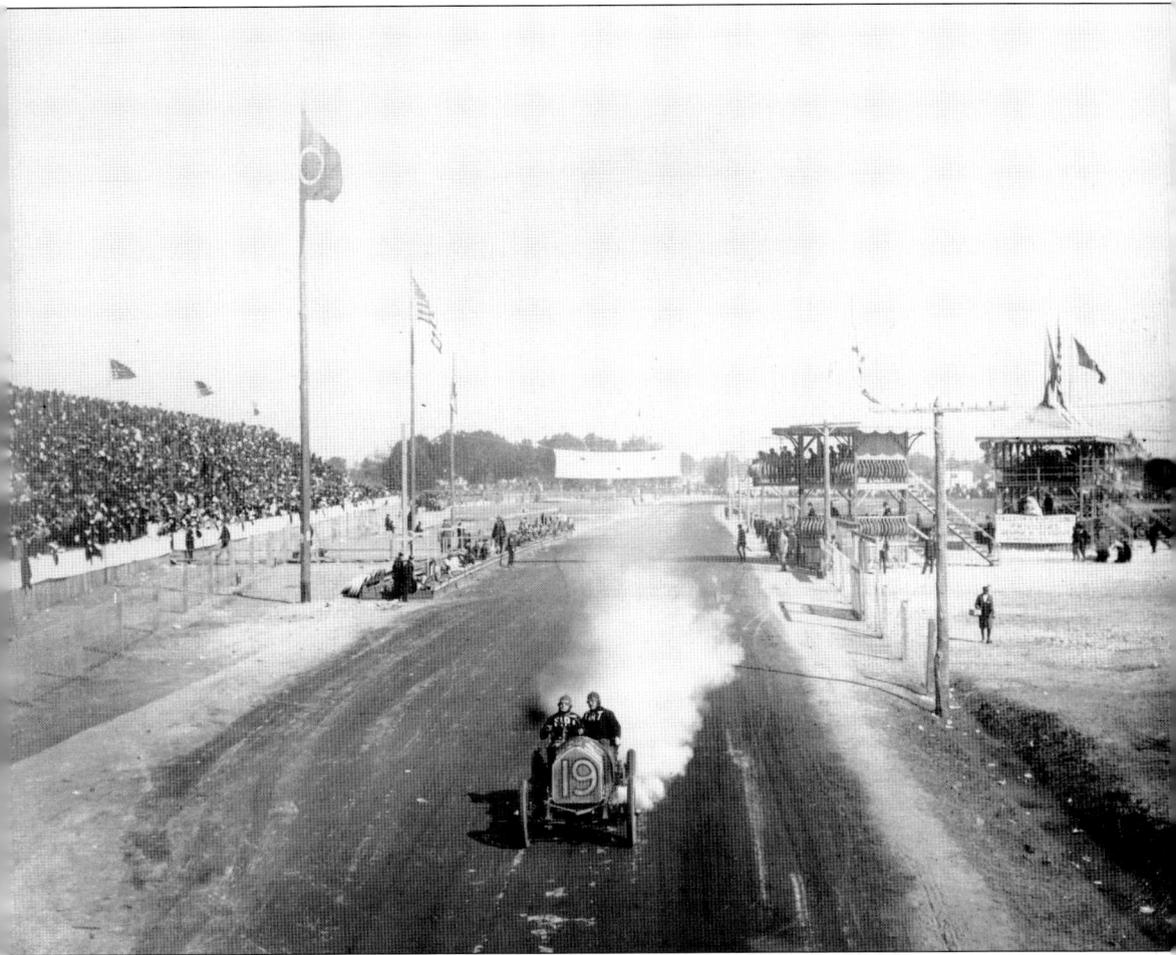

DePalma is shown passing in front of the grandstand during the Grand Prize Race. DePalma was the highest finishing car of the Fiat team. Fiat had entered three cars and none of them completed the race. DePalma had engine problems in lap 23. He had been in first place since lap 17 and was a few minutes ahead of Bruce-Brown prior to his Fiat leaving the race.

This souvenir pennant from the 1910 races is part of the artifact collection of the Georgia Historical Society.

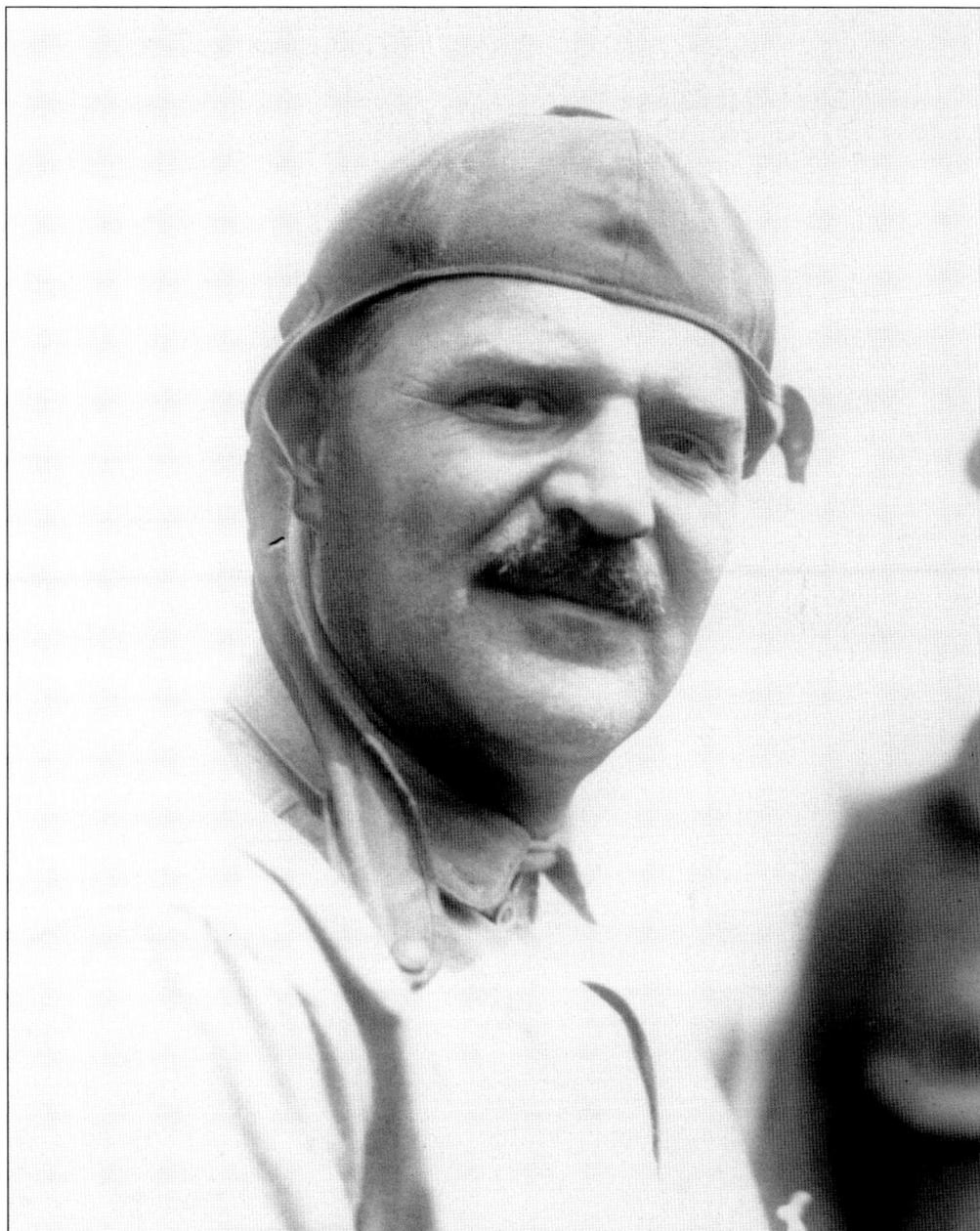

Louis Chevrolet was a respected driver but had decided to retire from driving and focus strictly on automobile design. His brother, Arthur Chevrolet, raced in the Grand Prize Race of 1910 in one of the two Marquette-Buick entries. At the completion of the eighth lap he was in 11th place. In the 12th lap he broke his crankshaft and his race was finished.

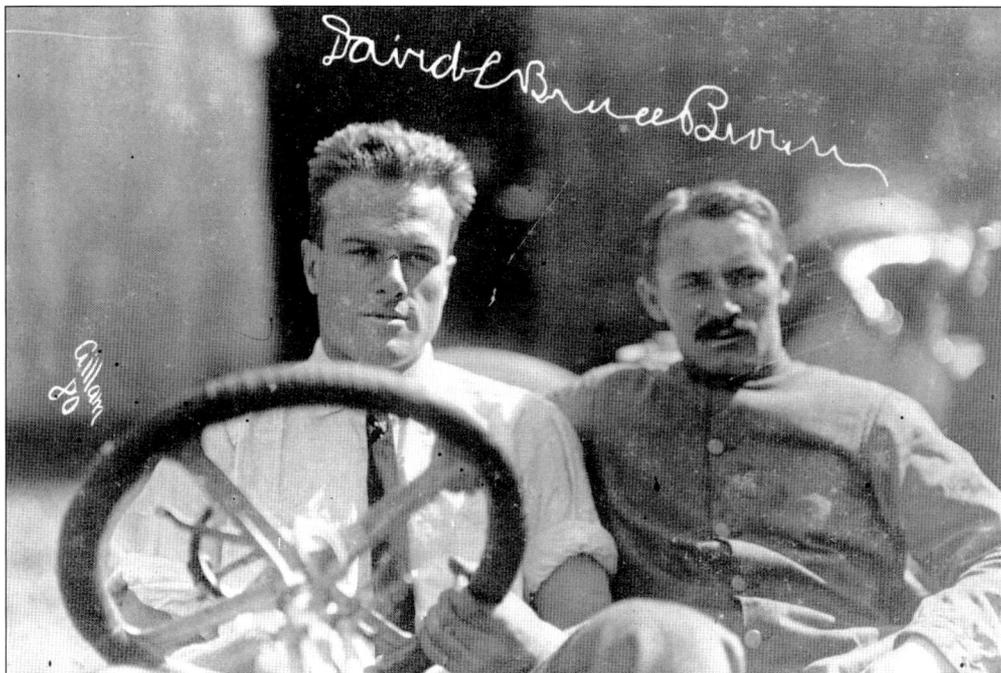

David Bruce-Brown and his mechanic, Kramer, were winners of the 1910 Grand Prize Race. It could be argued that Bruce-Brown was the best American driver in these early races. He was aggressive and at times took risks. His mother was extremely worried about him being injured or killed. She went to the races and was quoted in the paper talking about her son's safety. He won the race and his mother relented and told him that the decision to race in the future was his.

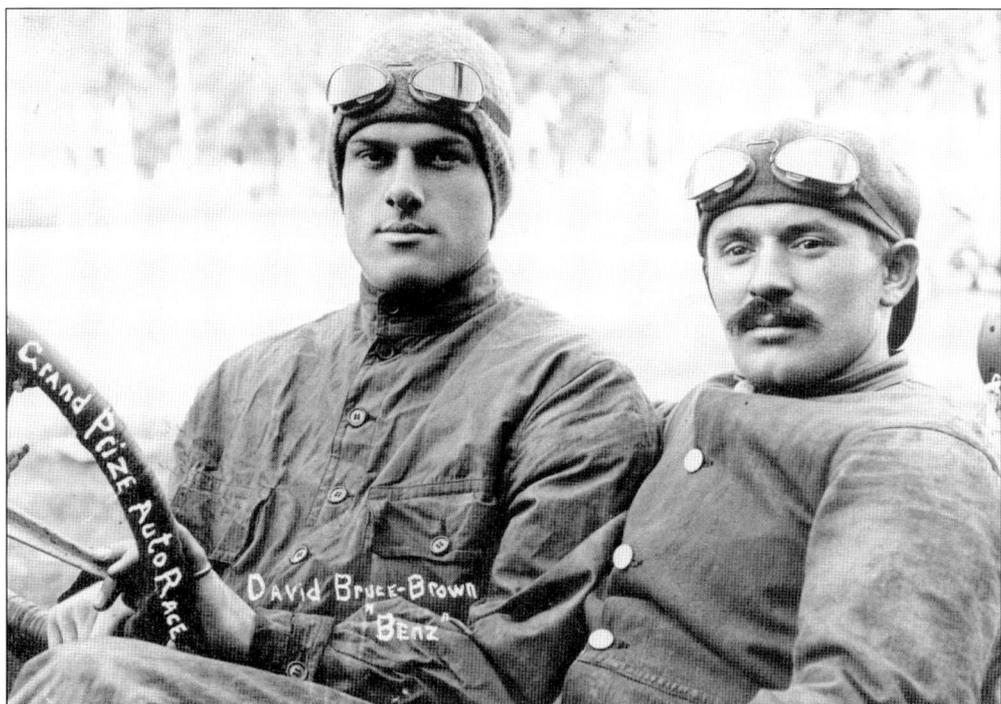

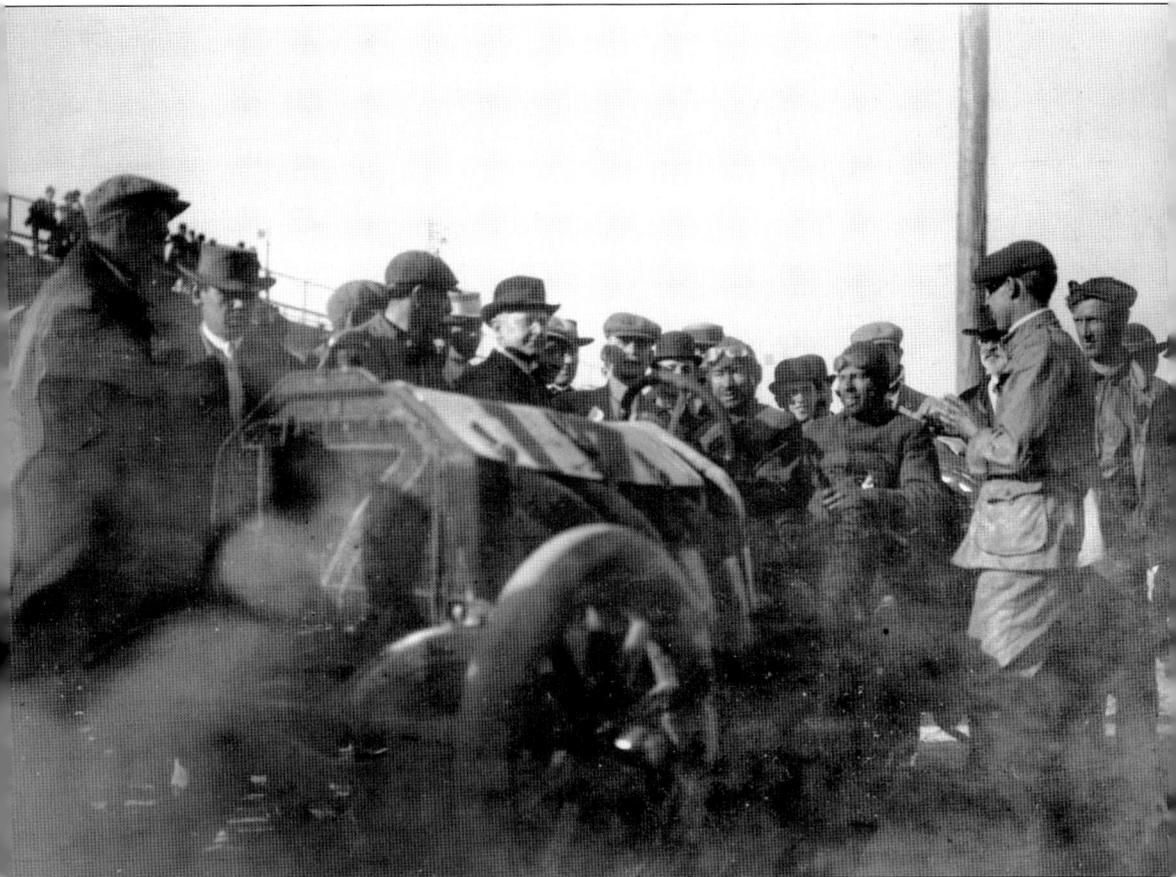

Bob Burman, driver of the Marquette-Buick entry, was congratulated on his third-place finish in the Grand Prize Race. This was the best showing ever made by an American car in a long distance road race. The car went through 15 tire changes and took a beating. The strategy employed by this team almost seemed reckless, as they attacked the curves at speeds higher than any other drivers would dare. This led to the numerous tire changes and could have cost them the race. Burman received $2,000 for being the first American to finish.

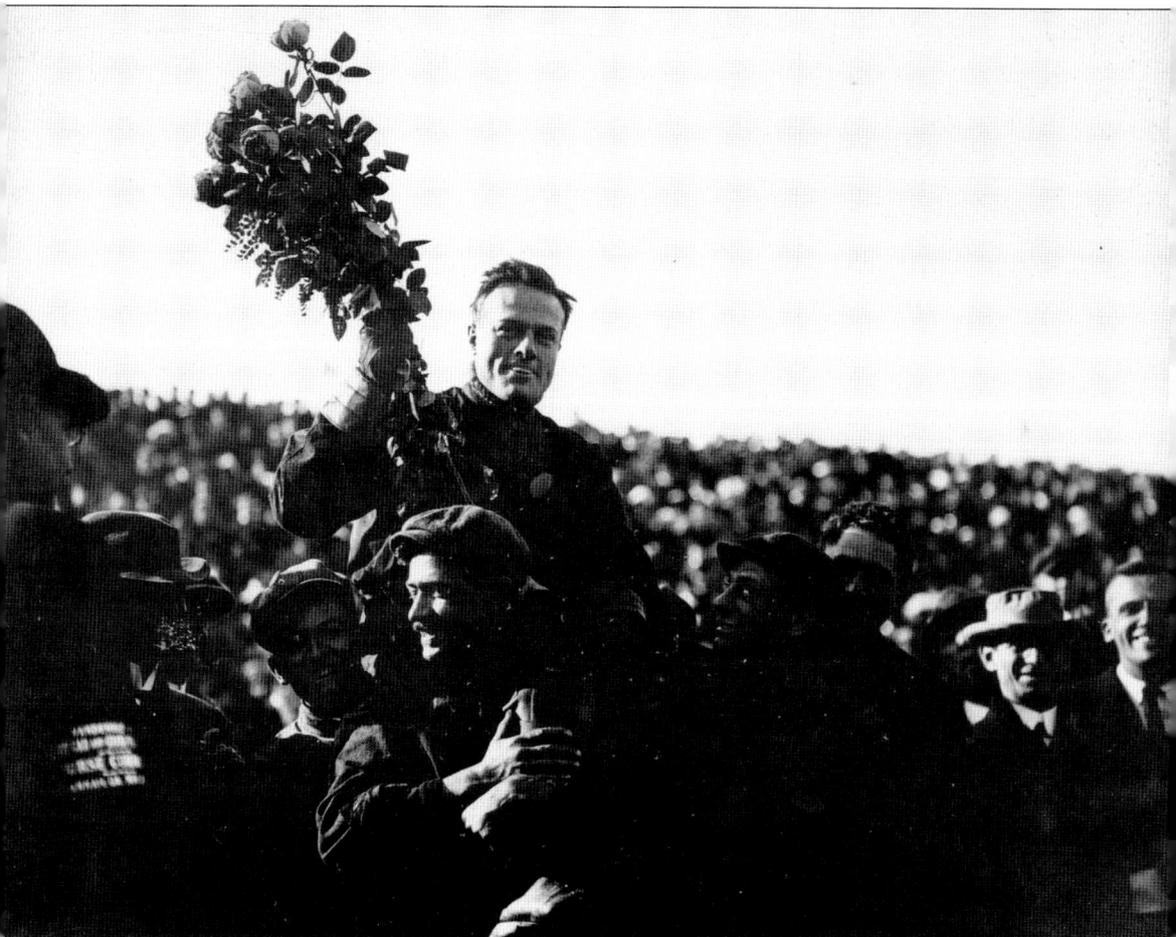

David Bruce-Brown finished the race in 5 hours, 53 minutes, and 5 seconds. As Bruce-Brown neared the end of the race his mother's anguish turned to excitement. People sitting near her in the grandstand said that she became very excited upon realizing that her son was a contender. She struck other spectators with her umbrella and wildly shouted to her son to "step on it." Fred Wagner, the official starter for all of the Savannah races declared Bruce-Brown to be the greatest road race driver he had ever seen. He was loved in Savannah and would return to race in the 1911 races.

Four

November 1911

The William K. Vanderbilt, Jr., Cup
———— AND ————
The Grand Prize (Gold Cup)

International Automobile Races
AT SAVANNAH, GA.

Sanctioned by The American Automobile Association
and The Automobile Club of America

NOVEMBER 27th and 30th, 1911

GRAND STAND

Reserved Seat, $3.00

Sec. A Row 10 No. 8 | SAVANNAH AUTOMOBILE CLUB

COMMERCIAL LITHO. & PTG. CO.

RESERVED
SEC.
A
ROW
10
NO.
8

SEAT CHECK
THIS COUPON NOT TO BE DETACHED UNTIL
30th
NOV. 30TH

Savannah became the center of the automobile racing world in 1911 when it was announced that the city would host the Grand Prize Race and Vanderbilt Cup Race in the same week. It was also announced that there would be two light car races preceding the two main events. The members of the Savannah Automobile Club finally had what they wanted.

OFFICIAL PROGRAM and SCORE CARD of the VANDERBILT CUP and GRAND PRIZE RACES

also Savannah and Tiedeman Trophy Races

under the auspices Savannah Automobile Club

to be held at Savannah Ga.

November 27th and 30th 1911

PRICE 25 CENTS

Cover designed and printed by Jaques & Company, Inc., New York

This program for the 1911 races features photographs of the race course, as well as information on previous races.

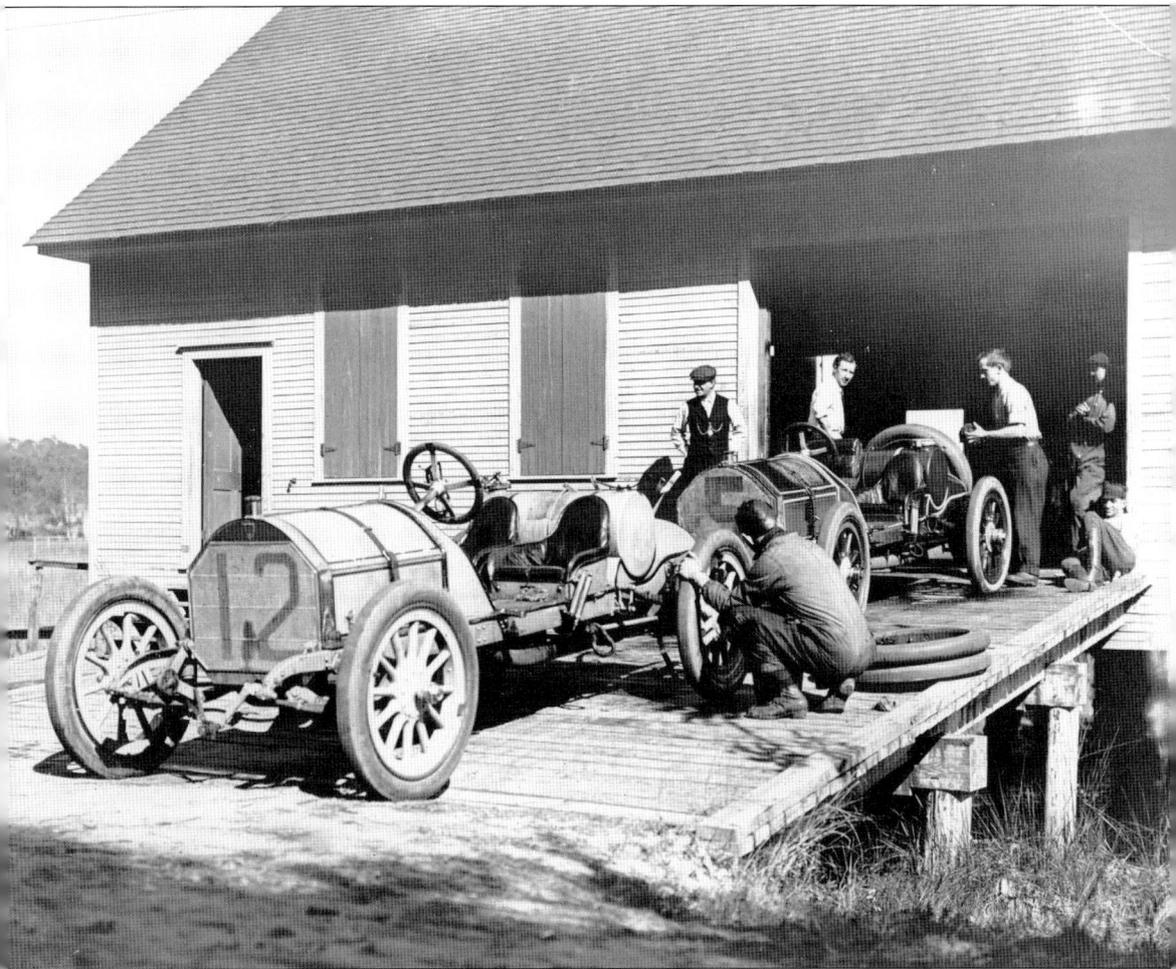

As in the other races, the teams established camps along the course. Pictured here is the Mercer Camp at Bona Bella.

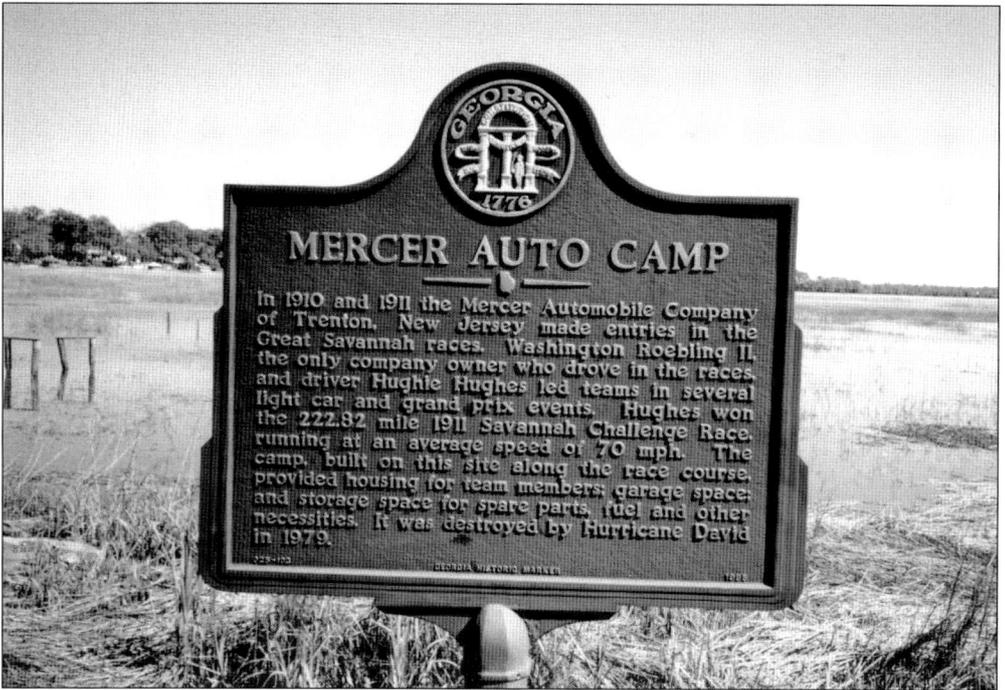

MERCER AUTO CAMP

In 1910 and 1911 the Mercer Automobile Company of Trenton, New Jersey made entries in the Great Savannah races. Washington Roebling II, the only company owner who drove in the races, and driver Hughie Hughes led teams in several light car and grand prix events. Hughes won the 222.82 mile 1911 Savannah Challenge Race, running at an average speed of 70 mph. The camp, built on this site along the race course, provided housing for team members, garage space, and storage space for spare parts, fuel and other necessities. It was destroyed by Hurricane David in 1979.

These are two current photographs of the site of the Mercer camp. The camp was on LaRoche Avenue and sat on the marsh side of the road. All that remains is seen in the picture below. As stated on the historical marker, this structure stood until it was destroyed by Hurricane David in 1979.

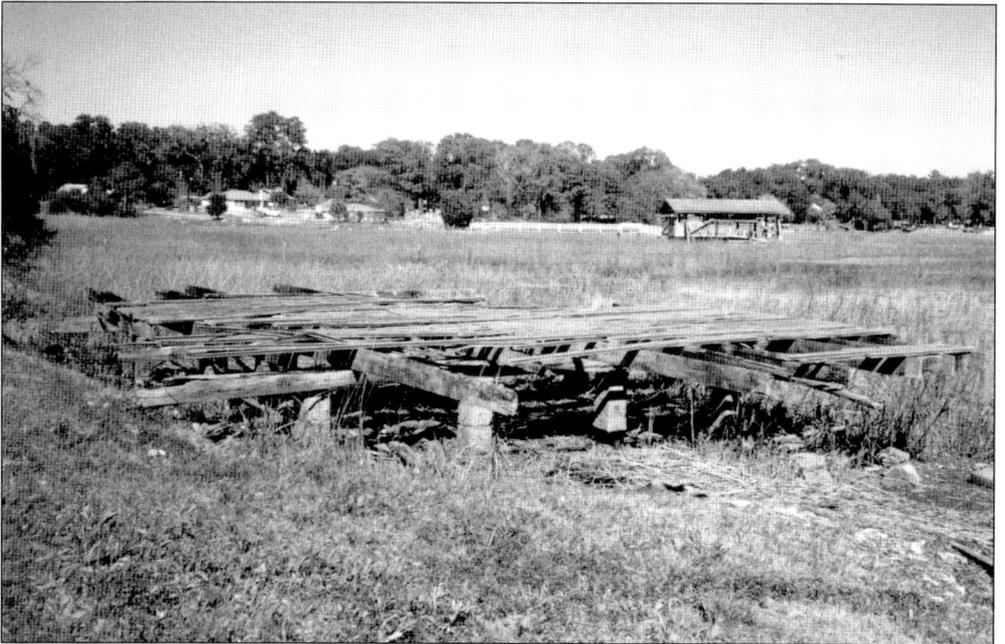

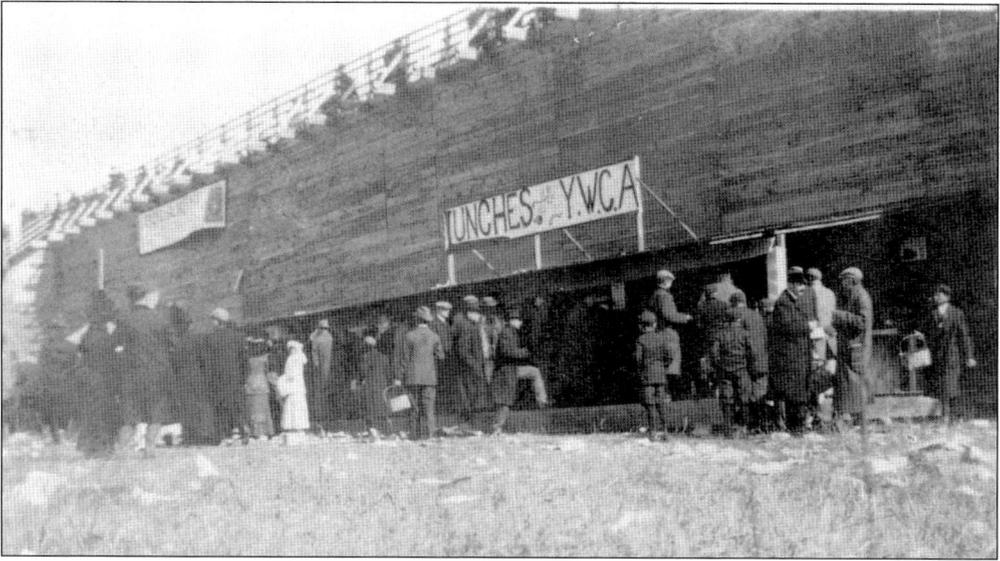

The YWCA was again responsible for the concession stand. However, this year "Negro waiters" circulated among the crowd with trays containing glasses and liquor. They were selling shots of whisky for 50¢. Few people opposed this, as the morning of the race was one of the coldest experienced in Savannah.

Once again the military was used to protect the course. It was becoming more and more difficult to keep people off of the course. Savannah was now experiencing what Long Island had experienced a few years earlier.

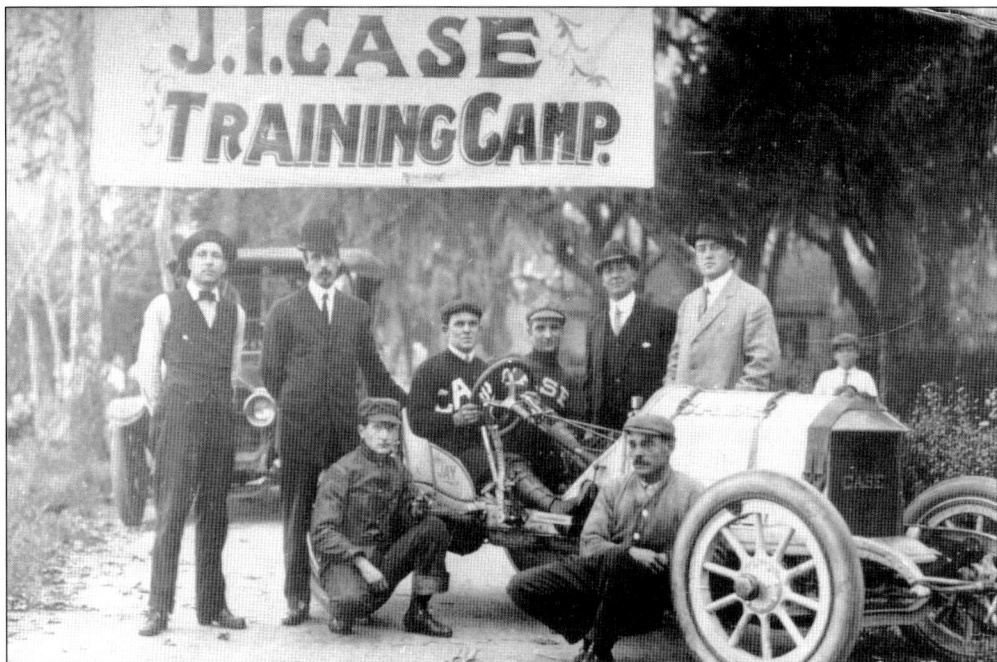

Jay McNay, driving the Case car and pictured here in the driver's seat, was instantly killed when he lost control of his car on LaRoche Avenue. McNay came off of a curve at a very high speed during the practice rounds and was forced to avoid a wagon in the road. It was evident to the organizers of the Savannah races that a lot had changed since 1908, as it was now difficult to keep the roads closed and free of traffic. The bottom photograph was taken while McNay circled the course during the practice days. This is the last photograph taken of him or the car prior to the wreck. The car was extremely fast and the Case Company had invested a lot of time and money in its construction. The wreckage was boxed and buried on the grounds of the Case factory.

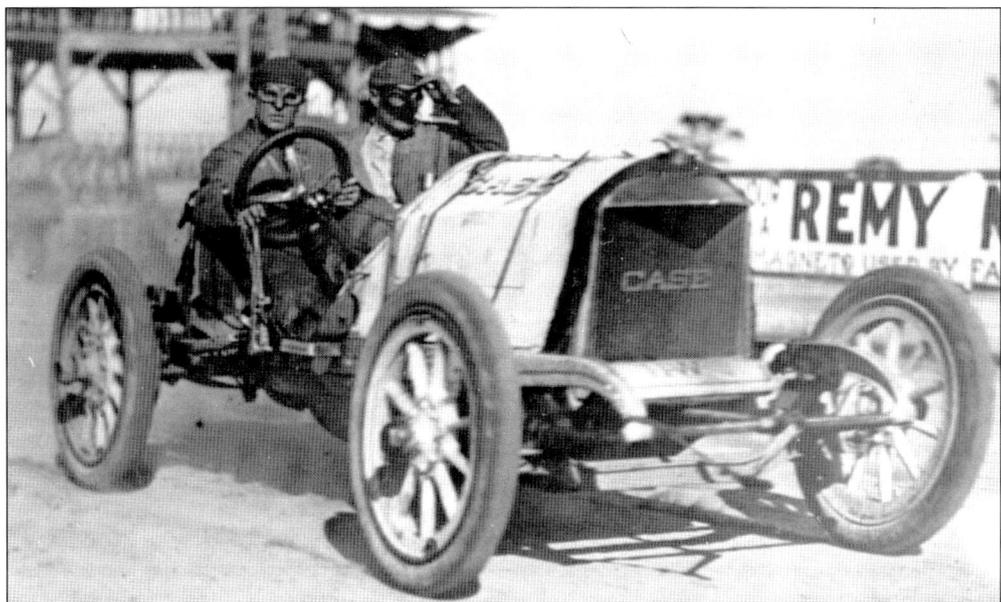

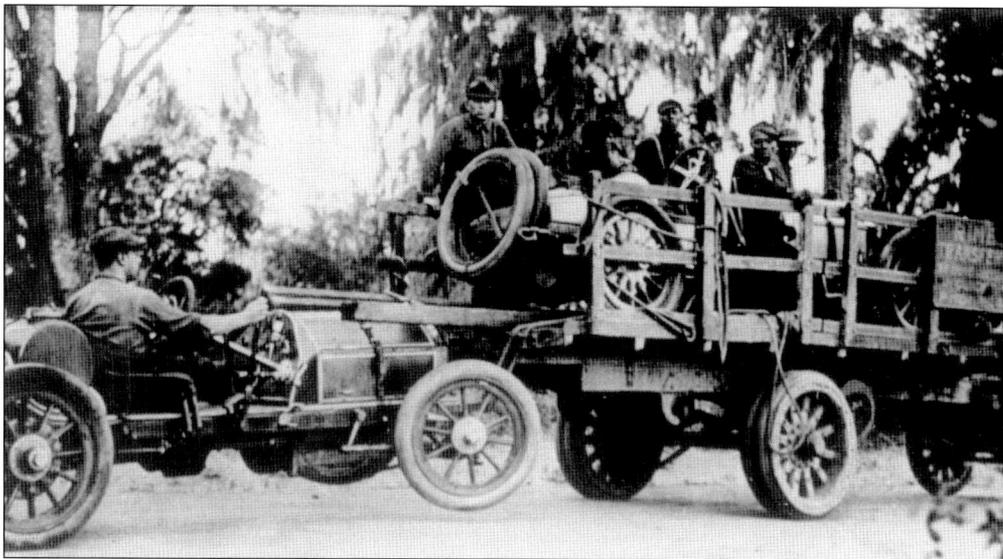

During the 1911 races, several car makers made their debut. Fiat unveiled a new, faster Fiat designed specifically for the races. Mercedes had entered two cars into each event and was even favored in the Vanderbilt Cup. The Abbott-Detroit also made its first appearance in Savannah, as well as the Ford. The Ford team entered a car in the Tiedeman Trophy Race.

The Tiedeman Trophy, the Savannah Challenge Cup, and the Vanderbilt Cup Race were all held on the same day—November 27, 1911. The light car races both started at 7:45 a.m. and ended before the Vanderbilt race scheduled to begin at 10:30 a.m. Several drivers were able to drive in both the early and late races.

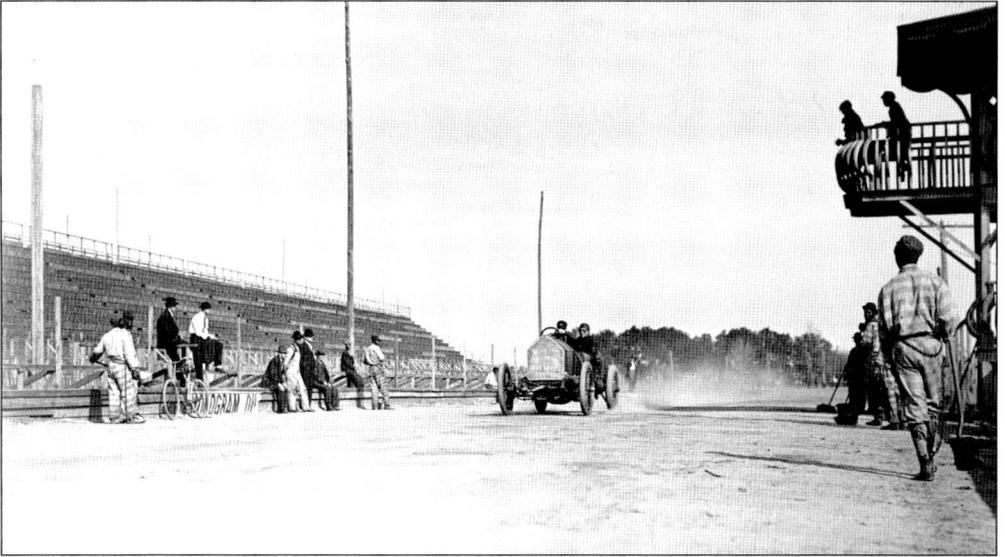

Work on the roads was started months in advance, under the supervision of Newell T. West, county superintendent of road construction. Once again prison labor was utilized. Newell West assured everyone that the roads would be second to none. The curves were lengthened and broadened, while the road surfaces were widened, oiled, and rolled, again and again.

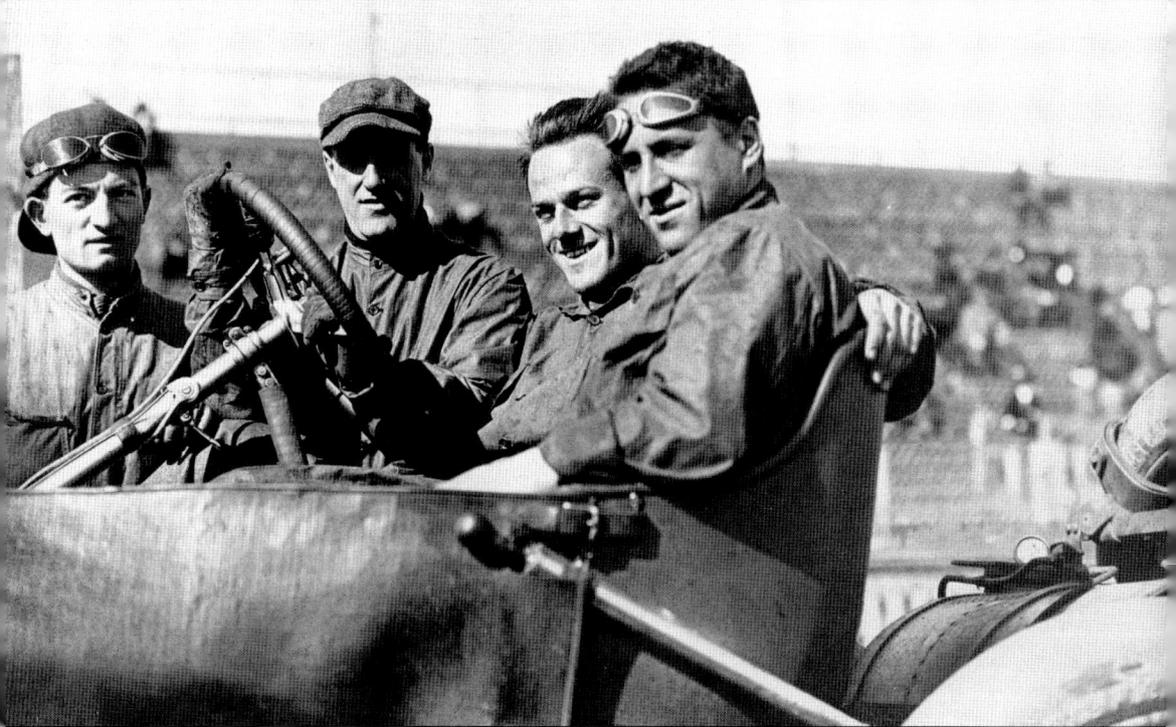

David Bruce-Brown, pictured in the driver's seat, was in Savannah to race in both the Vanderbilt Cup race and the Grand Prize Race. He was the most famous American driver and considered by some to be the favorite. Bruce-Brown had won the Grand Prize Race in Savannah in November of 1910.

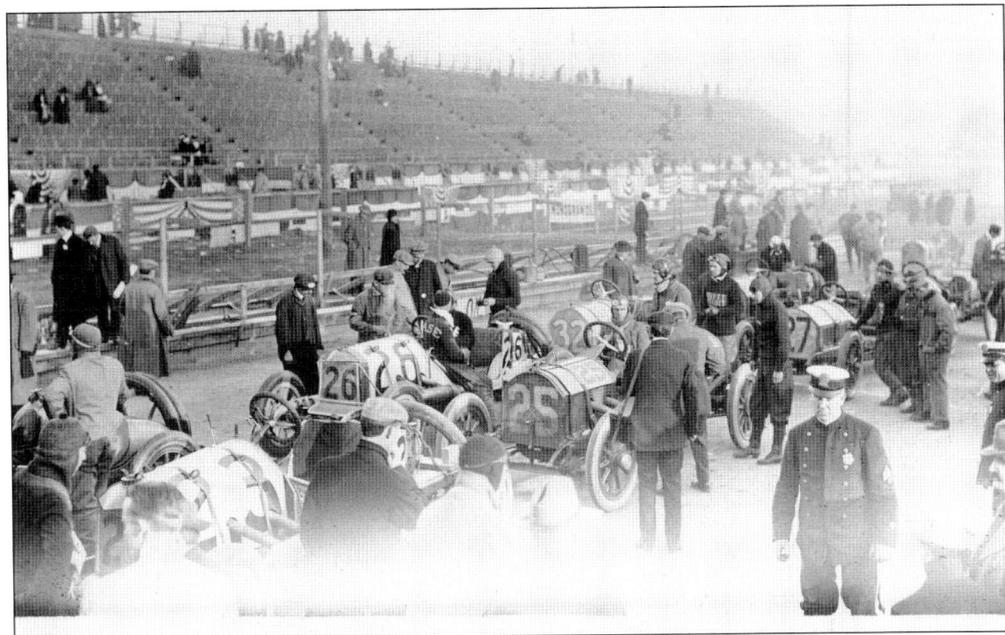

Pictured here is the starting line for the Savannah Challenge Trophy Race, which took place on November 27. The race had seven entries and the length of the race was 222.82 miles. Only three cars completed the course—two from the Marmon team and one from the Mercer team.

Pictured here is one of the two Marmon team cars driven in the Savannah Challenge Trophy Race. The car was driven by Heineman and finished second. After the first lap, Heineman was in fifth place and he slowly moved to second by the completion of the eighth lap. He finished six minutes behind the winner and three minutes ahead of the third-place finisher. He completed the course in 3 hours, 21 minutes, and 41 seconds.

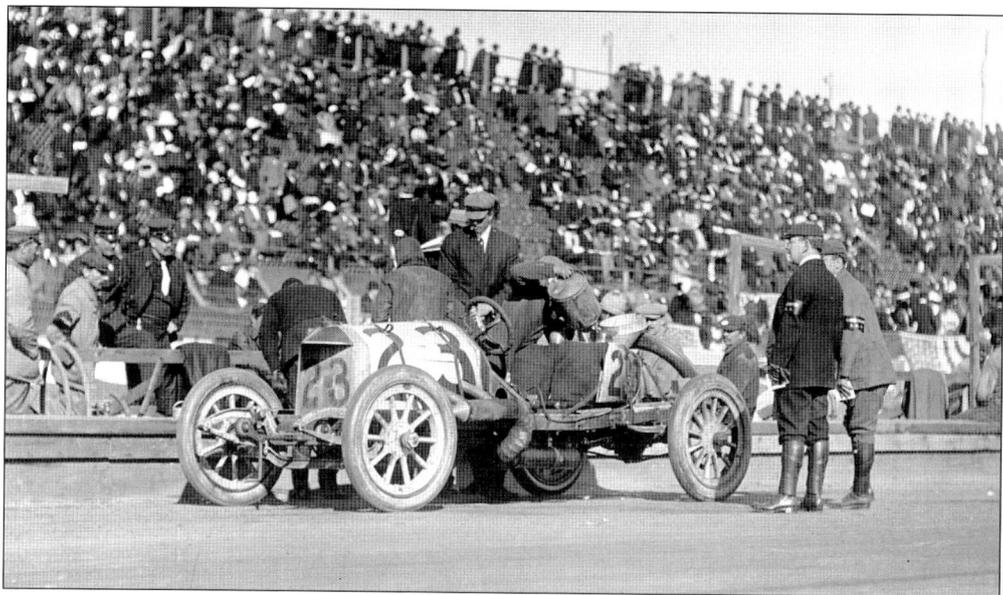

The Case car driven by Buckley stops in the pits in front of the grandstand. There was an additional Case car driven by Disbrow which also started this race. Disbrow was out before the end of the fifth lap, having broken a camshaft. Unfortunately for Disbrow, he had been in first place through the first four laps of the race, leading for its entirety. Buckley was able to go a little over twice the distance traveled by Disbrow. Buckley was in the 11th lap when the race ended. He had a terrible sixth lap.

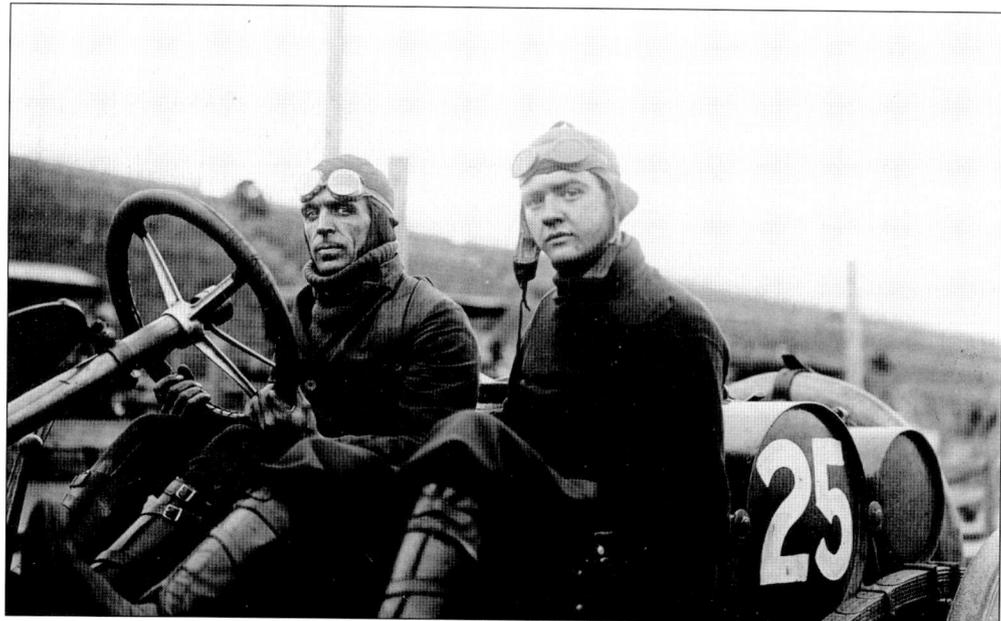

The first day of practice saw not only the death of Jay McNay, but also a wreck involving Nikrent in a Marmon, Barnes in a Mercer, and Billy Knipper in a Mercer. This wreck occurred near Bethesda on Whitefield Avenue and was caused by unauthorized traffic in the road. The wreck was blamed on a flagman giving the wrong signal. Pictured here is Nikrent in the Marmon car.

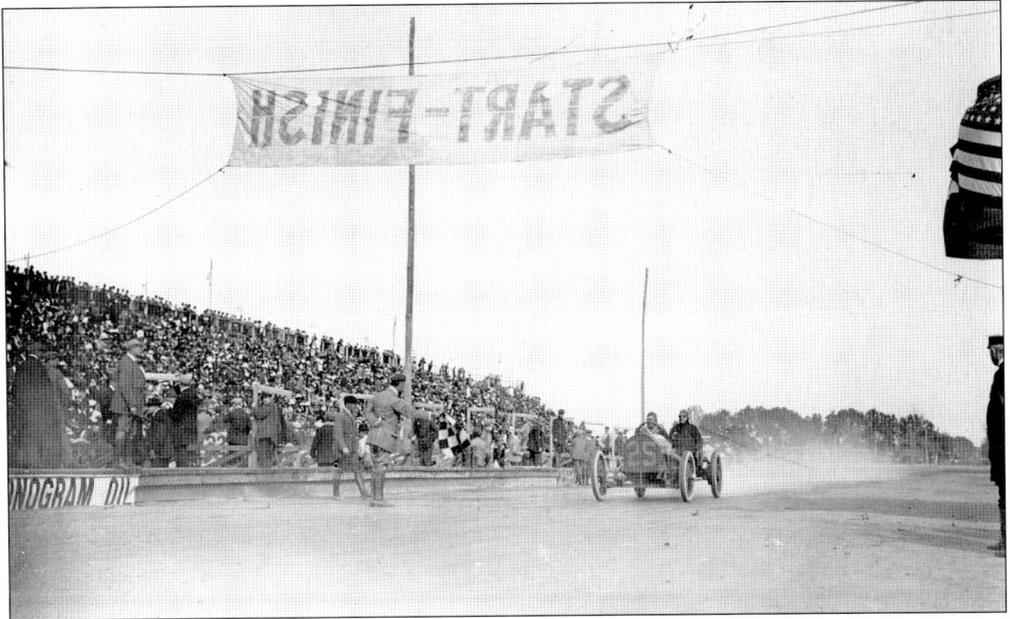

Nikrent crossed the finish line in third place in the Savannah Challenge Trophy Race, driving a Marmon. He completed the first lap in sixth place and never got higher than third place. He took possession of third place in the last lap. His time was 2 hours, 24 minutes, and 42 seconds. Nikrent was the last driver to complete the race. Joe Dawson had been in Nikrent's car when it was involved in a wreck during the practice round, and Dawson was thrown clear of the spinning car and run over by Nikrent. Dawson was so severely injured that he was unable to race in any of the 1911 events.

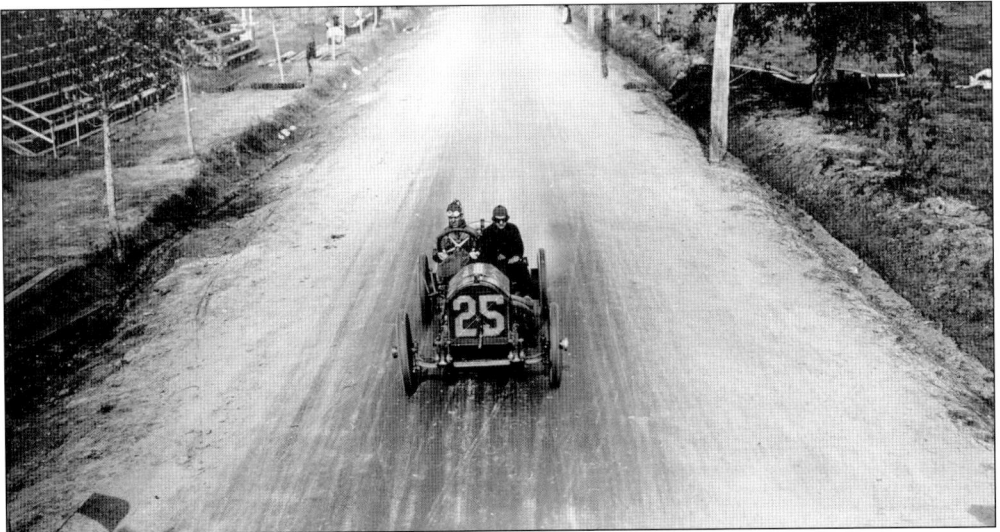

Pictured here is a Mercer driven by Hughie Hughes in the Savannah Challenge Trophy Race. Hughes completed the race, with an average speed of 70 miles per hour, in 3 hours, 15 minutes, and 37 seconds. He completed the first lap in fourth place, and by the end of the fifth lap he was in first. He would hold the first position for the remainder of the race. Hughes was unable to bask in the glory of his win very long as he was scheduled to drive a Mercer in the Vanderbilt Cup Race immediately following his victory.

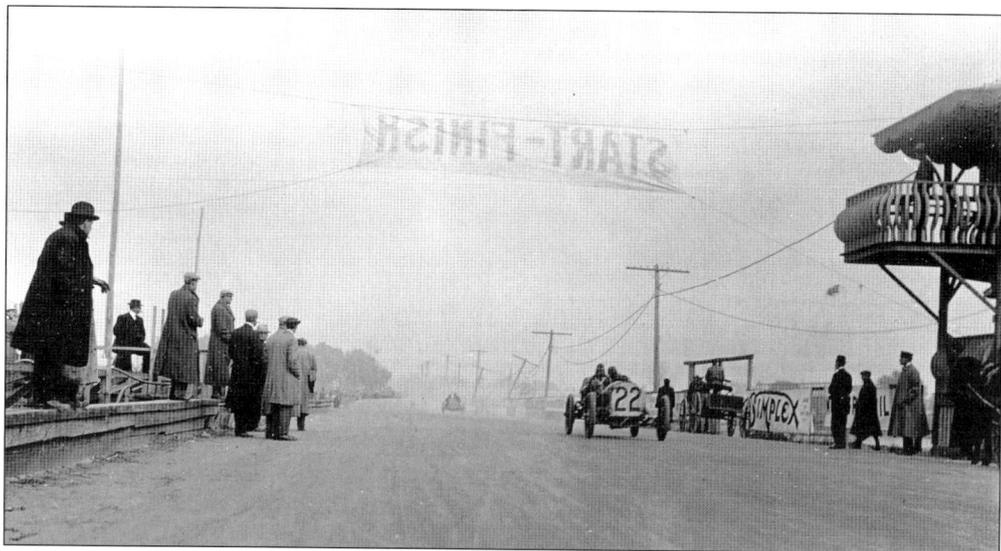

Only six cars entered the Tiedeman Trophy Race. There were supposed to be eight entries but two of the Ford entries failed to arrive for the start. The drivers were to go 171.40 miles. This was 10 laps on the 17.14 mile course. The favorites seemed to be anyone driving for the Ford or Abbott-Detroit teams. Pictured here is the car driven by Mortimer Roberts. These cars were new to the races and were considered the fastest of the light cars.

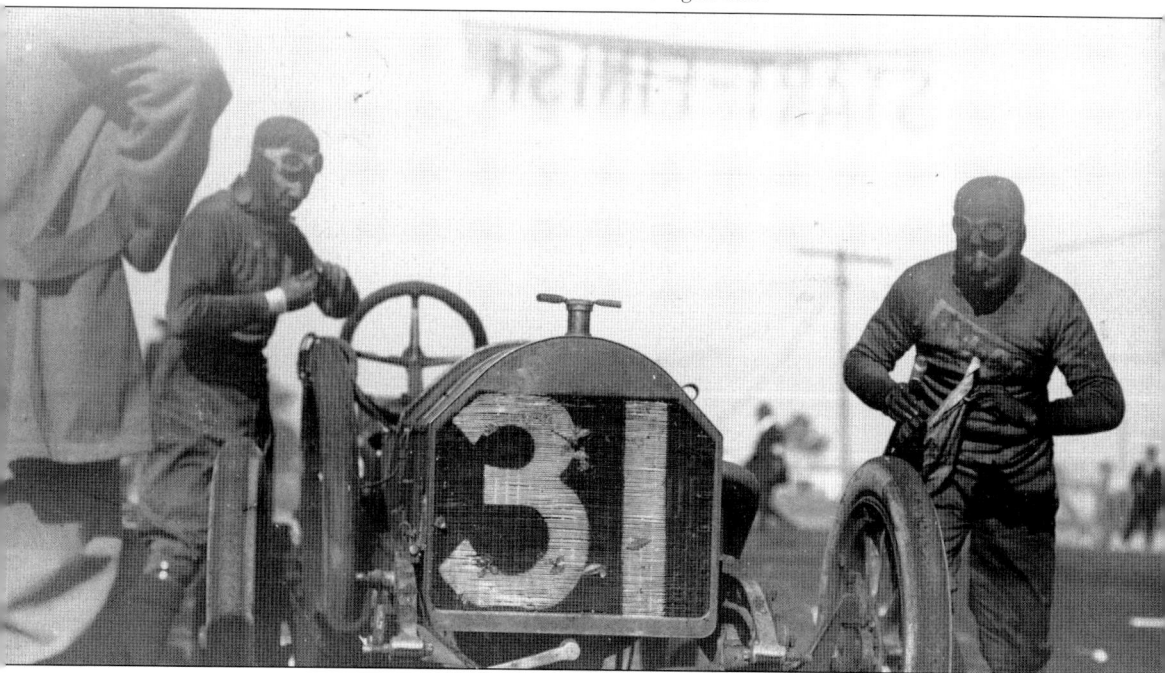

The two Abbott-Detroit cars did not complete the race. The first to fall out of the race was driven by Hartman, and it blew two cylinders in the second lap. He had been third at the completion of the first lap. The other Abbott-Detroit, driven by Roberts and pictured here coming onto Estill Avenue, completed laps one through six in first place and then in the seventh lap broke a camshaft. At the completion of the sixth lap, Roberts had a seven-minute lead over the eventual winner.

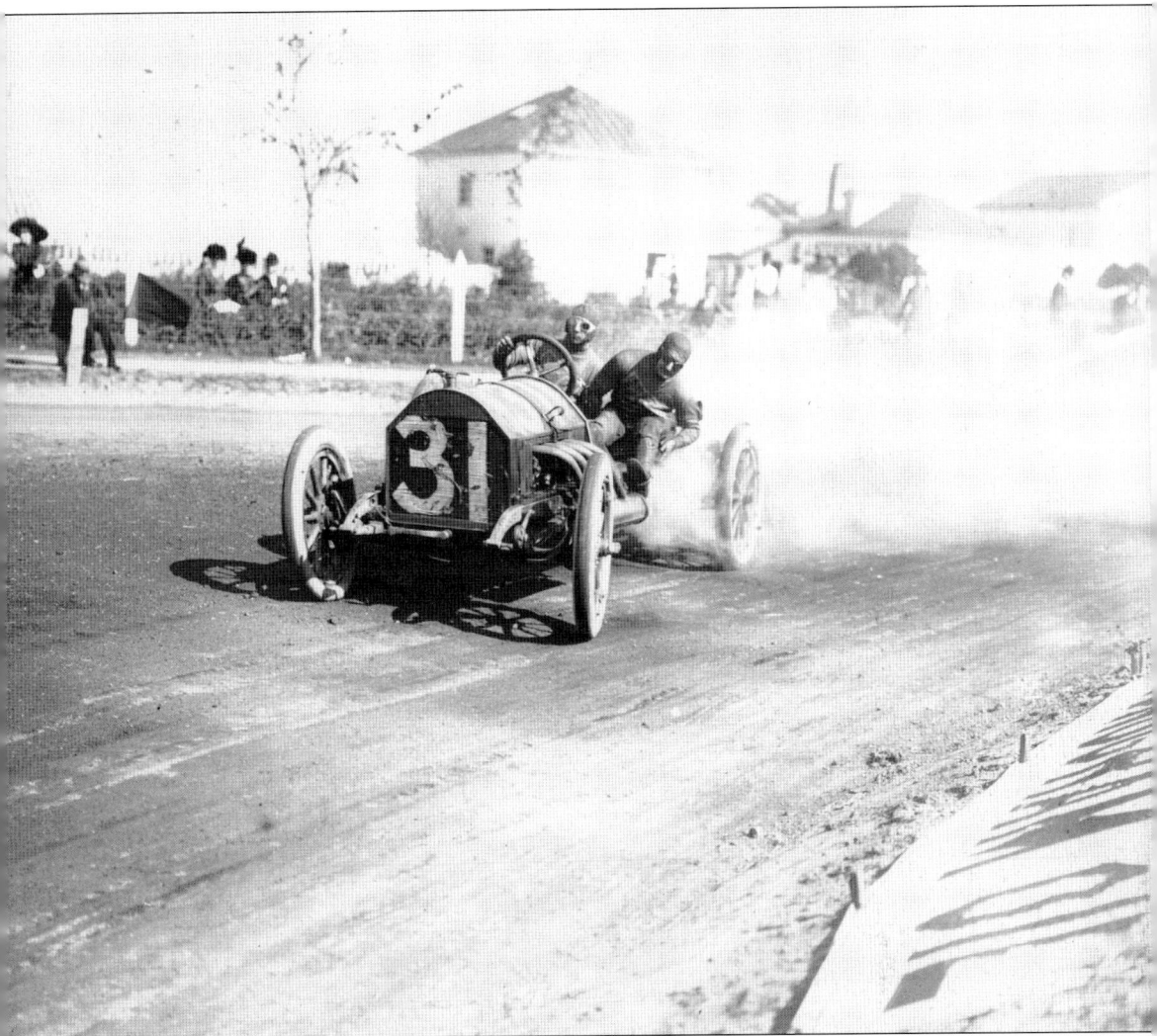

The winner of the Tiedeman Trophy Race was Frank Witt, driving an EMF and averaging 58.10 miles per hour. He completed the course in 2 hours, 56 minutes, and 23 seconds. The crowd was thoroughly amused by the Ford entry. This car finished in fourth place and drove a good portion of the race with a radiator leak. The driver would pull over to add more water and then, much to the amusement of the spectators, would resume the race in a cloud of steam.

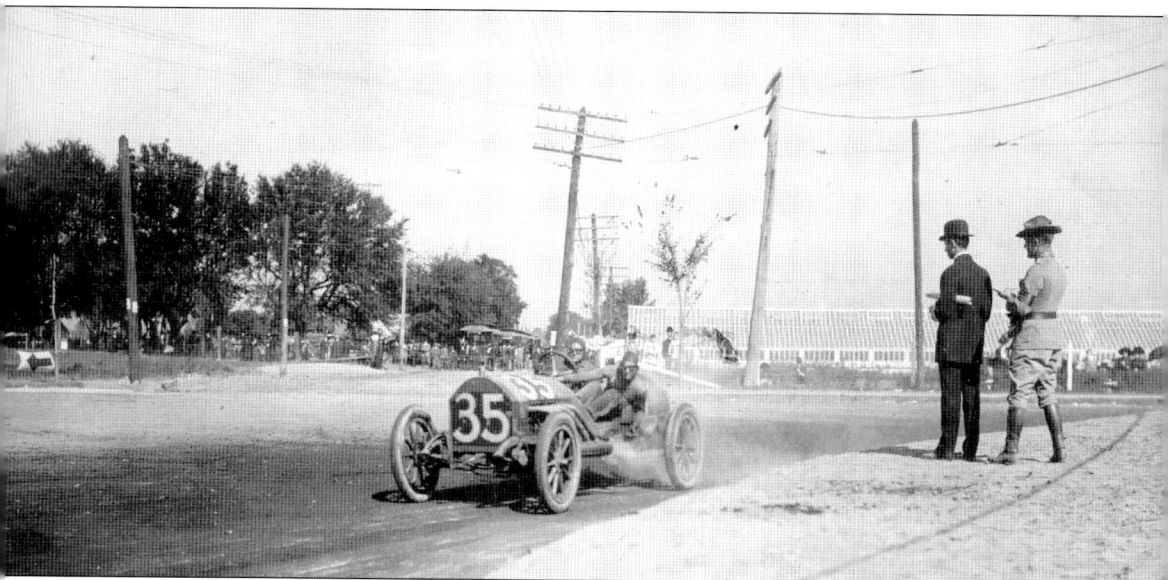

Pictured here is Frank Witt crossing the finish line and winning the Tiedeman Trophy Race. He ran a very consistent race and was either in first or second place at the end of every lap. He was in second place and seven minutes behind Mortimer Roberts in the Abbott-Detroit when Roberts left the race. Witt took over first and never looked back. He won the race over Evans by four minutes.

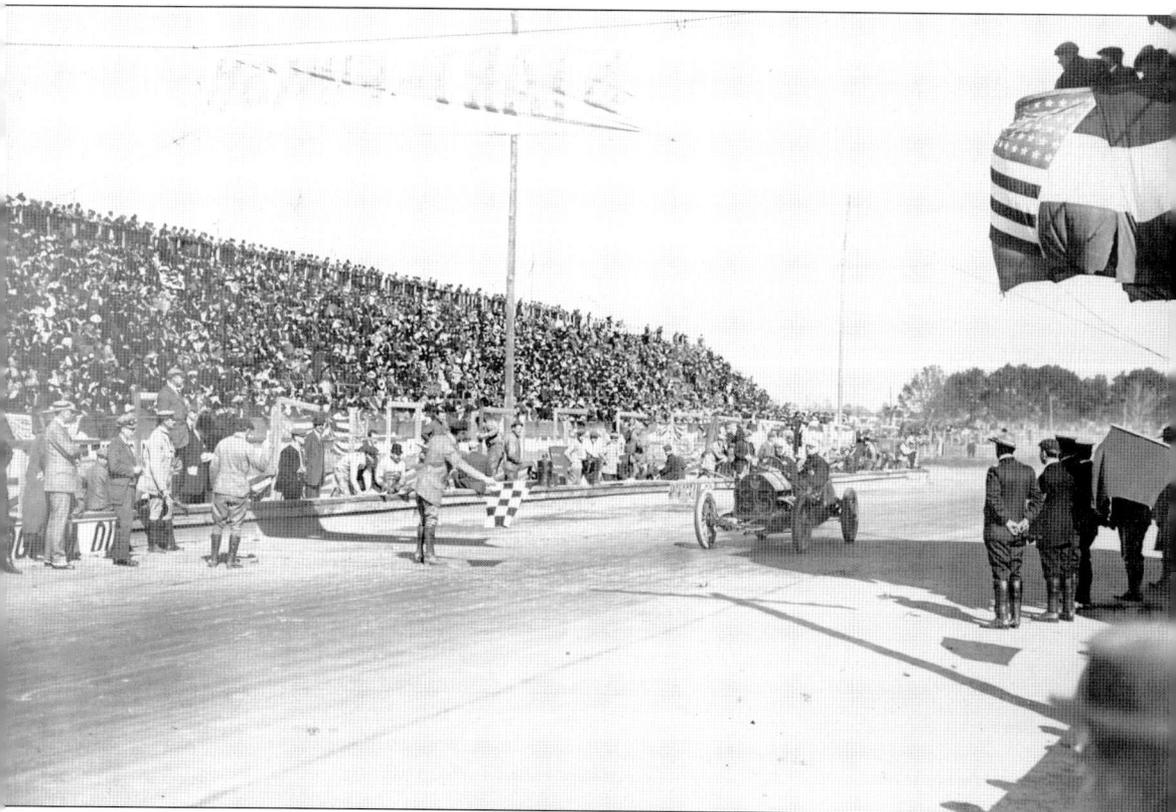

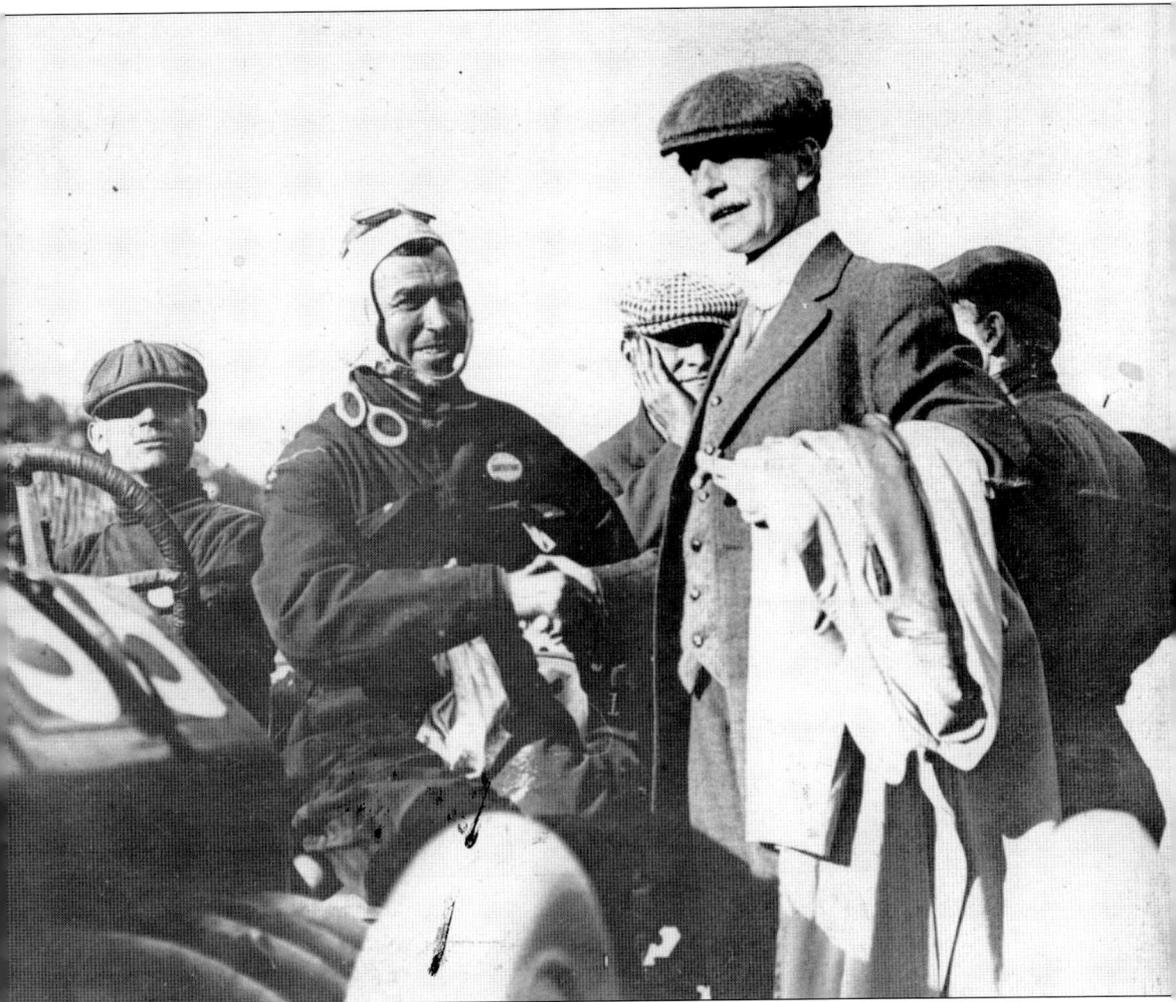

Frank Witt is being congratulated by George Tiedeman after winning the Tiedeman Trophy Cup. Had it not been for the misfortunes of the two Abbott-Detroit entries, Witt probably would not have been victorious. At the completion of the first lap he was 1 minute and 40 seconds behind Mortimer Roberts and 1 second ahead of Hartman. Once the two Abbott-Detroit cars were out of the race, it was Witt's to lose. The EMF team had three cars entered in the Tiedeman Trophy Race, and they finished first, second, and third.

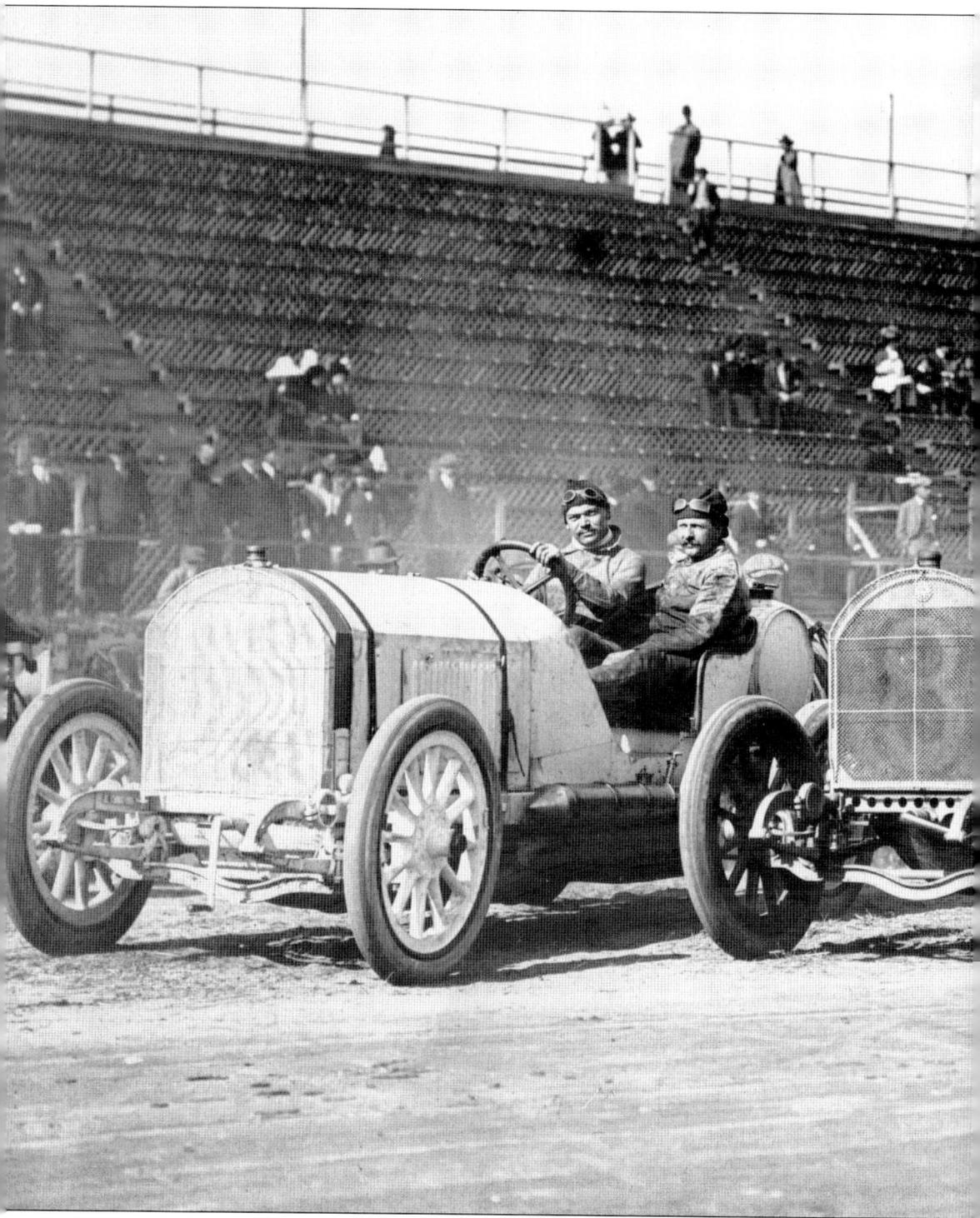

Prior to 1911, the Vanderbilt Cup had been held on Long Island. The first Vanderbilt Cup race was October 8, 1904, and was won by George Heath. Vanderbilt felt it was unsafe to run the races on Long Island, as there was no protection for the drivers and the spectators. The

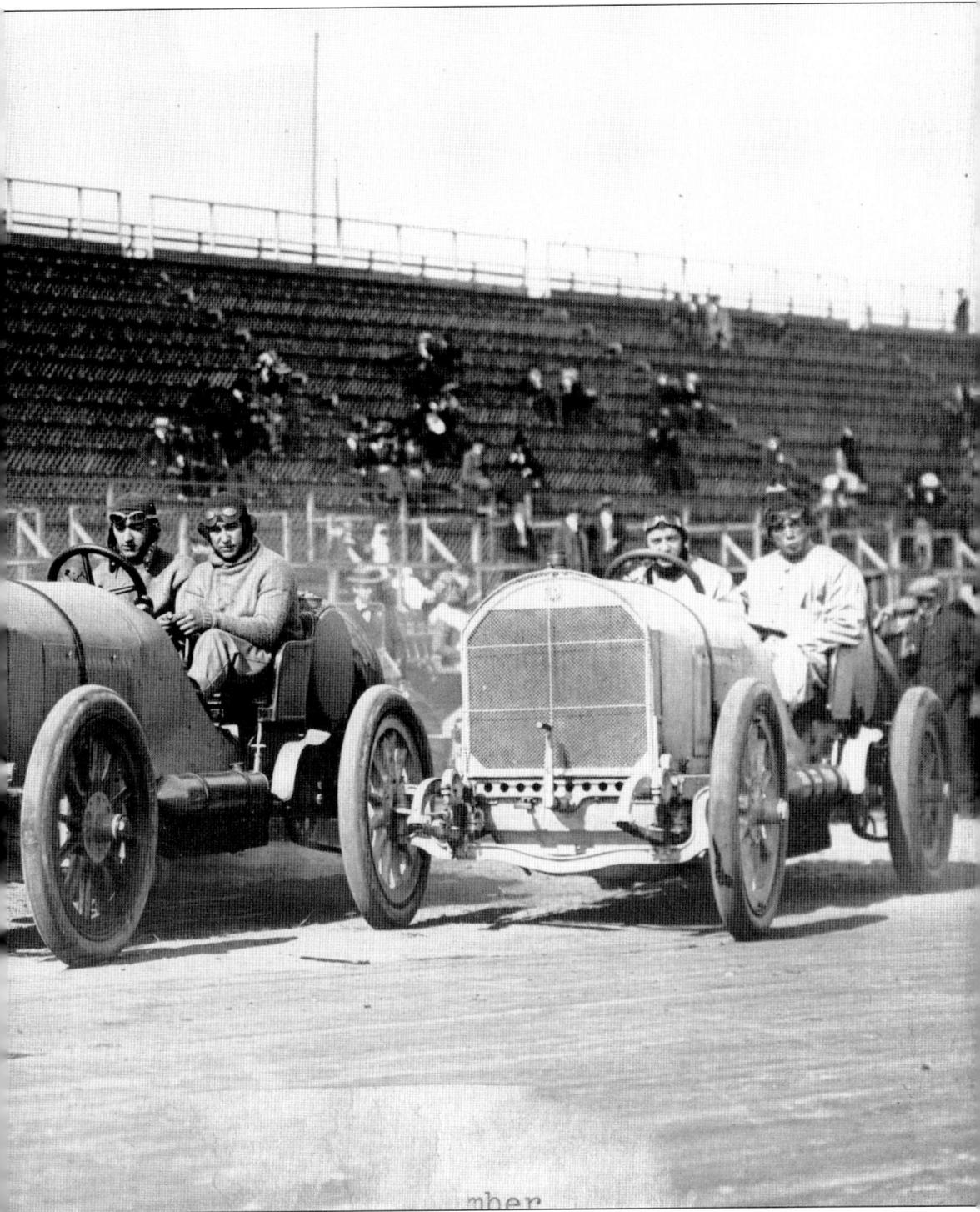

governor of New York refused to help and Vanderbilt frequently canceled the race. He was looking for a new site and finally relented to the requests of the Savannah Automobile Club and ran the race in Savannah in 1911.

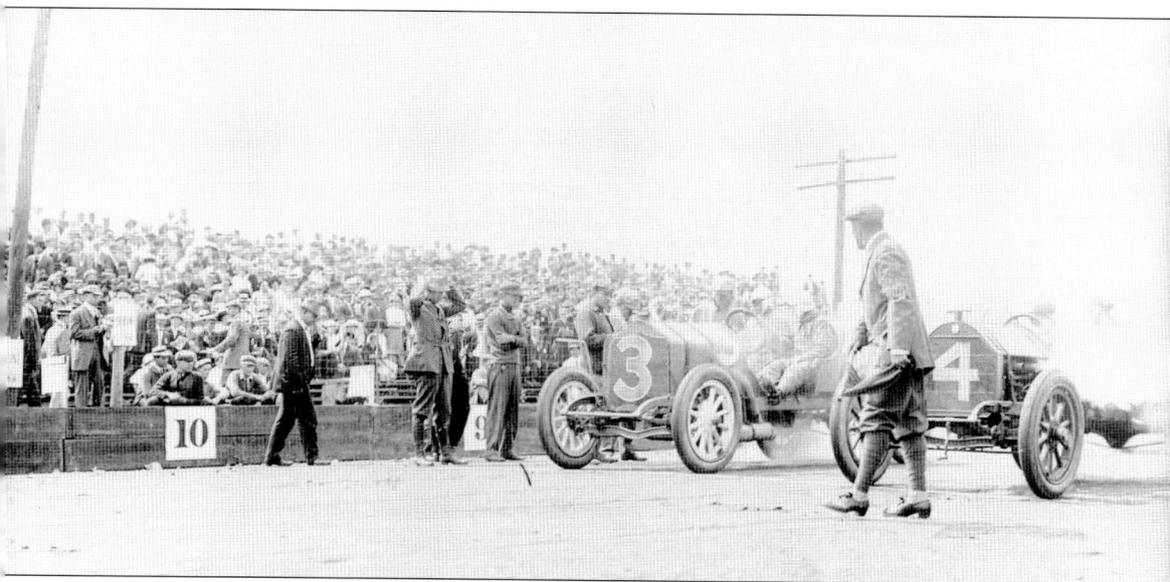

Sitting at the starting line are the Mercedes driven by Wishart (#4) and the Pope Hummer driven by Disbrow (#3). Both cars completed the Vanderbilt Cup race, with Wishart finishing third and Disbrow finishing sixth. The race started with 14 entries and only 6 cars completed the course.

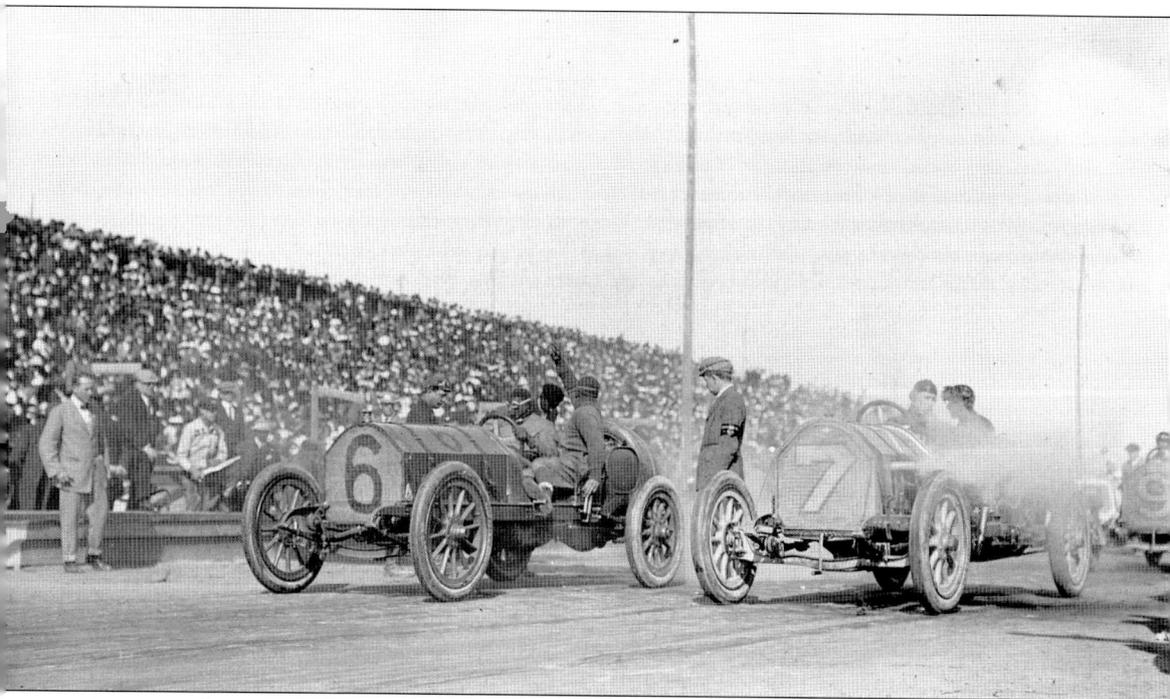

Sitting at the starting line are Hughie Hughes in the Mercer (#6) and Limberg in the Abbott-Detroit. Unfortunately, neither one of these cars completed the race. Hughes was out of the race before the end of the fourth lap with a burst water connection and Limberg recovered from early troubles but was still on the course when the race ended. The start/finish line was on Waters Avenue at Forty-Sixth Street, just as it had been in 1910.

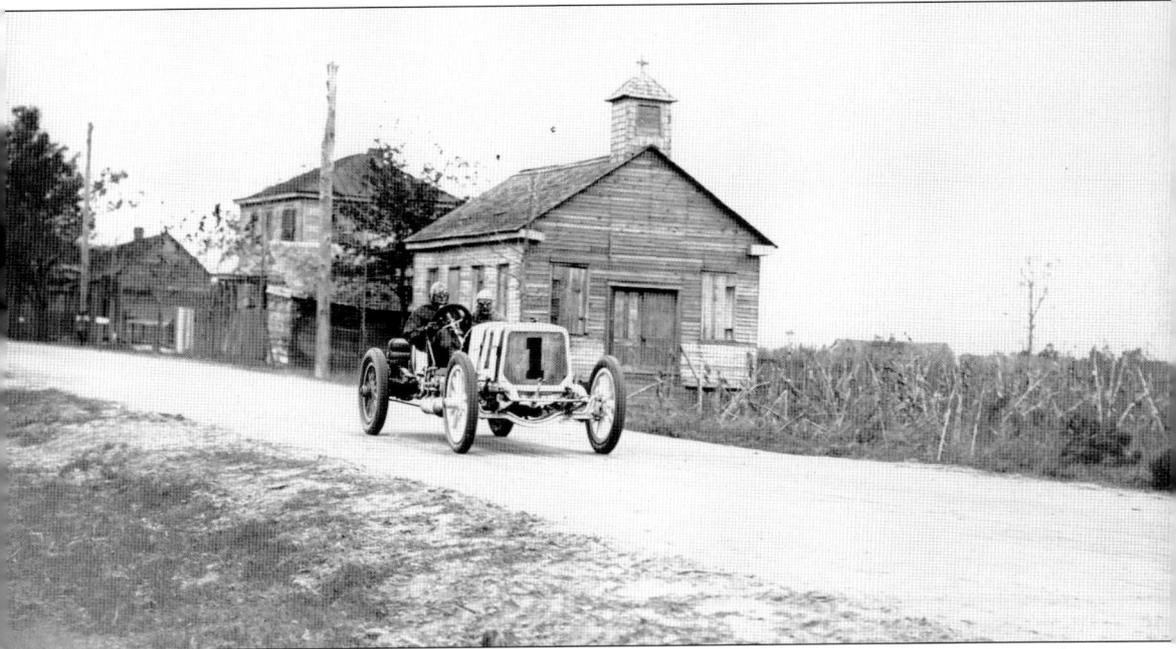

Pictured here is one of the two Lozier entries in the Vanderbilt Cup. This car was driven by Grant and finished the race in fourth place. It made an impressive run, as it had fallen to tenth during the second and third laps but climbed steadily to win fourth by four minutes over one of the "supercharged" Fiats.

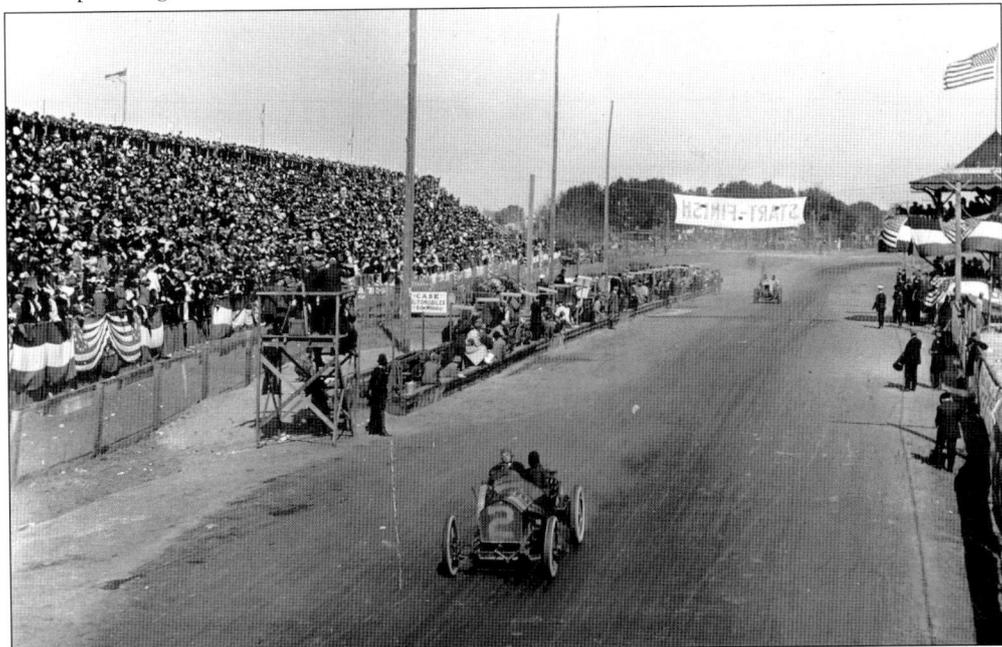

The number 2 car, driven by Burman and owned by the Marmon team, started slow but by the third lap had made up a tremendous amount of time. At the completion of the seventh lap the Marmon was in second place, only 1 minute and 30 seconds behind the leader. In the eighth lap a stone was thrown by the tire of another car and broke the gasoline tank connection.

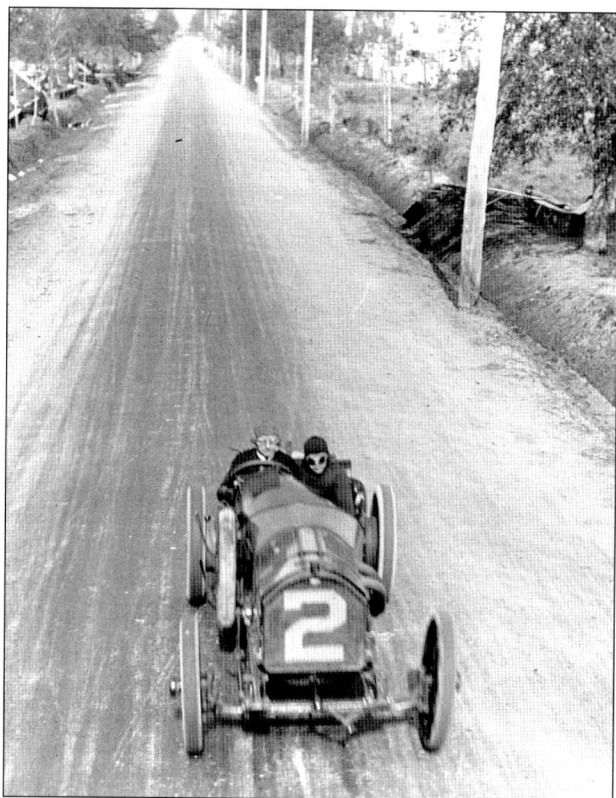

Bob Burman tests the course during the practice rounds in his Marmon. Within days the track would be lined with eager fans clamoring to see the cars competing in the Vanderbilt Cup Race.

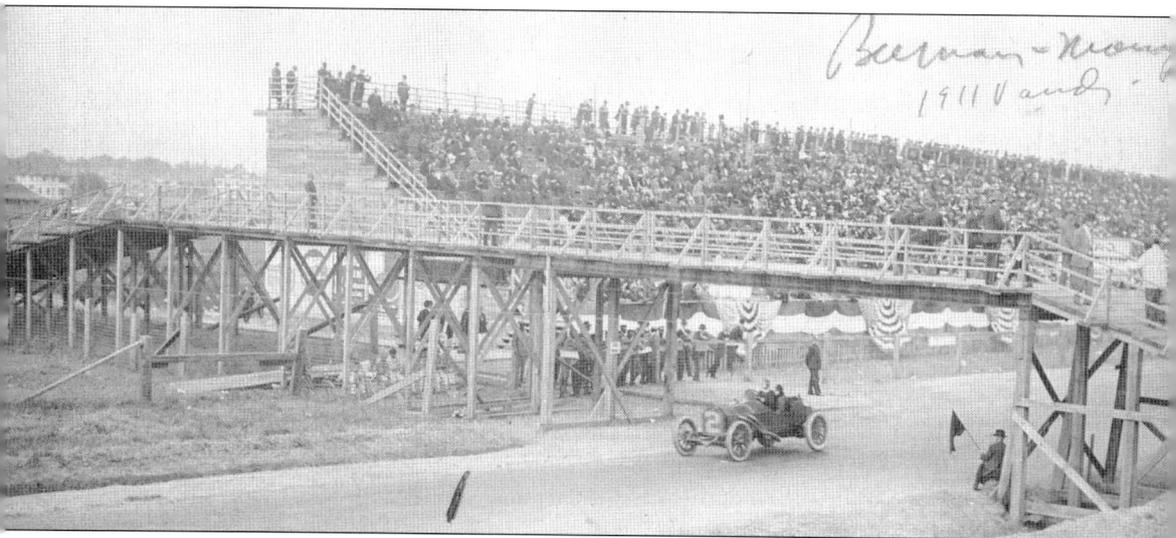

The same form of track protection and signaling were used in the 1911 races as had been used in previous years. The pedestrian crosswalk was to allow for safe crossing of the road. In 1910 and 1911, the grandstands were on both sides of Waters Avenue. This allowed for more spectators at the start/finish line. The crossover also allowed for the numerous photographers to obtain straight-on photographs of the racers coming down the straightaway and crossing the finish line.

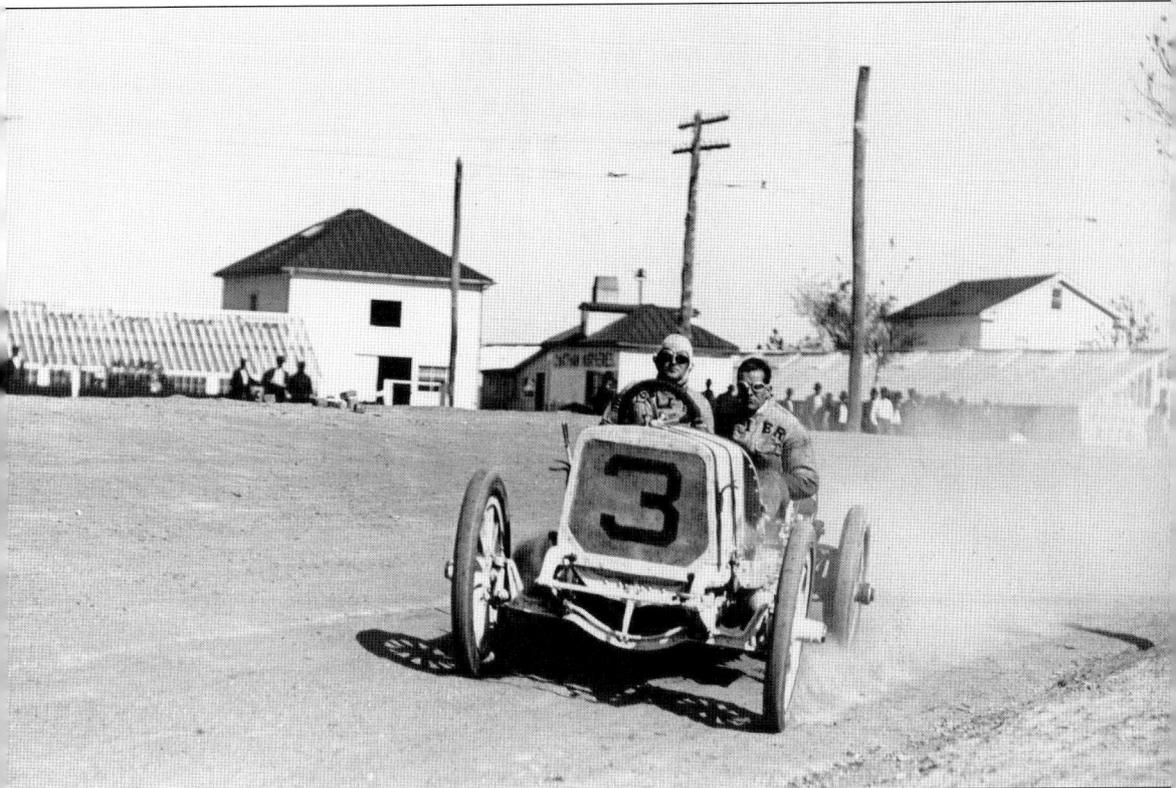

Pictured here is the Pope Hummer car driven by Disbrow. He is driving during the practice laps and entering Estill Avenue. During the actual race, most of the drivers were protective masks over their faces. However, during the practice laps they usually kept them off in the hopes of having their photographs taken.

As before, the cars were sent off of the starting line in 30-second intervals. Fred Wagner was once again the official starter. The fans knew that they were in for an exciting race when the last car to start was out of sight and they could hear the roar of the first car approaching the grandstand.

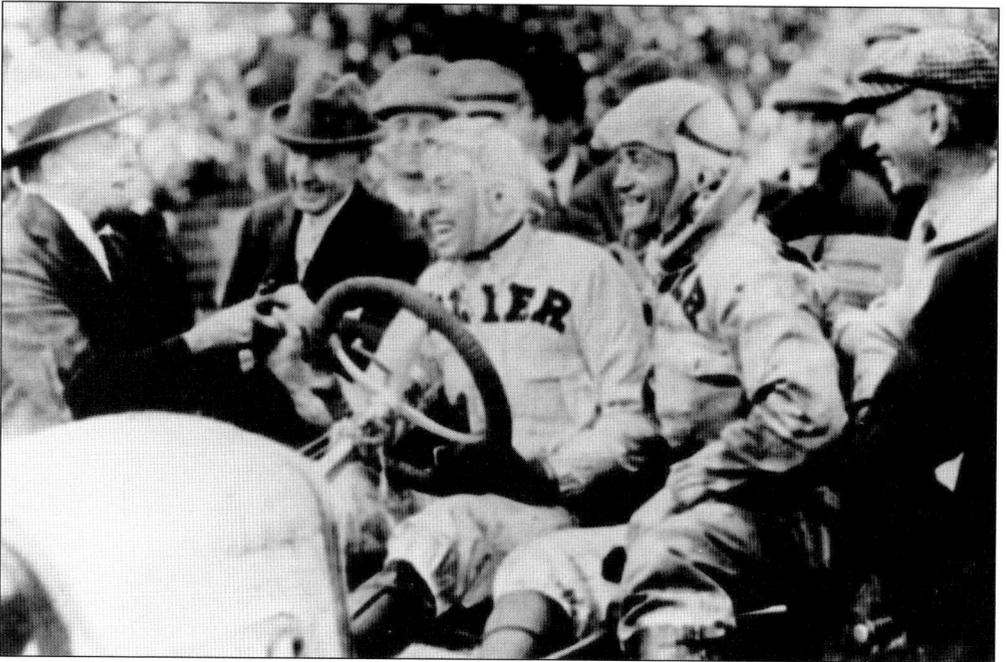

The Vanderbilt Cup race started with two from the Lozier team, two from Mercedes, three from Fiat, one from Pope Hummer, two from Abbott-Detroit, two from Marmon, and one each from Mercer and Jackson. The Mercedes team was the only team with all cars completing the Vanderbilt Cup.

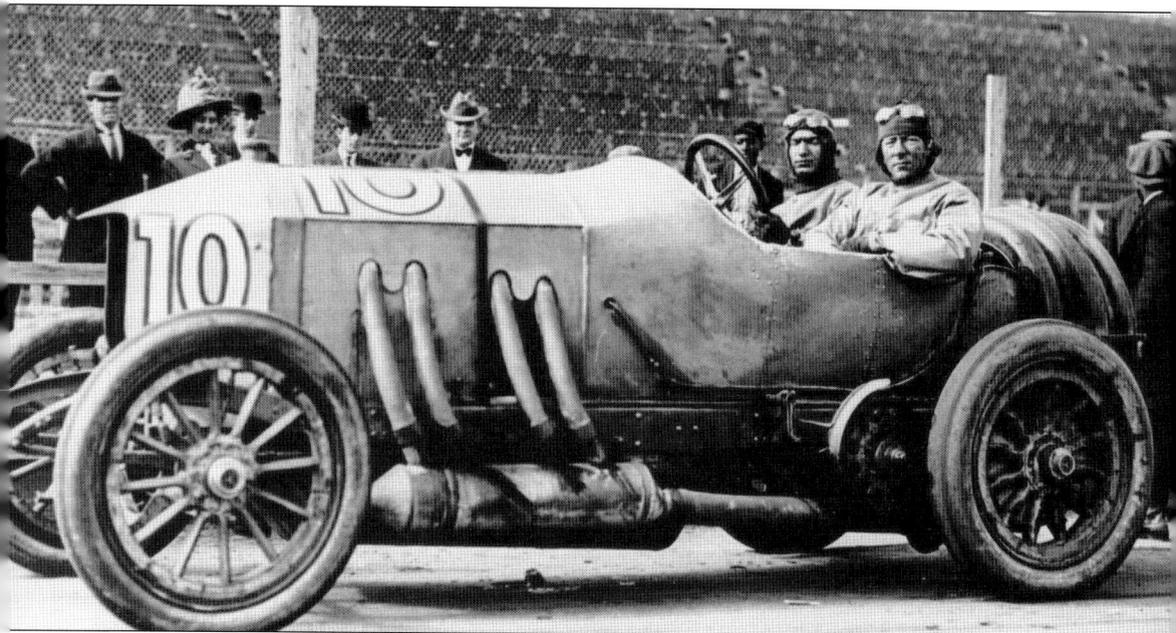

Pictured here is the Mercedes driven by DePalma. This car finished second in the Vanderbilt Cup, 2 minutes and 11 seconds behind the winner. DePalma led the race through the first four laps but suffered some delays on the fifth lap and fell to second. By the end of the sixth lap he was in third and remained there until climbing into the second position in the 11th lap.

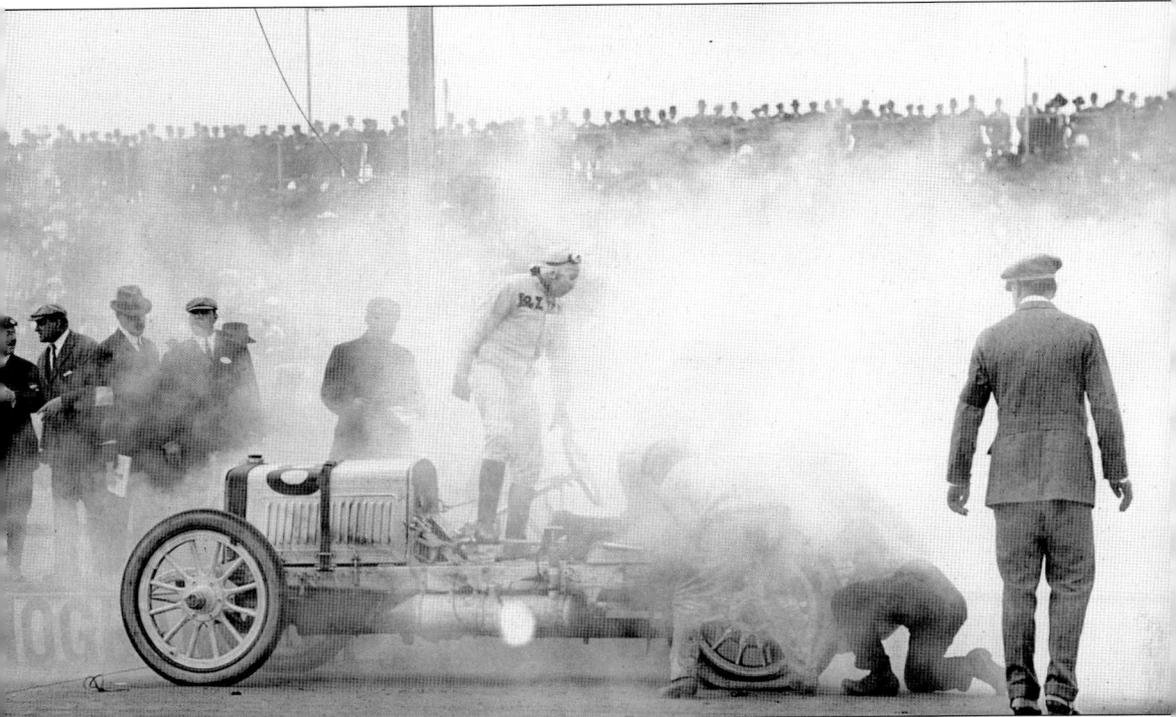

Pictured here is the Lozier car driven by Mulford as it sits in the pits in front of the grandstand. The situation looks more serious than it is, as Mulford stopped for 1 minute and 6 seconds between laps 12 and 13 to change a tire and add fuel and oil. Mulford's lead was substantial enough that he was not passed while in the pits.

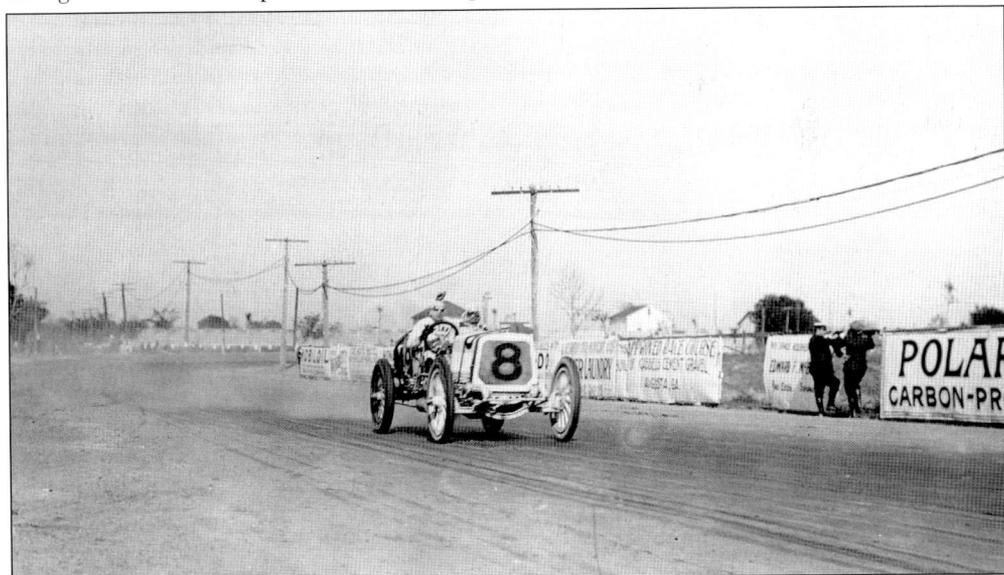

Mulford was leading the Mercedes by 3 minutes and 47 seconds at the end of the 13th lap. However, DePalma, in the Mercedes, was flying and was cutting into the lead. In the 15th lap Mulford stopped on the course to change a tire and he also stopped as he passed the pits to put another tire on the rack of his car. By this time his lead was cut to 2 minutes and 33 seconds.

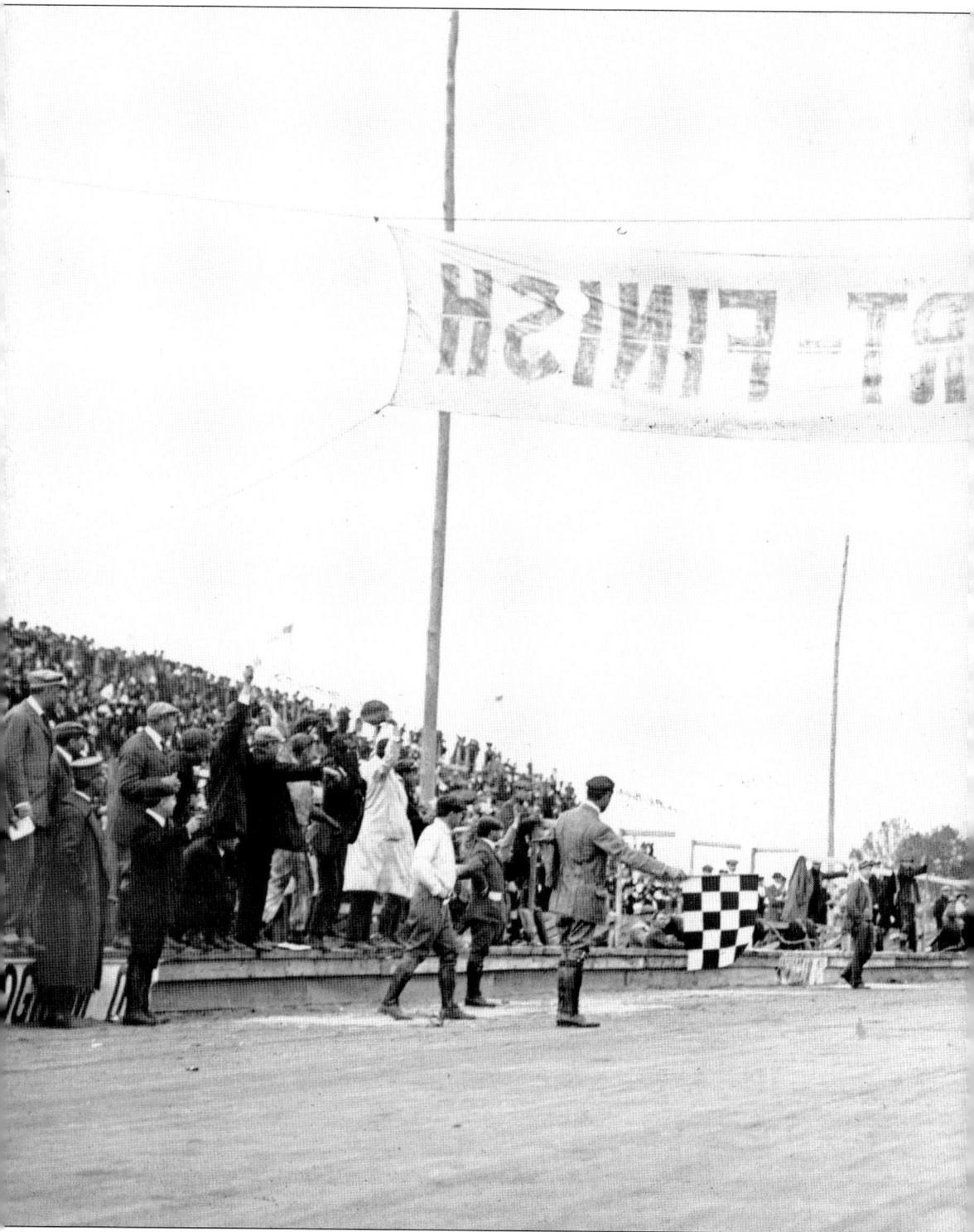

Everyone wondered if Mulford would have to stop again because the spectators thought that two stops close together meant a more serious problem. He was able to make it to the green flag

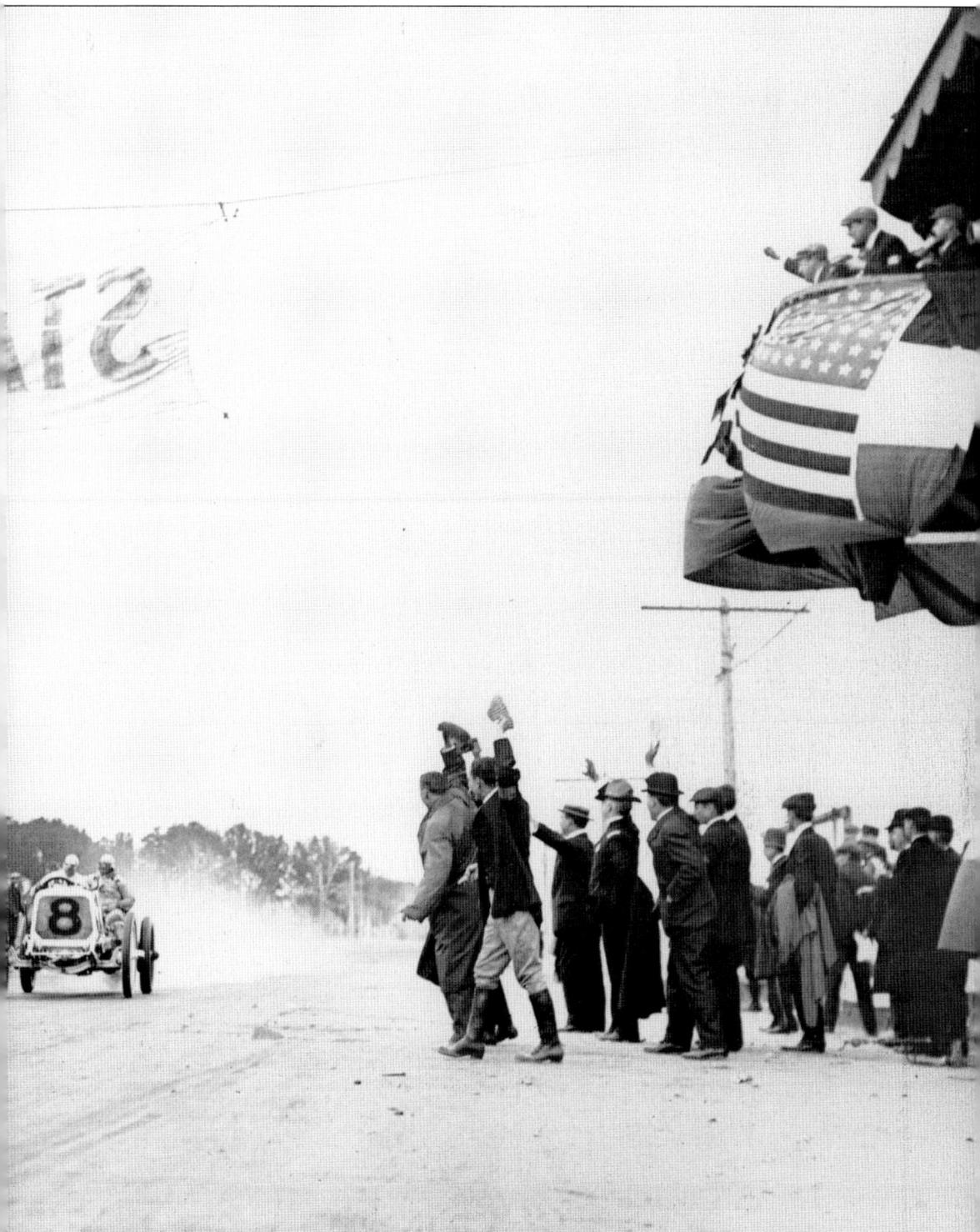

as he passed the start/finish line, telling him that he had only one lap remaining. Mulford was determined to win the Cup and actually added four seconds to his lead in the final lap.

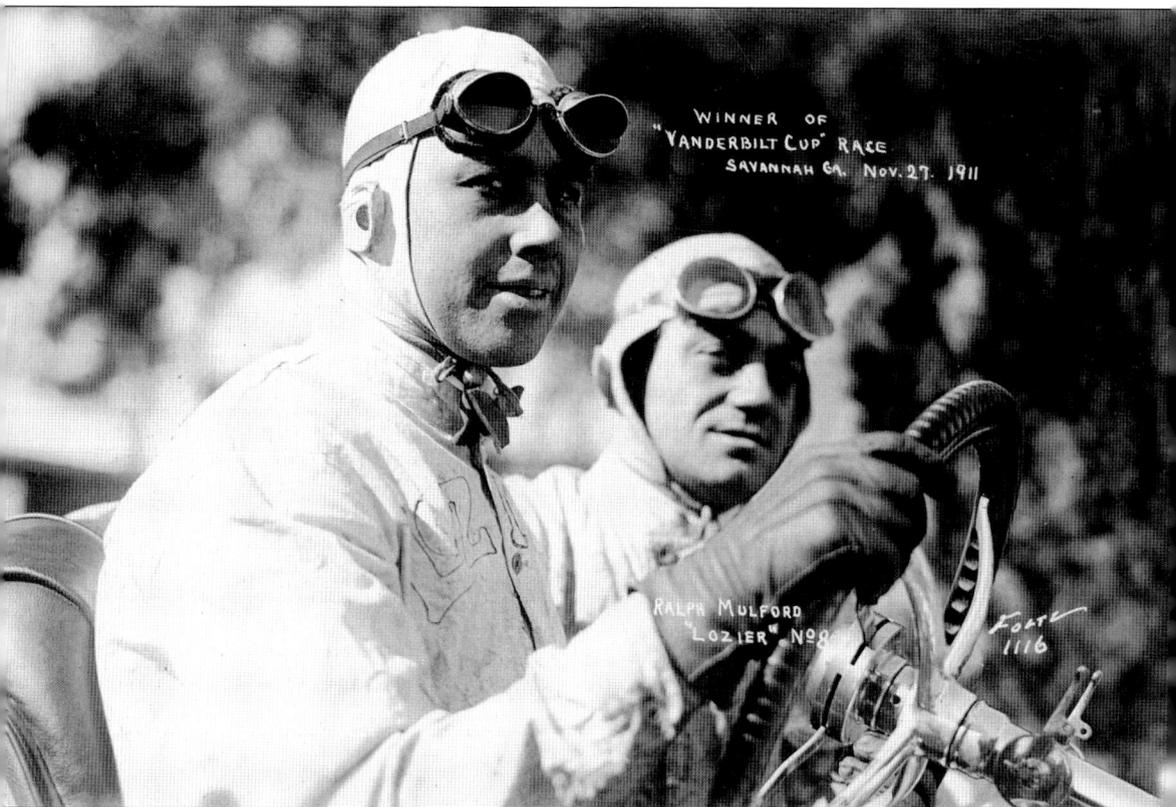

WINNER OF
"VANDERBILT CUP" RACE
SAVANNAH GA. NOV. 27. 1911

RALPH MULFORD
"LOZIER" No 8

Foote
1116

Mulford was an unexpected winner. He was swarmed over by fans after he crossed the finish line. The Savannah races were truly exciting. Mulford gave his mechanic, Billy Chandler, much of the credit for the win. Not only did he say that the car ran perfectly, but he also acknowledged the two stops that they made and the flawless speed with which Chandler worked. Mulford had set a record for the Vanderbilt Cup, averaging 74.07 miles per hour. Mulford was entered in the same car in the Grand Prize Race just three days away. Could the American driver do it again?

Unloaded Cars
for
Grand Prize Race

The 1911 Grand Prize Race started with 16 cars and proved to be just as exciting as the two previous Grand Prize Races. Several cars had the opportunity to win in the final laps, and in some cases the spectators had to wait for the official announcement before knowing the winner. Only five cars completed this race.

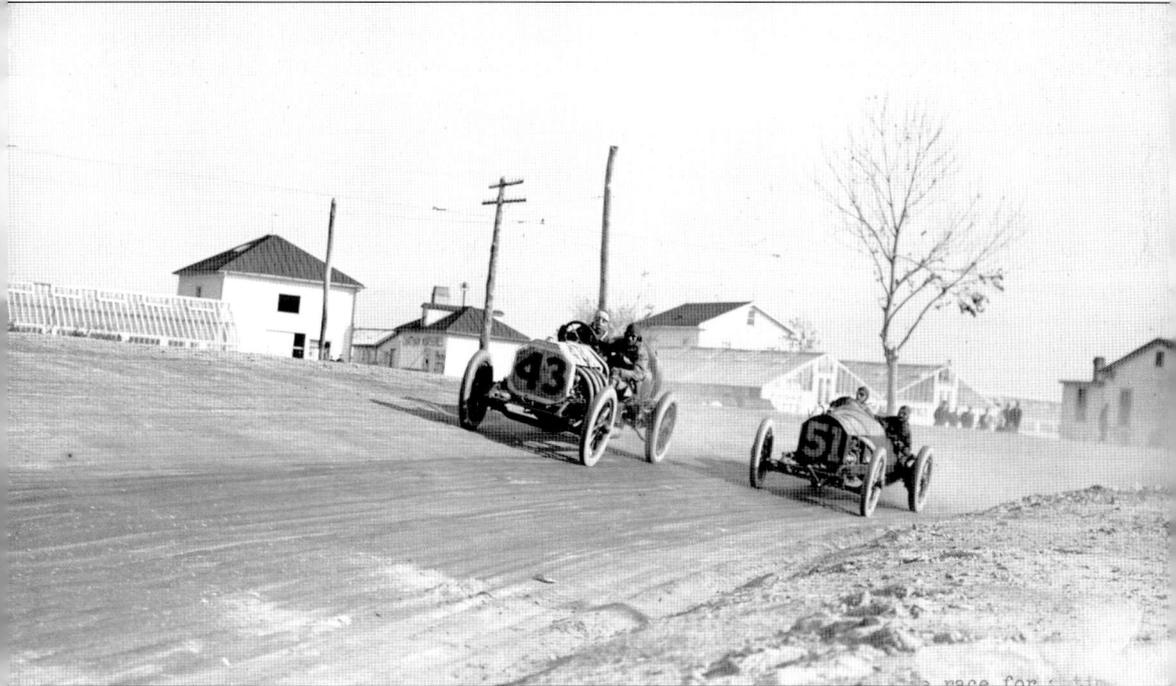

Patchke, driving the Marmon (#51), and Basle in the Buick-Hundred (#43) race around the curve approaching the straightaway on Estill Avenue. Neither car finished the race. Patchke turned his car over on Montgomery Crossroads in the 9th lap and Basle blew a cylinder in the 10th lap. Patchke was in first place when he rolled his car.

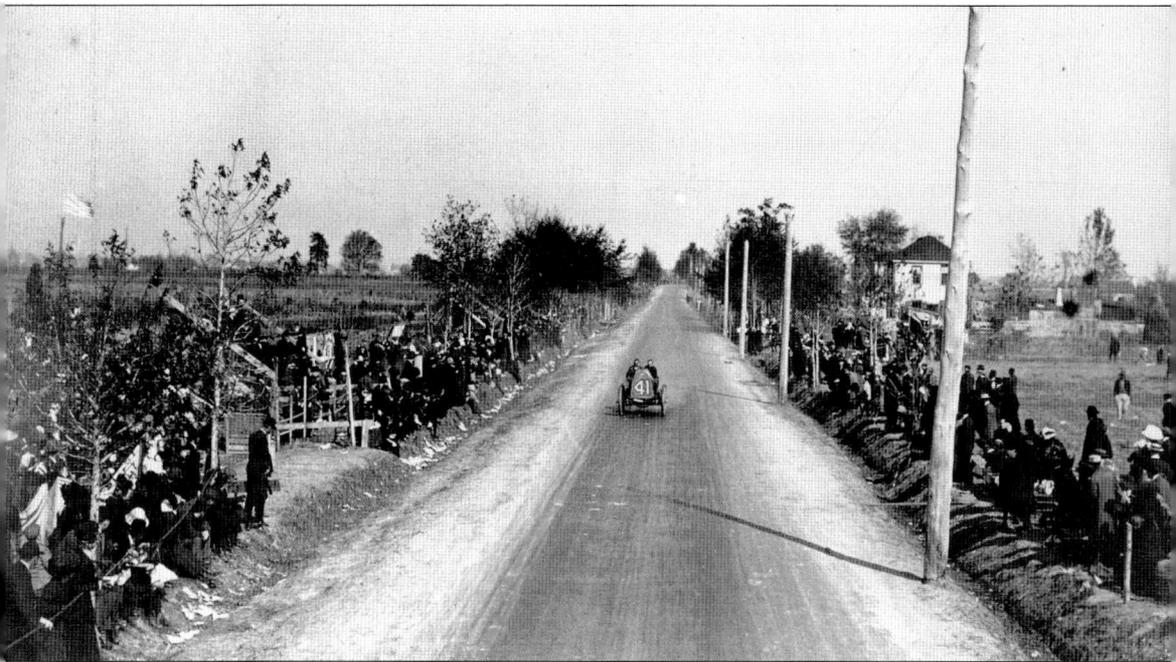

This photograph was taken from one of the pedestrian crosswalks. Approaching is Louis Wagner in a Fiat. Wagner damaged his steering gear in the 15th lap and was forced out of the race. At the time he was in second place, only 24 seconds behind the leader.

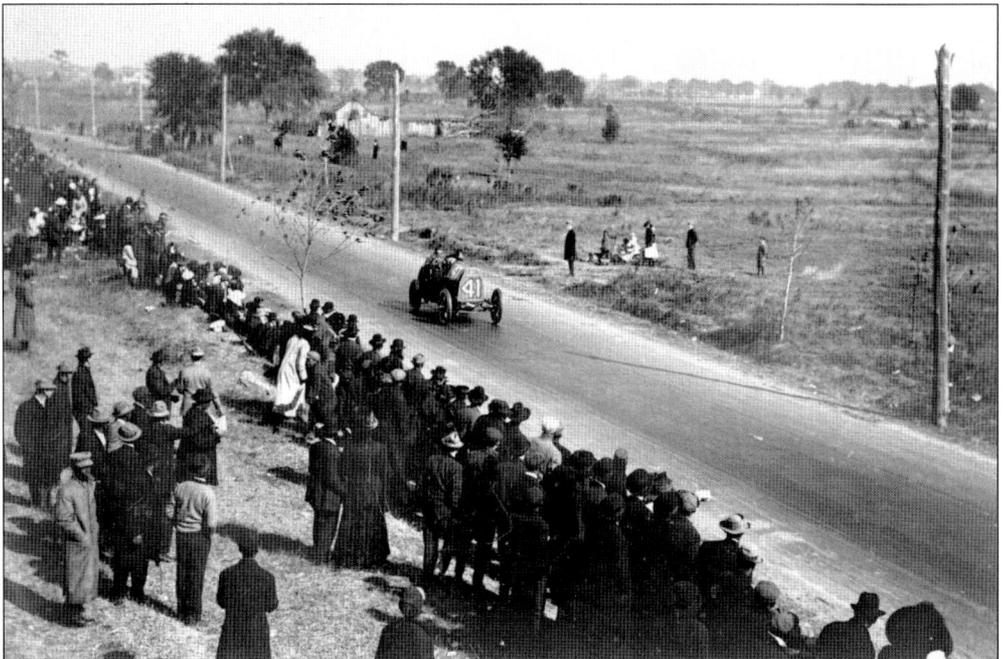

Pictured again along Estill Avenue is Wagner in the Fiat. He completed the first lap in fifth place and rapidly climbed towards the top before leaving the race for mechanical reasons. Wagner was a fan favorite, and most spectators did not realize that this was the last time he would race in Savannah.

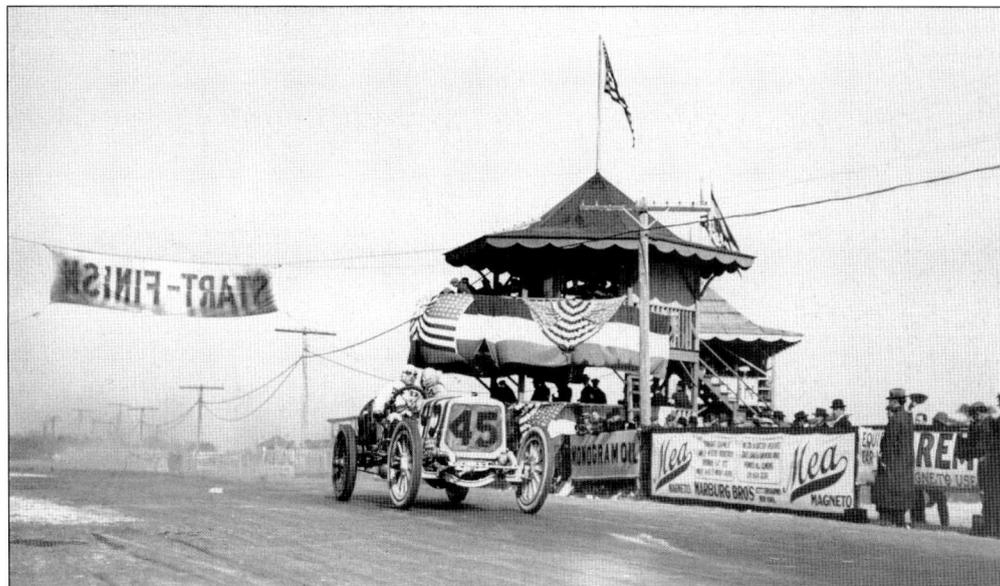

Passing the judges' stand in this picture is Mulford, driving the Lozier. Mulford had been the unexpected winner of the Vanderbilt Cup three days before. In the 23rd lap of the Grand Prize Race, Mulford's car suffered a broken steering mechanism. He had climbed to third from ninth place throughout the race. When Mulford was forced out of the race, he was only 32 seconds behind the second-place car and 1 minute and 14 seconds off the lead.

This photograph shows Victor Hemery during the practice days. He recorded fast laps during the practice rounds in the Fiat. Even though David Bruce-Brown had won the Grand Prize Race the year before, European drivers such as Wagner and Hemery were considered the favorites. Hemery had vowed to set a speed record during the race and he completed the fifth lap in 12 minutes and 36 seconds. This was a speed of 81.6 miles per hour, the fastest official lap ever made on this course, which would never again be challenged.

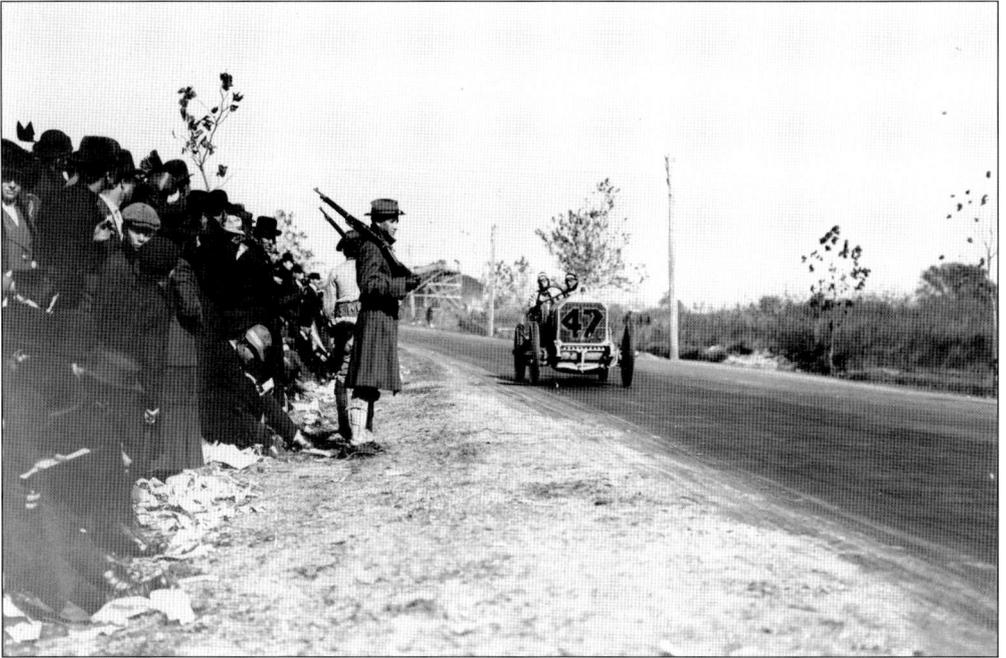

Pictured in both of these photos is the Benz car driven by Hearne. He put on quite a show for the fans as he completed the first lap in eighth place. He then climbed into first by the end of the fifth lap with a series of quick laps. He then fell to second, and at the completion of the 10th lap was back in first. He remained in first until the 20th lap when he fell to third. He jumped back into the mix and finished second, just 2 minutes and 13 seconds behind the winner.

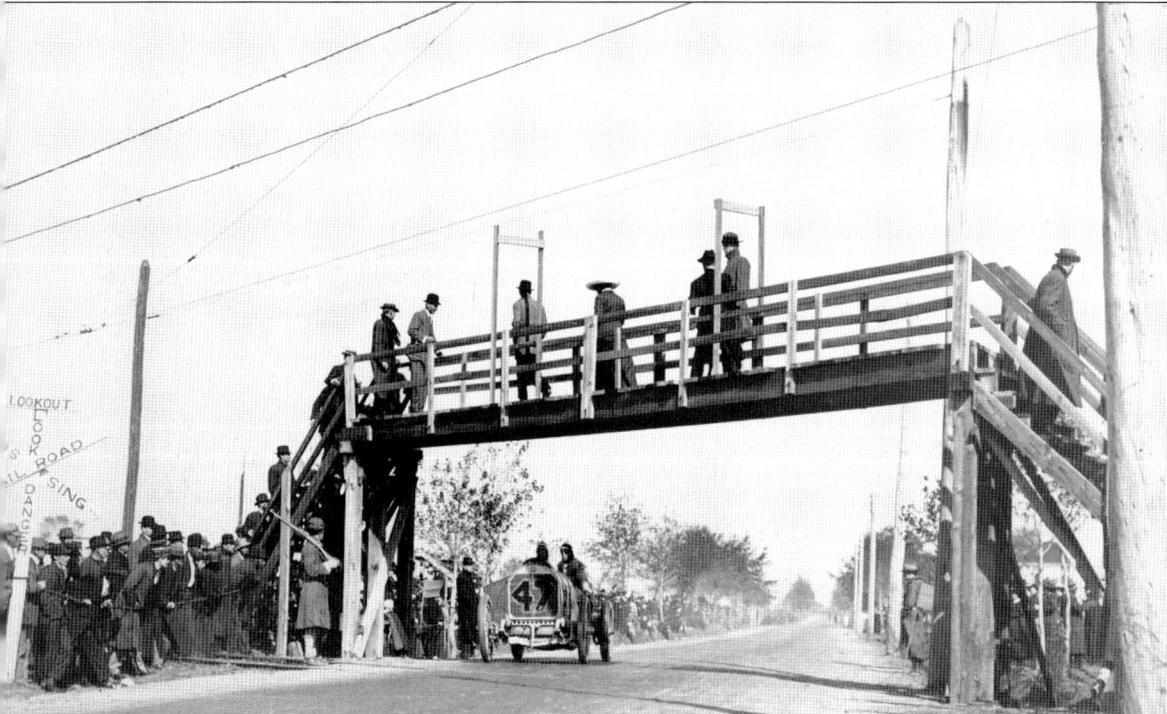

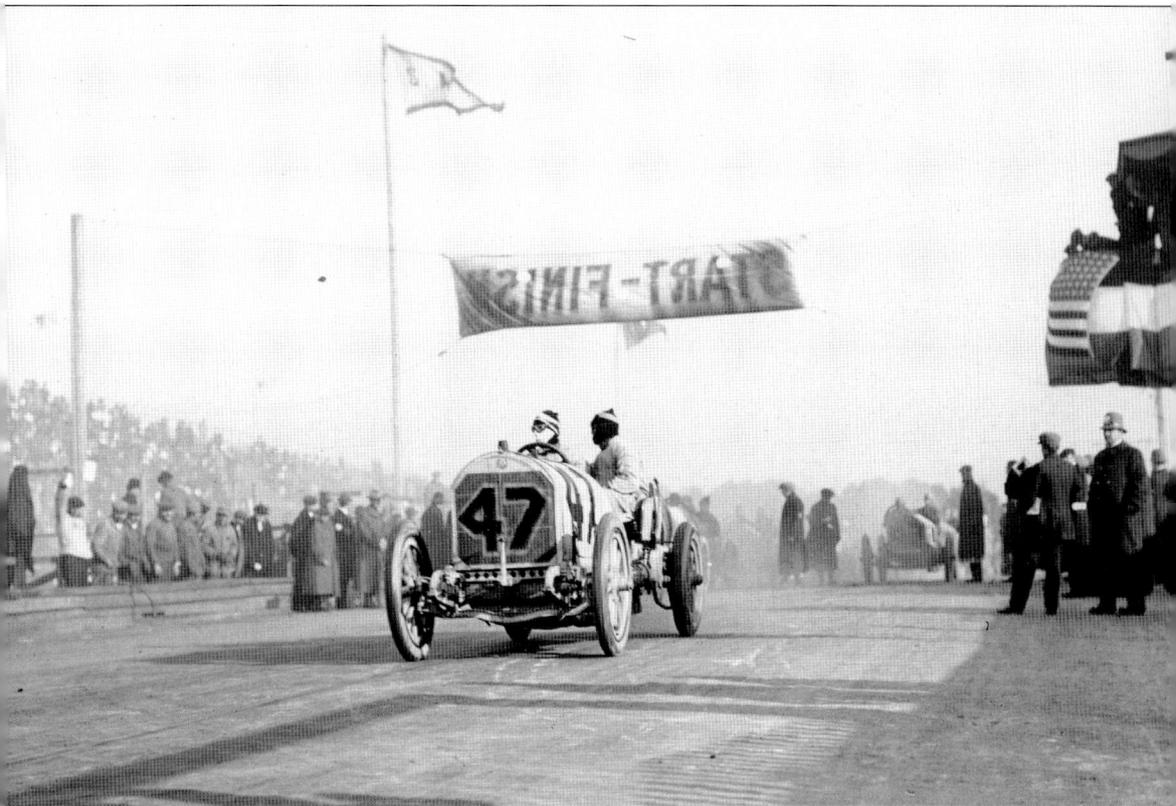

The top photograph shows Hearne in the Benz as he leaves the starting line. The bottom photograph is of Limberg in the Abbott-Detroit. Limberg did not complete the race, as he was still on the course when it ended. His lap times were much slower than the other racers. The bottom photograph provides a nice view of the pits in front of the grandstand. Also, in the center of the photograph is a stand for the Republic Film Company. It is currently unknown if this film footage still exists.

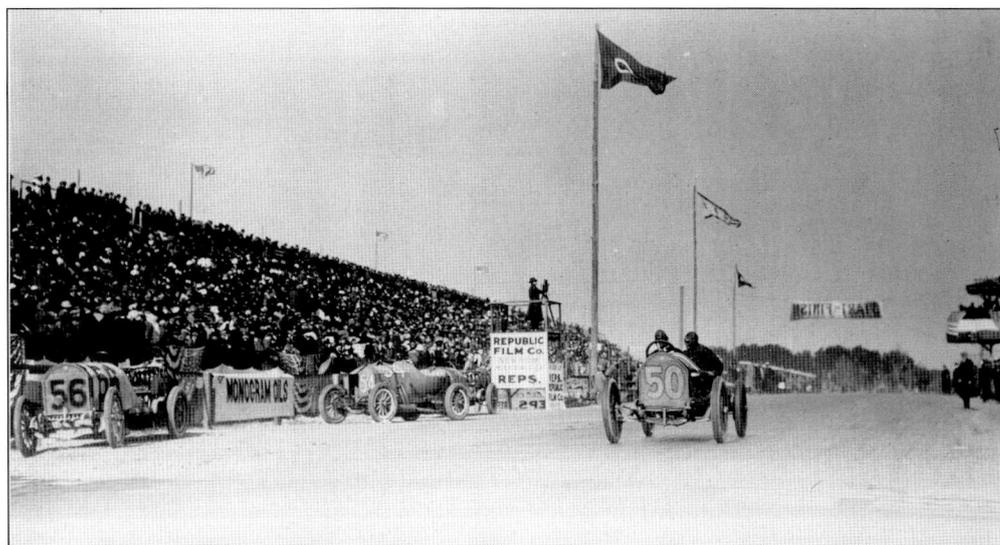

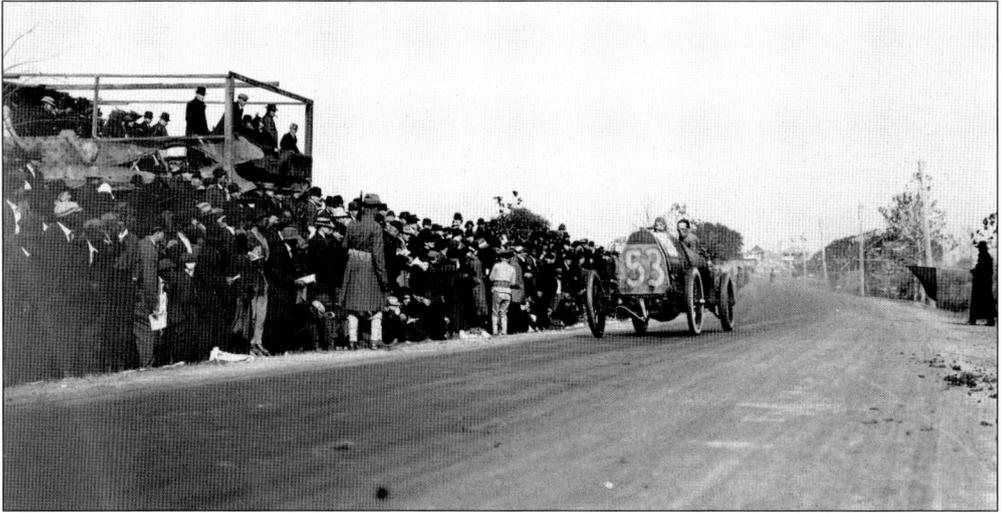

This photograph shows Bragg in one of the three Fiats entered in the race. Bragg finished fourth, a little over 17 minutes behind third. He had experienced trouble on the fourth lap and dropped to fifth place. Up to this point he had run the entire race in first. Fiat provided two of the top four finishers in the Grand Prize Race.

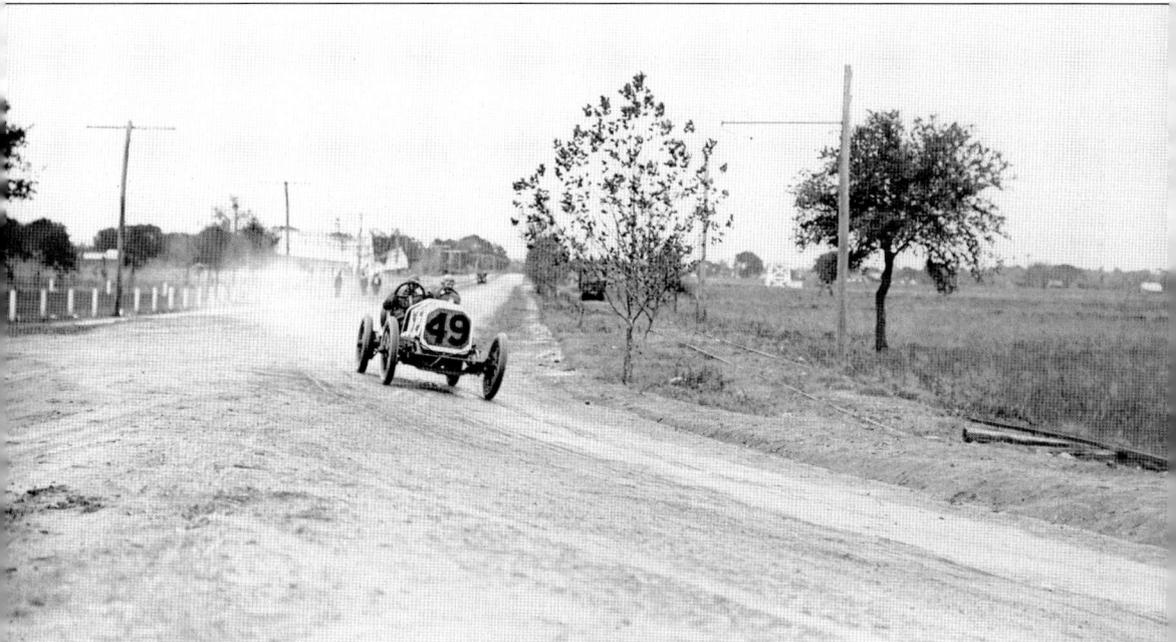

This photograph of Cobe in the Buick-Hundred was taken in either the first or second lap of the race. The car suffered a broken steering gear in the third lap and was the first entry to fall from the competition. He was in 14th at the time and had posted two very slow laps.

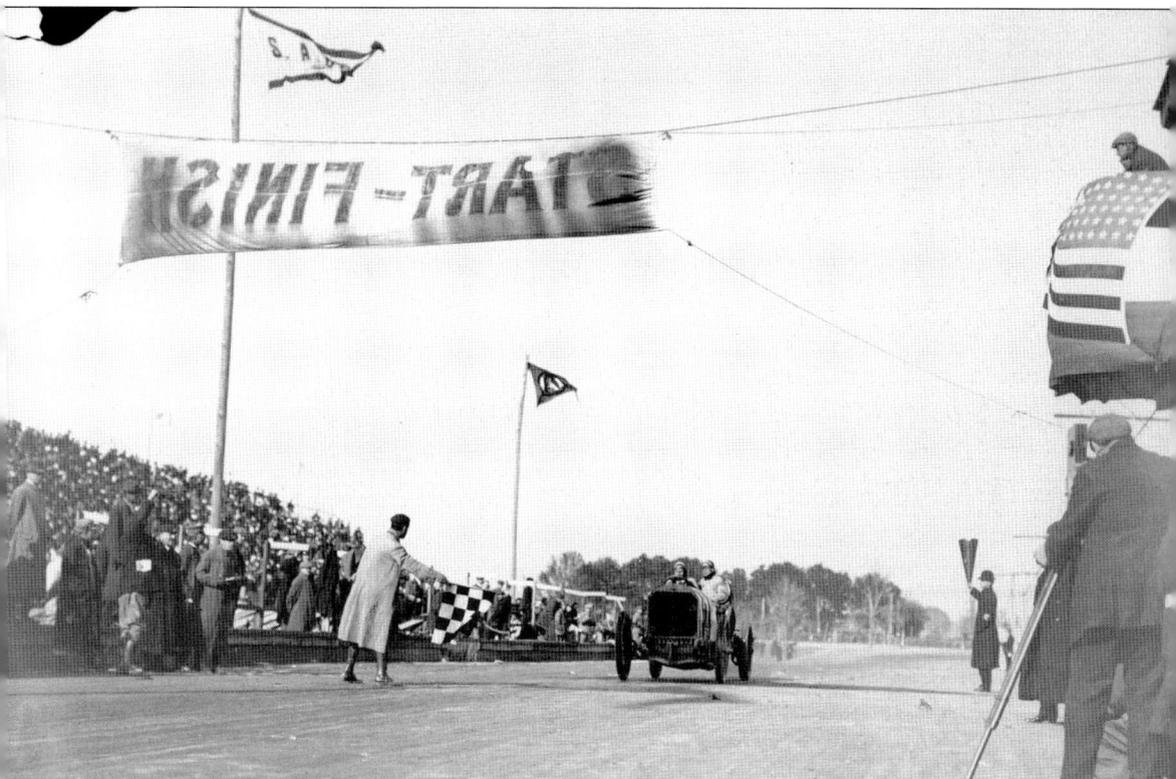

This photograph shows Hearne in the Benz winning second place in the Grand Prize Race. He was one of three Benz entries in the race and was the highest finisher on the team. The other two Benz entries exited the race in the eighth lap. One of these, driven by Bergdoll, suffered from carburetor trouble and the other, driven by Hemery, suffered from ignition trouble. At the time that they exited the race, they were running 13th and 14th, respectively.

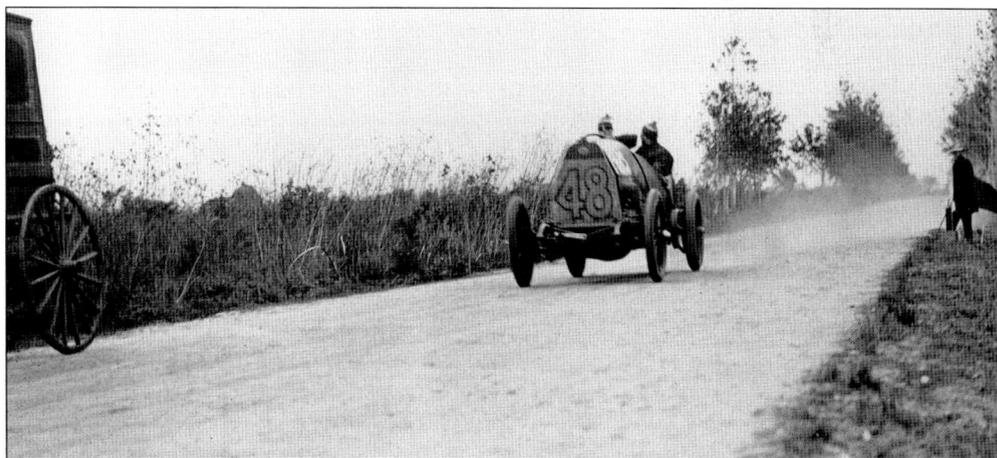

The Grand Prize Race of 1911 was won by David Bruce-Brown, the same winner as the previous year. In 1911 he averaged 74.45 miles per hour and set a record for that distance. As with the Grand Prize Race of 1910, his mother was in attendance. It was known that she still wanted her son to stop racing but relented because she knew it was his passion. He would survive this race, but his passion would claim him within a year.

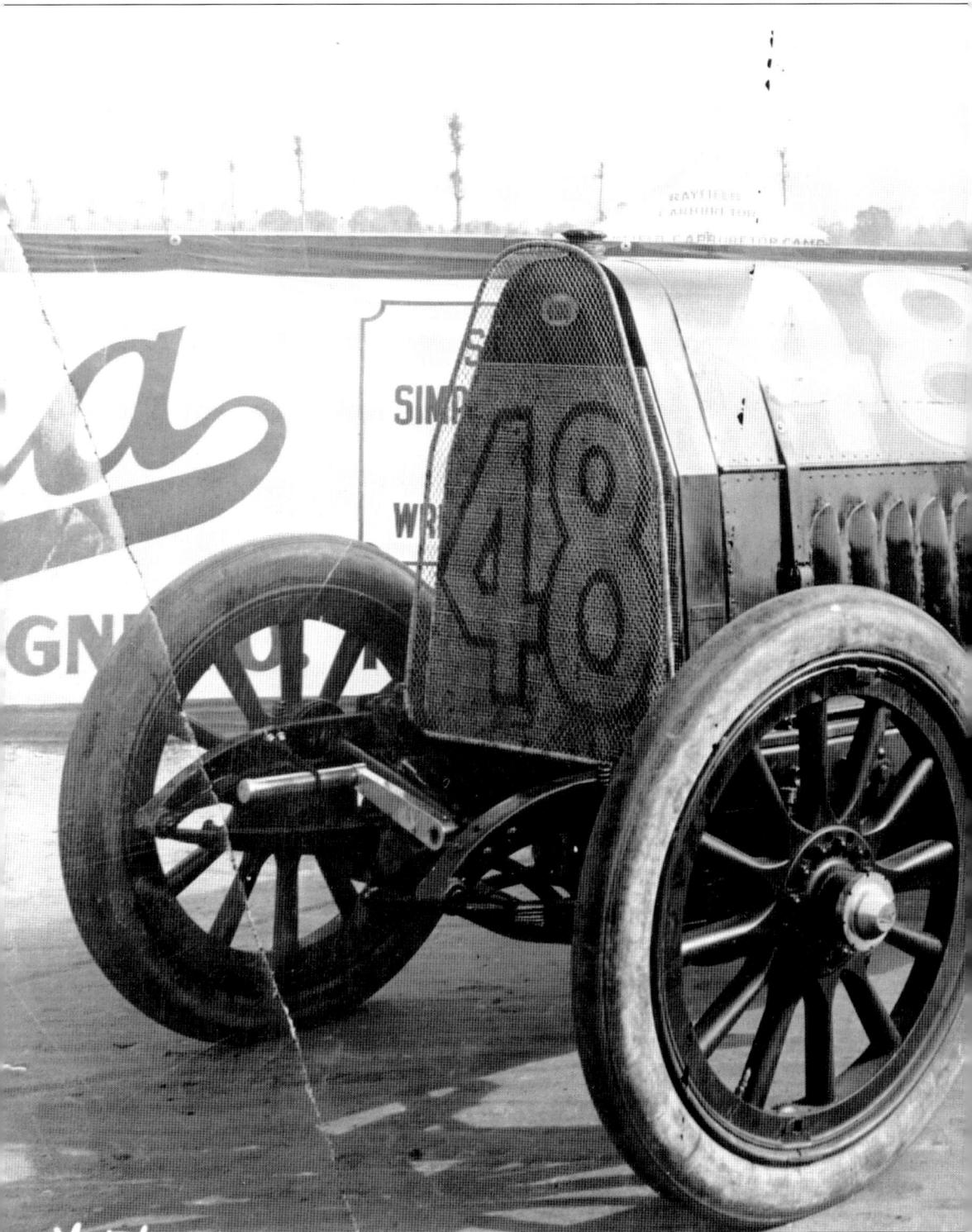

Bruce-Brown is pictured here for a publicity photograph. Businesses were rapidly learning the

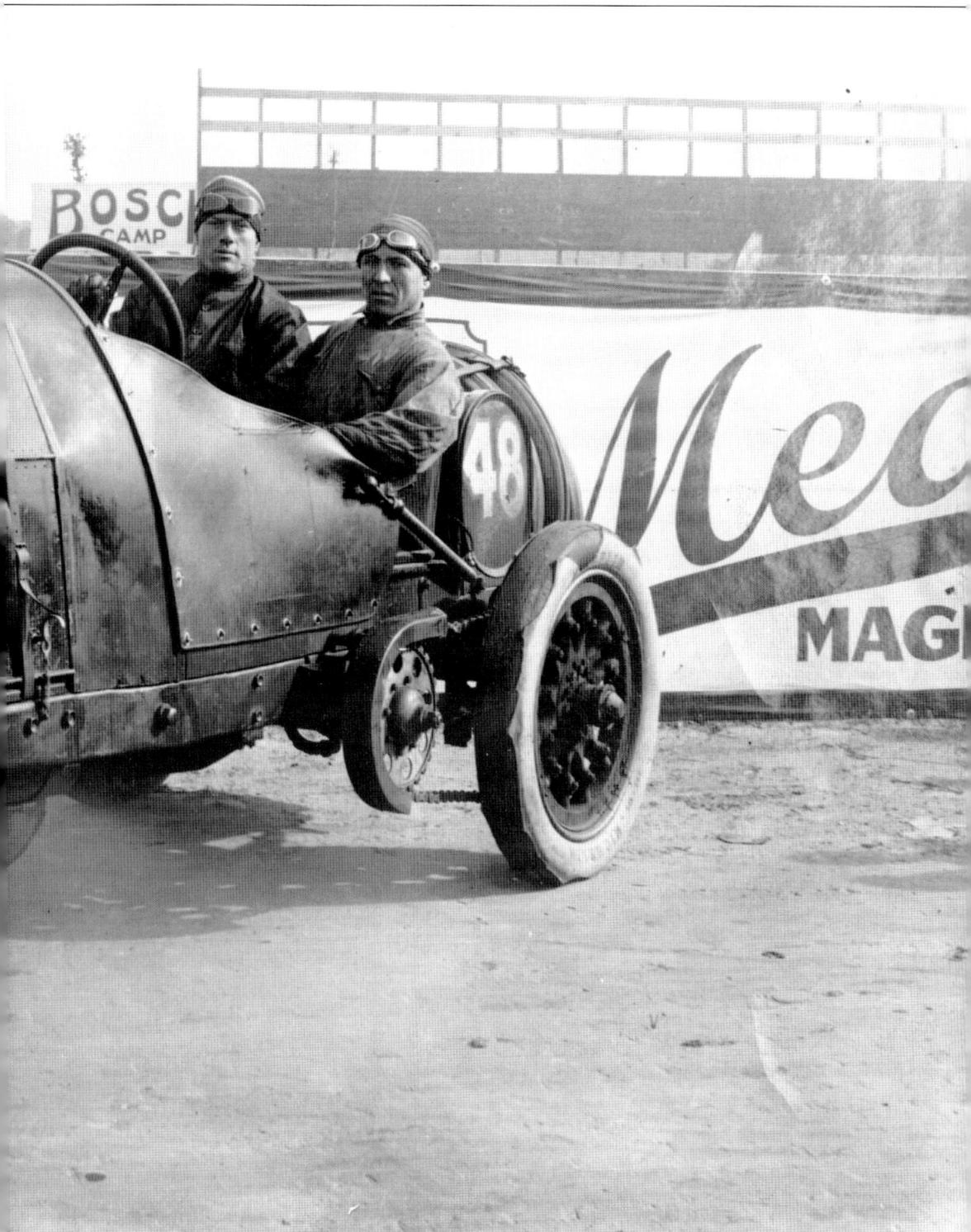

value of sponsorships and mass advertising.

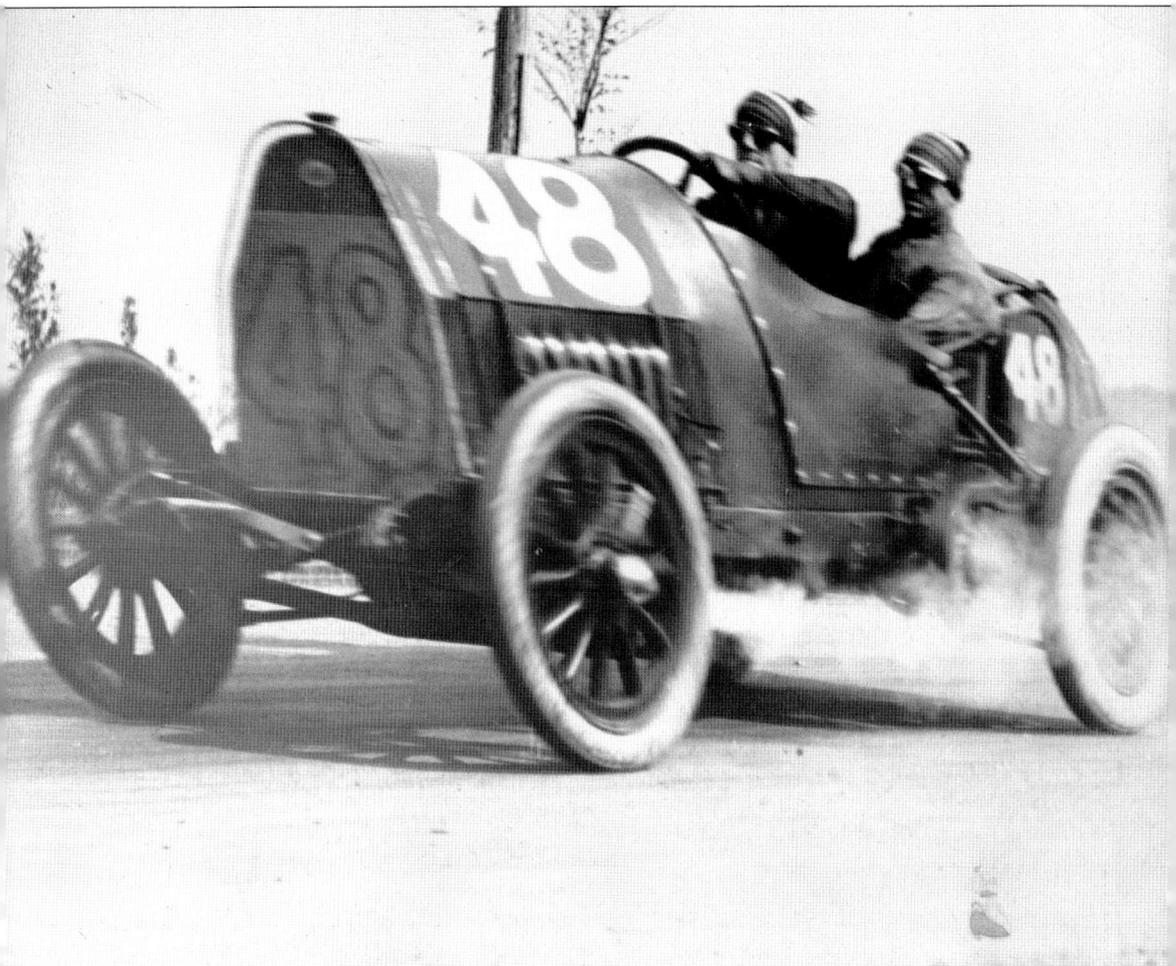

Bruce-Brown completed the first lap of the Grand Prize Race in second place. He was six seconds behind Bragg in the Fiat. Bruce-Brown experienced some problems in lap four, which took him almost 20 minutes to complete. By the end of the fourth lap he was in ninth place. He gradually climbed back into the race due to both his excellent driving and the mishaps of cars ahead of him. By the end of the 20th lap he was in first place. For one lap he fell to second and first was taken by Hearne in the Benz car. The next lap Bruce-Brown retook first place and stayed there until the end of the race. He made his move in the 23rd lap and completed it in a blistering 12 minutes and 23 seconds, averaging almost 80 miles per hour. Hearne completed the lap in 15 minutes and 5 seconds. In the last lap Bruce-Brown needed to only drive conservatively and not get caught in among other racers and the race would be his. He ran the last lap in 13 minutes and 12 seconds.

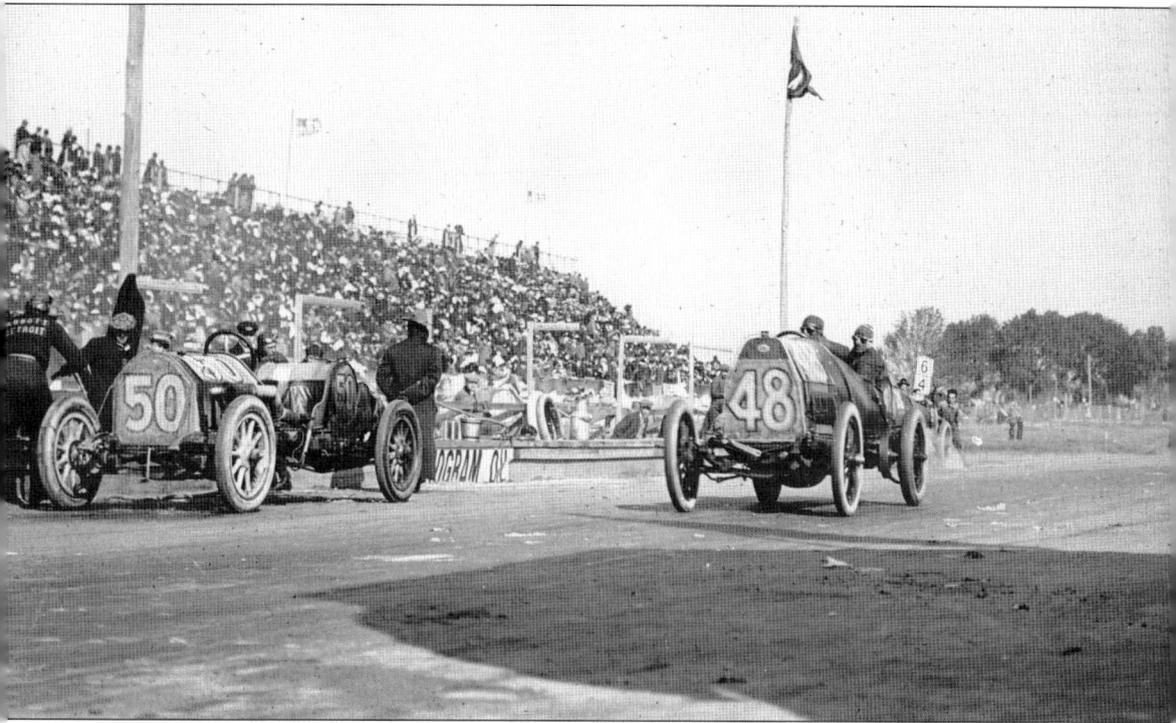

These two photos show David Bruce-Brown passing the grandstand and the Abbott-Detroit car driven by Limberg, in the pits. This is most likely between the 18th and 21st laps. An interesting and unprecedented thing happened at the end of the race. The Abbott-Detroit company presented their drivers with the cars they had driven in the Savannah races of 1911.

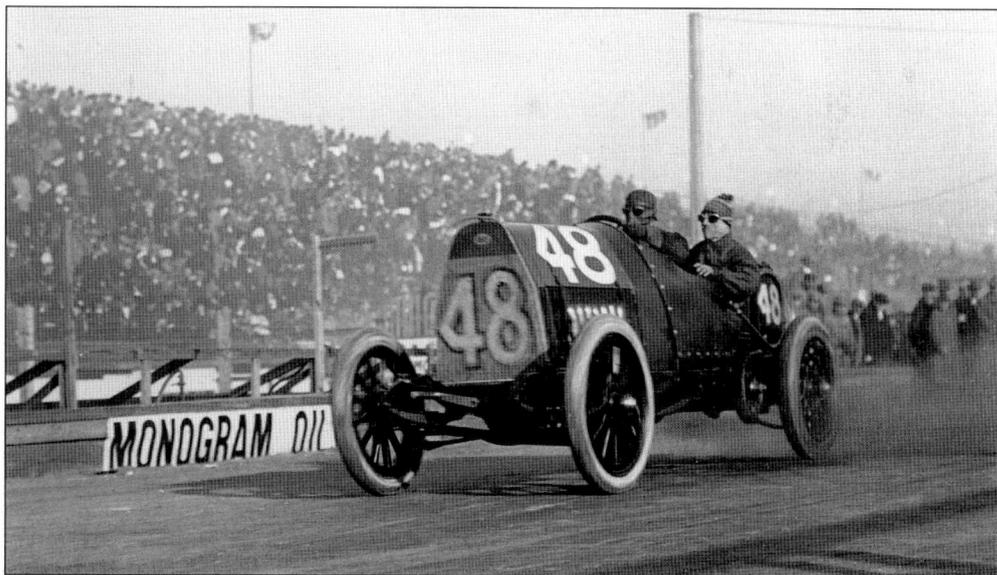

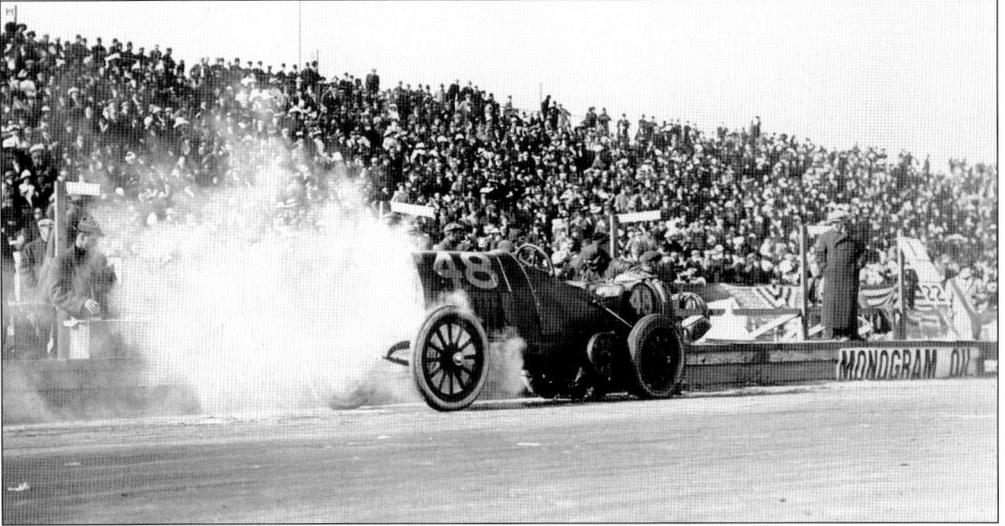

Bruce-Brown really pushed his big red Fiat to the limit. He stopped early in the race for tires and then pushed on, putting the pressure on anyone ahead of him that might have been about to stop. He was posting rapid speeds while the drivers in front of him were wasting time in the pits.

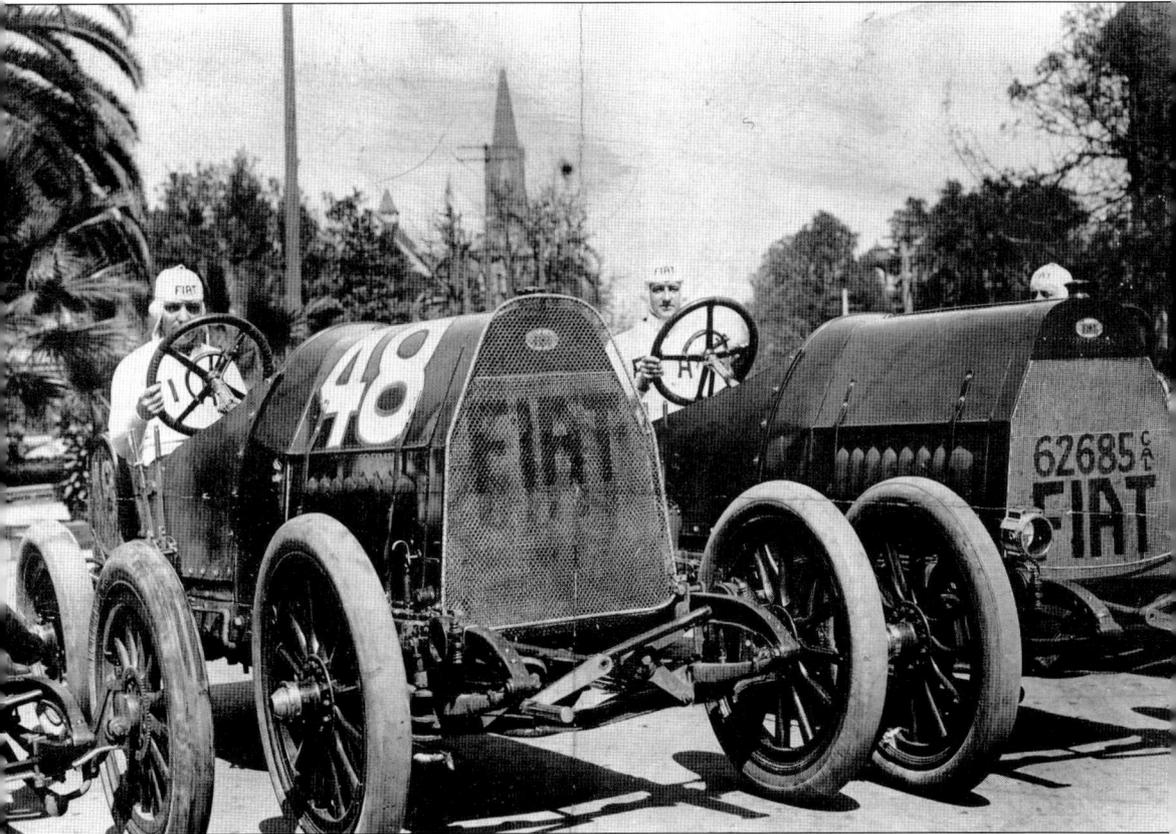

Pictured here are two Fiats. The number 48 was the same car driven by David Bruce-Brown in winning the 1911 Grand Prize Race.

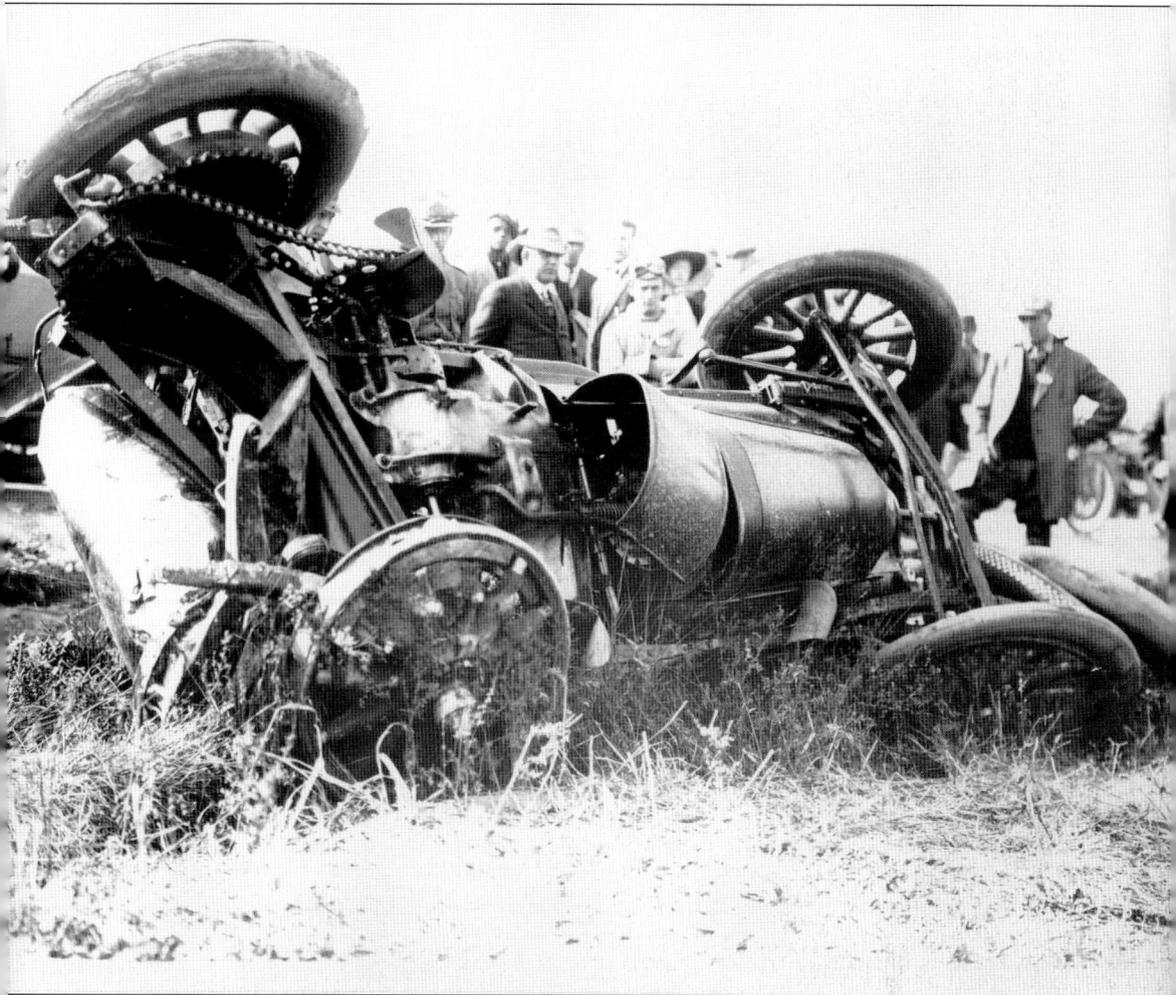

In 1912 David Bruce-Brown and his mechanic were killed in Milwaukee during practice rounds. This photograph is of the wreckage, which was the same car that he drove to victory in the 1911 Grand Prize Race in Savannah. A few days prior to the Grand Prize Race in Milwaukee, Bruce-Brown asked for an additional practice lap. The officials denied his request, but in typical thrill-seeker fashion he passed over the start/finish line and went for another lap. Half way through the lap he was struck in the face with a large stone. He lost control of the car and it flipped over, fatally wounding the driver and mechanic. Bruce-Brown died in the operating room from massive skull fractures and brain injury.

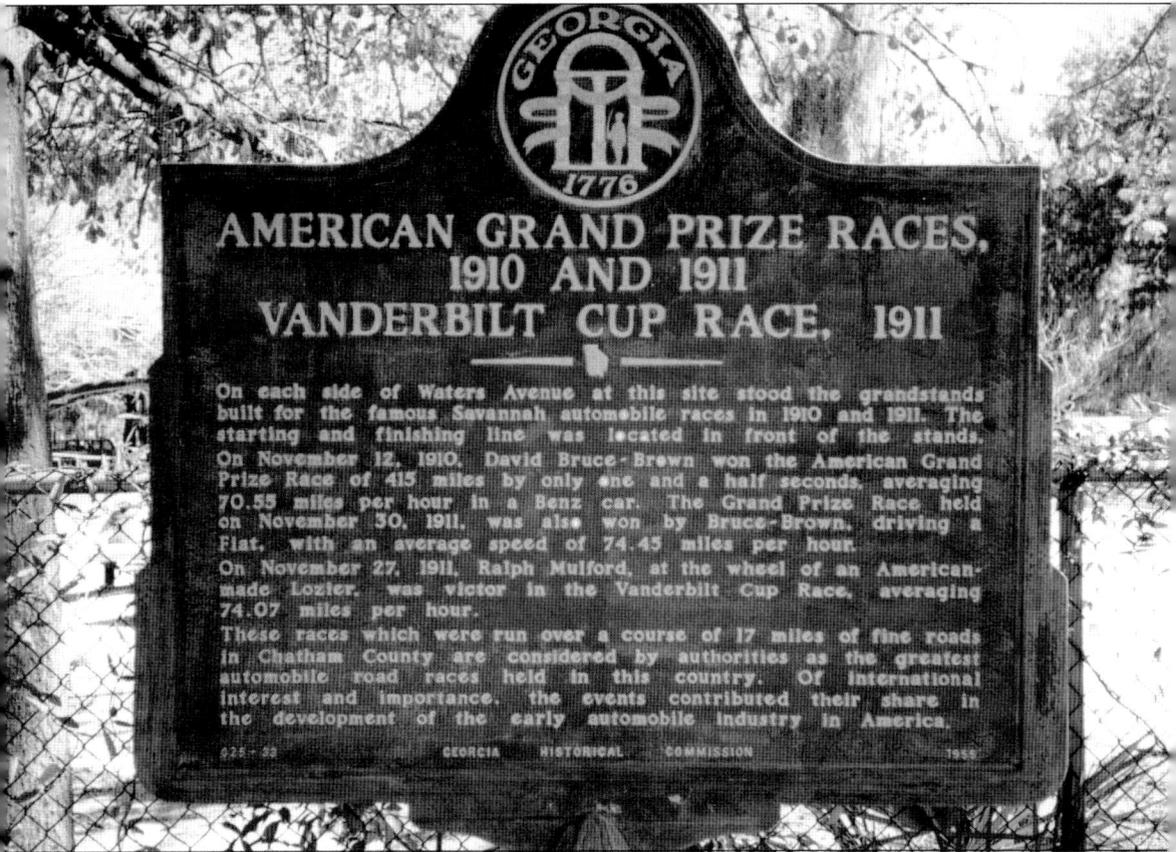

AMERICAN GRAND PRIZE RACES, 1910 AND 1911
VANDERBILT CUP RACE, 1911

On each side of Waters Avenue at this site stood the grandstands built for the famous Savannah automobile races in 1910 and 1911. The starting and finishing line was located in front of the stands. On November 12, 1910, David Bruce-Brown won the American Grand Prize Race of 415 miles by only one and a half seconds, averaging 70.55 miles per hour in a Benz car. The Grand Prize Race held on November 30, 1911, was also won by Bruce-Brown, driving a Fiat, with an average speed of 74.45 miles per hour.
On November 27, 1911, Ralph Mulford, at the wheel of an American-made Lozier, was victor in the Vanderbilt Cup Race, averaging 74.07 miles per hour.
These races which were run over a course of 17 miles of fine roads in Chatham County are considered by authorities as the greatest automobile road races held in this country. Of international interest and importance, the events contributed their share in the development of the early automobile industry in America.

025-33 GEORGIA HISTORICAL COMMISSION 1956

Savannah received worldwide publicity for the races held in 1908, 1910, and 1911. During the 1911 races it was realized that this was probably the last time the races were to be held in Savannah. Only a few historical markers and a few banked curves remain to remind us of the races. Few even know about the grand events as they drive along the roads that entertained the daring drivers. In 1997, attempts were made to return racing to Savannah, but these efforts proved futile. This marker sits at the intersection of Waters Avenue and Forty-Sixth Street as a reminder of Savannah's major role in the development of the automobile.